Journal Fodder
365

DAILY DOSES OF INSPIRATION
FOR THE ART ADDICT

NORTH
LIGHT
BOOKS

Cincinnati, Ohio
www.createmixedmedia.com

BY ERIC M. SCOTT AND DAVID R. MODLER,
THE JOURNAL FODDER JUNKIES

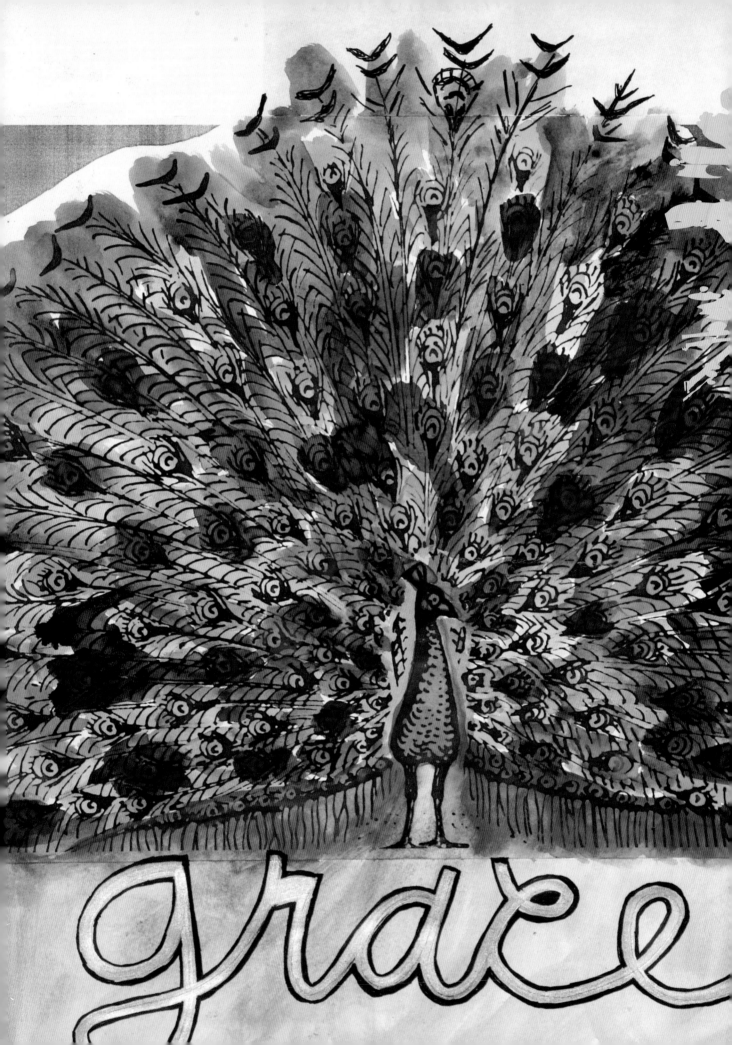

Foreword

One of the greatest joys as a teacher is to motivate, encourage, and inspire your students to witness their own creative potential. In the past dozen years, we have presented annual Visual Journal sessions at the National Art Education Association Conference. We believe that visual journals have the potential to facilitate in this creative journey for both teachers and their students. During our sessions, we highlight the work of artists, books and websites that are particularly effective for inspiring journal possibilities and, of course, the extraordinary work of our own students. In one of these early sessions, journal sites and books such as *The Journey Is the Destination: The Journals of Dan Eldon* (1997) inspired David and Eric to begin their own continuous journeys with visual journals. Each year at the annual art education conference, we were privileged to see David's and Eric's work as they progressed from journal junkies of their own, to sharing their passion by teaching journaling in their own classrooms, presenting at state, regional and national conferences, and publishing as authors. This latest of their collaborations is sure to motivate, encourage and inspire you to engage in visual journaling on a daily basis.

The possibilities suggested in this book are an opportunity to grow both personally and professionally with great scaffolding to support your journey. Visual journals are a voyage of discovery where ideas, imaginings and observations can be brought into existence. They are sites for gathering information, exploring possibilities, making connections, resolving problems and thinking through the stuff of every day. By trying out the ideas, techniques, compulsions, prompts and fodder suggested by the authors, you will become more adept at finding your own path in the creative process. Make your journal your own personal playground, a nonthreatening space for exploration and reflection as well as fun!

This book aims to capture the spirit in which visual journals are kept, offering numerous practical strategies to make your journal a part of your daily life. This involves having a graphic dialogue with yourself inside the visual journal, taking your ideas and transforming them into something new while documenting the experimentation, reflection and invention that are at the heart of your creative process and increased "visual fitness."

There is no instant formula for a successful visual journal. A visual journal is about evolving personal strategies, and it takes time and commitment to discover how it can work for you. This book will give you possible tools and strategies to help you become critically engaged and involved with your ideas.

Kit had the great good fortune to hear David Hockney speak at the Royal Ontario Museum during the exhibit of his iPhone and iPad drawings and paintings—*Fresh Flowers*. He said it didn't matter which tools one used to keep the visual art process alive but that it was imperative that one sketched or drew daily. "Anyone who likes drawing and mark-making," he said, "will like to explore new media." Although Hockney's visual journal has become digital, his reasons for recording his ideas and reflections on a daily basis have stayed the same.

For those of you who are new to the process of visual journaling or those who are looking for continued inspiration, you are in for a wonderful ride. As we mentioned at the beginning of this foreword, one of the greatest joys as a teacher is to motivate, encourage and inspire your students to see their own creative potential. In this book, you have the tools necessary to motivate, encourage and inspire yourself day by day.

KIT GRAUER, ASSOCIATE PROFESSOR, DEPARTMENT OF CURRICULUM AND PEDAGOGY, UNIVERSITY OF BRITISH COLUMBIA, AND RENEE SANDELL, PROFESSOR, DIRECTOR, ART EDUCATION, GEORGE MASON UNIVERSITY

Contents

Have a smartphone with a QR code reader? Throughout the book you will find QR codes like this one—scan them for access to related bonus content and tutorials from the Journal Fodder Junkies!

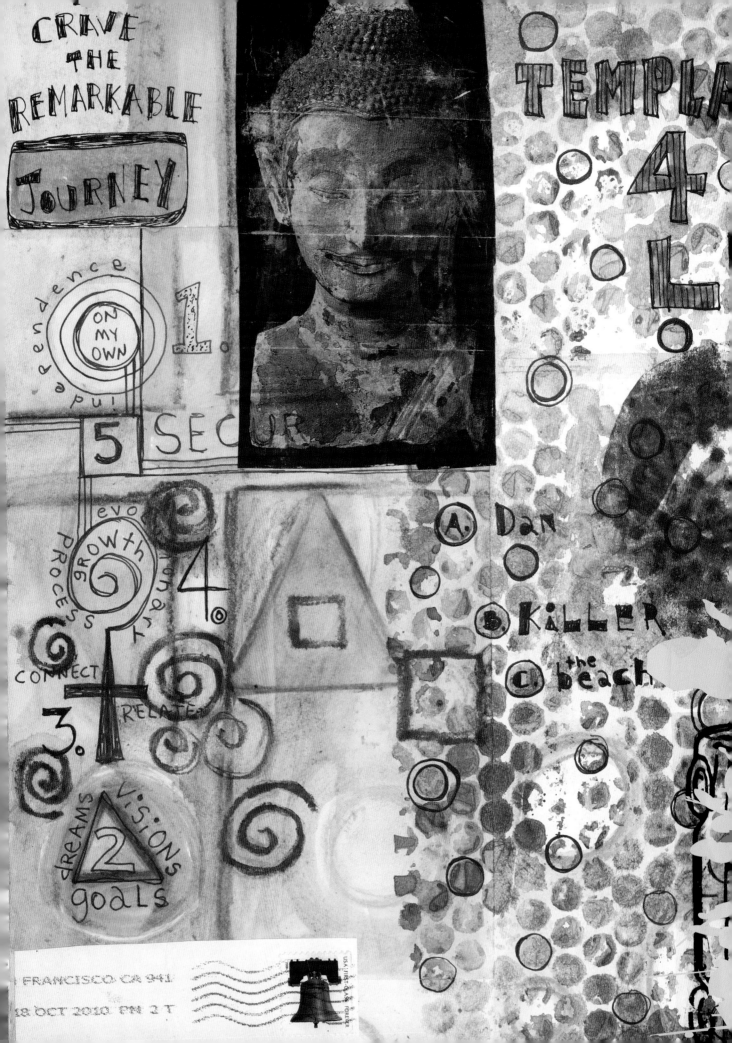

CRAVE
THE
REMARKABLE

JOURNEY

TEMPLA

4
L

ON
MY
OWN

1.

5 SECUR

A. Dan

B. KiLLER

the
C. beach

evo
GROWTH
PROCESS

4.

CONNECT

3.

RELATE

DREAMS VISIONS
2
goals

FRANCISCO CA 941

18 OCT 2010 PM 2 T

USA/FIRST-CLASS FOREVER

Introduction

With the release of our first book, *The Journal Junkies Workshop*, we began to understand and appreciate how our approach to the visual journal differs from many others out there. It is not about having completed, artful pages; it is about documenting our lives and throwing everything into the journal. A quick glance through some of the journaling books, makes it clear that many people use the journal as a very special place, an exalted place, a place to explore very specific and deep themes or a place to make finished works of art. And that's fine. We're not being critical of those approaches because the journal will be what it needs to be for each individual. We often explore deep issues in our journals and many of our pages are more like finished works of art. But overall we see the journal as more of a workhorse, for the everyday bloke, more blue-collar and not so prim and proper. That is because we put so much of our everyday into it. We don't scour shops for vintage ephemera because we empty out our pockets. We don't use a set procedure for working on pages because we just get to work. We don't worry about the archival qualities of materials because everything is fair fodder. We don't always set out to explore the deep and the personal because meaning gets made as we work. Our journals are much more random, unfinished, mundane and chaotic than others. Perhaps in a way they are more realistic and ordinary. It's the build up of simple ideas and techniques that give them their extraordinariness. It's the daily habit of working in the journal and the willingness to try new things that keeps the energy of working in the journal fresh and exciting.

We believe in the power of incorporating everyday life into the visual journal, and we often refer to our journals as Everything Books. We draw and write. We collage in the flotsam and jetsam of our daily experiences. We incorporate our personal and professional lives into the journal. Our journals become personally meaningful and relevant, but not necessarily in a contrived, picture-perfect way. They exhibit the ordinariness of our lives, our thoughts, our hopes, our fears and our art. The collection of ordinary things converts the blank journal into an extraordinary artifact.

With this book, we share simple conceptual strategies and new techniques that allow you to cultivate the habit of working in your journal on a daily basis. We also demonstrate ways to make the visual journal a part of your life and a place to record and refine your personal narrative in an authentic and unique voice. Some strategies are mere media explorations, and some are probing, introspective reflections, but each helps you add conceptual and physical layers to your journal as you transform it into a living, breathing document of your life. Whether you have five minutes or two hours, you can document your life in the journal.

Life is not always extraordinary in all its details, but it is the sum of those ordinary events that add up to extraordinary lives. The journal is no different.

How to Use This Book

We have organized this book into a year-long workshop that encourages you to reflect on who you are and what you want from life by using a variety of writing and art-making techniques. We have twelve chapters representing the next twelve months. Providing you a framework to structure your journaling, each chapter focuses on a different, yet specific, theme that we have personally explored in our journals throughout the years. These ideas are not one-and-done activities because they are reflective and beg to be readdressed time and time again. Along with the overarching monthly mission, we have included weekly writing prompts that will invite you to encounter different aspects of each theme. As you delve into the prompts and focus on the most appealing topics, you will incorporate written expression into the visual journal. We also included activities and exercises that will entice you to explore the art-making facet of the visual journal and to cultivate the journaling habit every day.

As the reader, you may decide to develop your creativity in a different sequence than what we have laid out. Just as the journaling process doesn't have to be linear, using this book doesn't have to be linear, and you may find appealing techniques and ideas from one chapter to use as you work in another. You are not limited to only the ideas and techniques offered in each chapter. We strongly encourage you to use what you already bring to journaling as well as ideas from other sources. We have structured this as a year-long workshop, but you are free to use as much or as little time as necessary. Maybe some ideas do not strongly appeal to you, so give them less time and attention. Perhaps you work very slowly or have a life packed to the gills, and it may take you much longer to get through it all. It's all right. You need to work in the manner that fits you best.

Structure of the Book

To facilitate the large variety of writing and art-making activities, we have structured each chapter with the same framework to maintain continuity.

GATHER YOUR FORCES

After a brief introduction to the month's concept or theme, you will find **Gather Your Forces**. In this section we identify the physical items you will most likely want to have on hand and the art materials to explore. We give you specific types of collage fodder and artist materials to consider with options for how to push your practice beyond its current level. You may decide to use different materials, but we have purposefully designed the activities to give you the chance to explore both familiar and unfamiliar materials and techniques.

STRATEGIC PLANNING

In the **Strategic Planning** section, the weekly writing prompts will push you to focus on the specifics of the monthly concept. Writing is a key component of the visual journal, and as you explore a different concept each month, we encourage you to explore a variety of methods and techniques for including writing and text in your journal. We offer four main prompts for each month, along with a variety of questions with each prompt. We prod you to be thoughtful and to write a lot. However, you may decide that particular prompts need to be examined more thoroughly than others. Write as much or as little as you feel necessary. It's one of the reasons we have structured it this way—to give you time to develop your ideas.

We also include a variety of writing techniques in this section so that you can consider two or three new techniques each month. Most of us grew up writing from left to right on evenly spaced, lined paper. Nowadays we are just as comfortable with pecking out words on a computer. We have become so familiar with the way we write that it is an unconscious act, one that we take for granted. Rethink how you write, and invite yourself to explore and experiment with your writing as you would with any art medium. You are free to use any writing method, style or technique, but like all strategies, look for ways to expand and widen your practice.

UTILIZING YOUR RESOURCES

Another key component of the visual journal is the art-making. In the **Utilizing Your Resources** section you will find hands-on demonstrations and visual examples for the daily art encounters using a variety of materials. This is where you will learn new and more specific techniques for using images, media and text each month. We didn't cram in thirty different ideas each month. Instead we share a few processes, leaving you to explore the potential of the various techniques while focusing on experimentation and practice. Although the materials may be familiar, we get more specific and more experimental with the techniques, going beyond the basics.

COMPULSIONS AND OBSESSIONS

We have found that there are lines, shapes, patterns, images and techniques that we continually add to the journal. These are often random and unconscious marks that we are obsessed with and compulsively include on pages. In the **Compulsions and Obsessions** section you will explore a variety of your own unique marks. They are most often small repeating patterns and easy-to-do embellishments, or they may also be specific uses for collage or paint. These compulsions and obsessions allow you to add to your journal when you only have five minutes, and it is this kind of mark-making that adds personal and stylistic continuity to your visual journal.

OBSERVATIONS

You are part of the world. Examining the visual culture that surrounds you is a great way to engage the world and bring the everyday into the journal. Each month in the **Observations** section we ask you to look at a variety of things. At times, these are tangible, material objects such as the work of other artists and simple items, and other times they are intangible, abstract situations and thoughts. These observations allow you to incorporate ideas and images from outside sources into your journal.

EXCURSION

For many people the visual journal is something that resides at home or in the studio. They come to it at night, in the middle of the week or on the weekend and fill it with their reflections. However, the journal can be an integral part of who you are and can accompany you out into the world. Near the end of each chapter you will find an **Excursion** where you are invited to include your journal as an integrated part of your everyday routine. It might be a trip to a museum to document your exploration of an art or history collection, or it might be a walk around your neighborhood to see what's out your front door.

ANATOMY OF A JOURNAL SPREAD

Finally, at the end of each chapter we include an **Anatomy of a Journal Spread** in which we show an example of a two-page spread where we have specifically used ideas, prompts and techniques from that chapter. We comment and diagram where different concepts are integrated so that you can see how we analyze these ideas in our own work.

As with *The Journal Junkies Workshop*, this is not a recipe book. With each activity, prompt and technique, we share some basic beginnings and specifics to get you started exploring the greatest number of possibilities. Although specific pages are shown to illustrate the techniques from the chapter, we do not lead you step by step through the making of these pages. You are on your own to decide where, when and how to use the ideas. You may decide to focus your month's attention on a single page or two-page spread, or you may intersperse the ideas throughout the journal so that each month's activities interact with other months.' We work in a nonlinear fashion, bouncing around working on multiple pages, and even sometimes book to book, so we encourage this type of divergent approach. We give you suggestions and strategies for incorporating the concepts and techniques, but we are just sharing the possibilities. As you work in the journal, feel free to use ideas, techniques, compulsions, prompts and fodder from different chapters and other sources to infuse your journal work with a variety of methods. We want you to explore the creative possibilities in your journal in a manner that makes the most sense to you.

Getting Started

Chances are that if you are reading this book, you are not new to visual journals. We don't want to bog you down with all the minutia of getting a journal and selecting materials, so we will say a quick word about getting started and the materials you may want to have on hand. If you are new to the world of visual journals, we highly recommend our first book, ***The Journal Junkies Workshop: Visual Ammunition for the Art Addict***, for more detailed information about journals, materials and basic techniques.

We keep the materials and equipment very basic, because it's not about *what* you have, it's about what you *do*. Many people feel that they need to bring everything and the kitchen sink into their process in order to tap into their creativity. But truthfully, you can overwhelm yourself with too many choices. Take a less-is-more attitude and limit the supplies you use so that you target simple creative solutions instead of grappling with complex material issues. Leave behind all the specialty paints, equipment and media, and focus on portability so it's easier to include journaling in your daily routine. You don't need a big studio, filled to the brim with materials with unlimited table space. You just need a basic journaling kit and a pocket of fodder, and you can create anywhere.

Here is what we use and recommend for getting started. We mention brand names and specific types of materials and equipment where we have a preference, but focus on portability and use what is available and comfortable to you.

a journal – We use 11" × 14" (28cm × 36cm) hardbound sketchbooks with 70 lb. paper.

watercolor paint

watercolor pencils – We like the brand **Prismacolor**.

colored pencils

scissors

glue sticks – We only use UHU, and get the jumbo size. It's worth it!

a variety of your favorite pens, markers and pencils

a water cup – An empty film container works well as a portable water cup.

a variety of paintbrushes – We like stiff nylon brushes that are suitable for a variety of painting media.

letter stencils – Thin plastic stencils can even be stored within the journal.

Take some of your most convenient and most used items and create your basic journaling kit. You can use a paintbrush bag, a pencil pouch or a small box. We recommend arming your kit with watercolors, watercolor pencils, pens and pencils, a glue stick, scissors and few paintbrushes. Keep it simple and portable.

As we share ideas, we may suggest more materials or equipment, but for now let's get started.

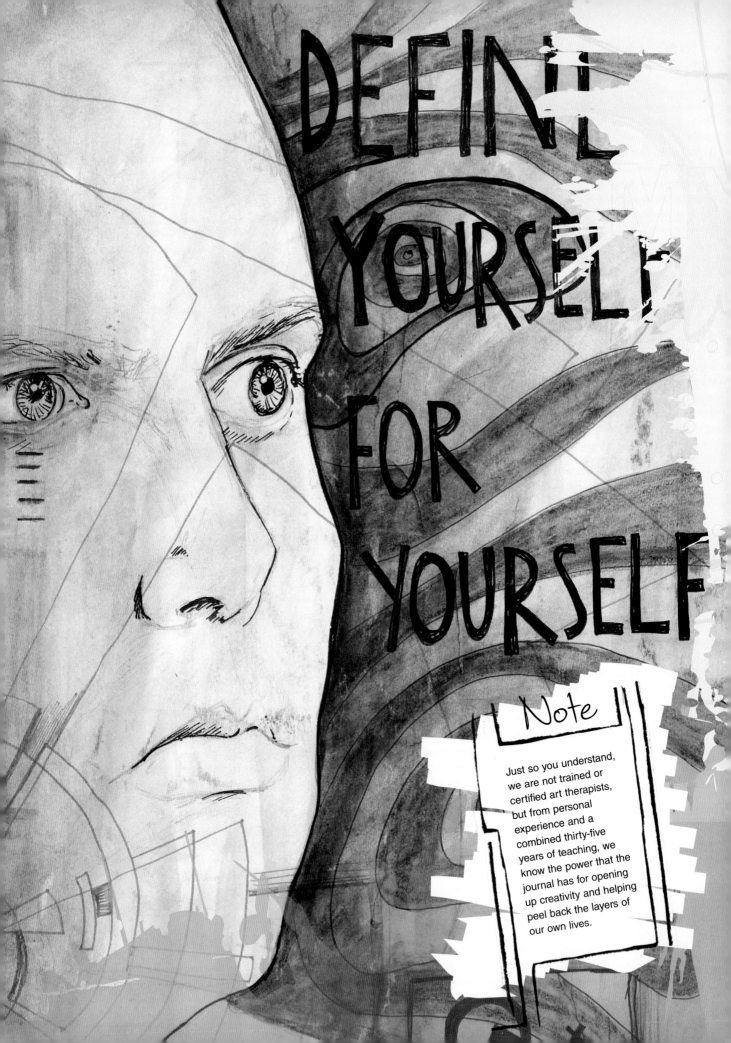

DEFINE YOURSELF FOR YOURSELF

Note

Just so you understand, we are not trained or certified art therapists, but from personal experience and a combined thirty-five years of teaching, we know the power that the journal has for opening up creativity and helping peel back the layers of our own lives.

Personal Mythologies and Histories

Begin your journey by reflecting on your past as you delve into your identity. Explore who you are as well as the stories you tell yourself. Explore significant people and events in your life as you slowly introduce or reintroduce yourself to the visual journal.

No matter what you put into the journal, it becomes a reflection of who you are, who you think you are and who you want to be. What better way to begin your exploration in the journal than to review who you are? As you work, keep thinking about your past and the stories you have built about yourself. Reflect on your personal journey to this point in your life. Think about the things that are important to you, and examine your strengths and areas for growth. Identify your core values and how they relate to your personality. Where did these concerns come from? Who has influenced them? Pain along with joy is a part of all of our lives. As you explore your identity and how it relates to your experiences, learn to lean into the pain and celebrate the joys. Confront the disquieting parts and embrace the pleasant memories. It is all about you.

GATHER YOUR FORCES

This is the story of your life, so gather fodder and ephemera to help narrate and illustrate that story. Make a reconnaissance trip to your parents' or grandparents' attic or basement. Pull out those old dusty boxes and rummage through those old photos and school papers.

Along with this personal fodder, look for some atypical types of images such as ID photos. You present these work, school, passport, or driver's license photos as proof that you are who you say you are. Do these images truly reflect who you are, though? Do they represent all that you encompass? They may be unflattering, but they plainly and blatantly depict you as you appear. How can you take ownership of these standardized images?

additional art-illery

Along with your basic art materials, think about using:

photos of yourself, especially at different points in your life or from IDs
photos of your family, friends and pets
ticket stubs, postcards, letters and other ephemera
old artwork, schoolwork or writings
anything that will help convey who you are

If you have precious fodder or one-of-a-kind photos or memorabilia, you can always scan and print copies of these items, or go to your local office store or library and make copies. This way you can preserve your mementos and experiment with the reproductions.

STRATEGIC PLANNING

The weekly prompts are designed to help you think about your personal journey and your personal mythologies. Writing about each of the prompts allows you to explore the specifics about yourself and inform the decisions you make about the art and images you include in the daily activities.

WRITING PROMPT 1: *I Am*

Who are you? This seems like a very easy and straight-forward question, but when was the last time you really tried to articulate an answer? Take some time to ponder and write about all the aspects of your "self." Think about where you come from, who your family is, and what is most important to you. Use adjectives to describe yourself, or describe all of the roles you play or have played in your life. Think about the stories that you build about yourself—the mythology you have constructed.

WRITING PROMPT 2: *Pivotal People*

Who in your life has influenced you strongly? This may be in a positive or negative way. Think and write about those people who have had a significant impact in your life and may have been responsible for the direction of your life path. Think about how old you were, how these people affected you, the obstacles that you faced and the way your life has changed. Recognize those that have had a profound effect on you. Who were they? What did they say to you? What do they represent?

WRITING PROMPT 3: *Roads Taken and Not Taken*

What have been the important decisions in your life? We have all grown, evolved and changed. At times the movement of our lives has changed direction because of the choices we have made, and at other times it has changed because of the choices that others have made. These are what psychologist Ira Progoff called Steppingstones in his Intensive Journal workshop. They are the roads that we have taken and the roads that we have not taken. What have been your stepping stones? What have been the significant moments of change and growth in your life? What have these shifts meant for you and the direction of your life? What have been the opportunities you have pursued—the roads taken? What have been your missed opportunities—the roads not taken?

WRITING PROMPT 4: *Personal Mythologies*

What are the stories that you have told yourself over and over again even if they are not true? A myth is a legendary or imaginary narrative that presents our beliefs, and a mythology is a collection of those stories. We have all created myths about ourselves—stories that are imaginary and unverifiable. We have puffed ourselves up with stories of accomplishment and torn ourselves down with stories of lack. We have self-talk, scripts and dialogues running through our heads, reinforcing those myths. Question your own mythology, and see if you can verify the myths. What are your personal myths? What is your personal mythology? What are your stories? Why do you believe them, accept them and perpetuate them?

WRITING TECHNIQUES

As you explore the prompts, focus on your natural handwriting, whether you prefer cursive or print, using a variety of pens, pencils or markers. There is something to be said for the physical act of putting a pen or pencil to paper. The way your letters slant or the way you cross your t's can say a lot about your personality or character. As you focus on writing your responses, try making lists, jotting down quick notes and freewriting.

Your lists may encompass your personality traits; your favorite food, music or movies; memories or descriptors and adjectives. Jot down quick notes about a person, a situation or a recollection to capture the details. Freewriting, also known as stream-of-consciousness writing, is a creative writing exercise that is often done for a set period of time. Give yourself from five to fifteen minutes, and write about whatever comes to mind, allowing your words to flow. The idea is to start writing using one of your prompts and not to stop until your time is up. You may want to set a timer, and don't worry about spelling, punctuation or grammar. Generate words as if your brain is directly connected to your hand as you record the thoughts that are emerging in your mind. If you get stuck, simply write the prompt over and over, or write, "I cannot think of anything to write about," over and over again until the writing moves forward.

The surface on which you write is just as important as how and what you write. Your writing does not need to be on separate paper; it can be done directly in the journal. Try to do a little of both as you work on your writing. Separate writings can always be glued in later.

Your writing is a crucial component of your journal, not a separate act. Many people get so caught up in writing and editing in order to fix mistakes in their journals that they never actually say anything. Cross out the spelling mistakes and leave the grammatical errors as a documentation of your process. It's part of your journey. It's much more raw and much more you.

UTILIZING YOUR RESOURCES

While you discover your authentic voice in your writing, ease into the art-making and begin to develop your artistic voice with some basic media and simple techniques. Keep in mind that the intention behind everything that you do is to explore who you are, so make your decisions based on that premise.

DRAW

LINES AND THREADS

As you begin to explore your initial marks, discover *your* line by experimenting with the type and quality of lines, coming back to those lines with which you most identify. We all seem to be drawn to particular elements in our art, and as you explore a variety of lines over time, you will find that for some reason you keep coming back to a specific type. Focus on discovering the qualities of your line using any material that you want—pen, pencil, marker, watercolor paint or watercolor pencil. Intentionally experience a variety of lines on your pages. You could begin on a blank page, one that has some writing on it or one that has some other image or element. Discover which lines feel the most comfortable. Are you a "straight line" person, a "zigzag" person or a "swirly line" person? What nature of line suits your personality? As you develop your lines, focus on dividing your journal pages into several larger shapes by drawing from edge to edge so that you are considering the experience and the entire space of a page. Along with the types of lines, explore a variety of colors and thickness. Make some extremely thick lines as well as some very thin, delicate lines. Mix up your colors and find the combinations that speak to you.

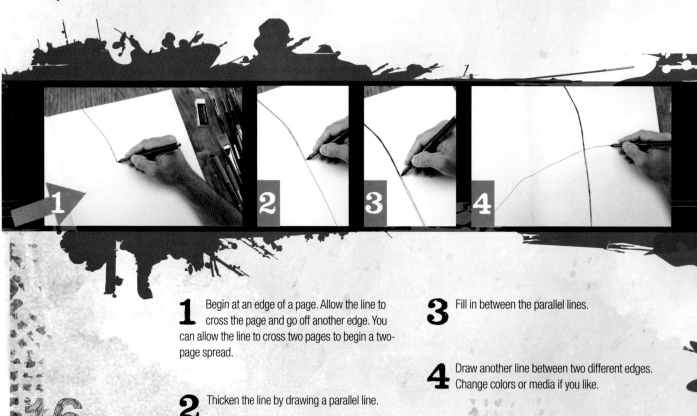

1 Begin at an edge of a page. Allow the line to cross the page and go off another edge. You can allow the line to cross two pages to begin a two-page spread.

2 Thicken the line by drawing a parallel line.

3 Fill in between the parallel lines.

4 Draw another line between two different edges. Change colors or media if you like.

LINES AND MARKS

Watercolor paint can also be used to draw lines or add color. Experiment with basic painting and mark-making with watercolor using a variety of paintbrushes and application techniques.

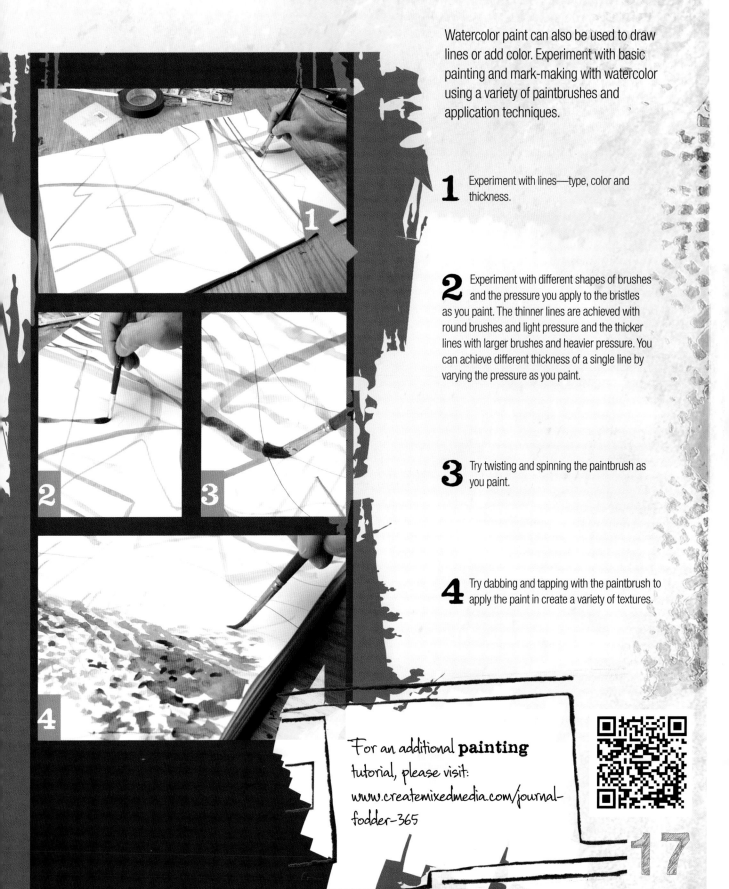

1 Experiment with lines—type, color and thickness.

2 Experiment with different shapes of brushes and the pressure you apply to the bristles as you paint. The thinner lines are achieved with round brushes and light pressure and the thicker lines with larger brushes and heavier pressure. You can achieve different thickness of a single line by varying the pressure as you paint.

3 Try twisting and spinning the paintbrush as you paint.

4 Try dabbing and tapping with the paintbrush to apply the paint in create a variety of textures.

For an additional **painting** tutorial, please visit: www.createmixedmedia.com/journal-fodder-365

COLLAGE

Collage elements are the food for your journal—hence the term "fodder"—and as you begin to glue in photos and other ephemera, your journal will begin to swell and grow. Incorporate personal fodder that helps to tell your personal history, and consider a basic procedure to make certain that all your pieces are glued in well.

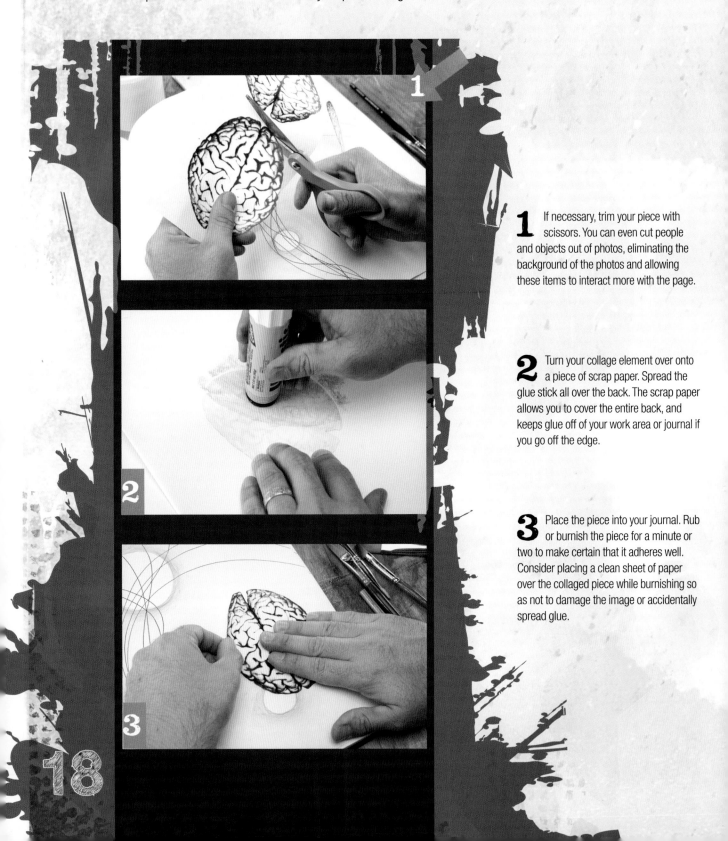

1 If necessary, trim your piece with scissors. You can even cut people and objects out of photos, eliminating the background of the photos and allowing these items to interact more with the page.

2 Turn your collage element over onto a piece of scrap paper. Spread the glue stick all over the back. The scrap paper allows you to cover the entire back, and keeps glue off of your work area or journal if you go off the edge.

3 Place the piece into your journal. Rub or burnish the piece for a minute or two to make certain that it adheres well. Consider placing a clean sheet of paper over the collaged piece while burnishing so as not to damage the image or accidentally spread glue.

COMPULSIONS AND OBSESSIONS: REPEATING LINES AND SHAPES

Think about simple yet random details and repeating elements that you can add without much thought or effort. For these embellishments focus on simple lines and shapes. Perhaps use a good waterproof pen for these marks so you can add wet media like watercolor over the marks with little to no bleeding and smudging. Relate these compulsions and obsessions to the lines you are focusing on, and don't think of them as something different. If you find yourself coming back again and again to straight lines, draw stripes, squares and rectangles as your compulsion. If curved lines and swirls appeal more to you, use spirals, waves and circles.

If you have not been working on several different pages, these compulsions are an easy way to expand your working practice. You can begin new pages with these marks, or you can add to pages that have words, lines, colors or images. When you do not have large spans of time to dedicate to the journal, add some of these compulsions and obsessions because they quickly build stylistic continuity among the pages.

Squares, Rectangles, Straight Lines

Circles, Ovals, Curved Lines

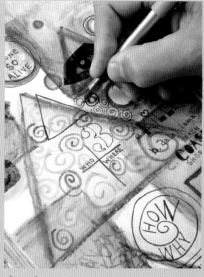

Spirals

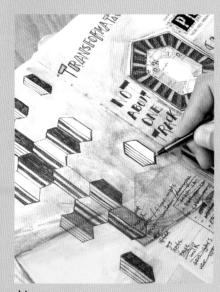

Hexagons

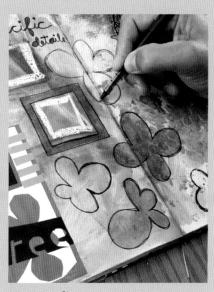

Organic Shapes

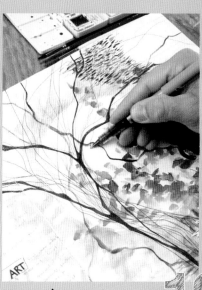

Organic Lines

19

OBSERVATIONS: LOOKING AT OTHER VISUAL JOURNALISTS

You make observations every day, and without much thought you use what you have learned to define who you are. What are you looking at? What are you drawn to? What do these things say about who you are?

With the sheer volume of resources, one place to start is by looking at other visual journals. Make a trip to the library, search online, look through this book and other journaling books and find still others that speak to you. Find a connection with someone out there, and make observations of their work. You don't need to understand the connection. Look and learn from them. Don't look so much at the techniques; look at the art—the pages. What speaks to you and draws you in? What grabs and holds your attention? Whose colors reflect your feelings? In the beginning, for us, it was Dan Eldon who informed our journaling practice. Over the years we have grown as artists and visual journalists, and we have looked at many other people and what they have said using this very unique form. Find your journal heroes.

Consider incorporating the way they use color, the way they use text or images or the way they organize their page layouts. At first you may feel like you are simply copying and not using your own voice, but over time you will learn from these heroes and begin to infuse their influence into your way of working. Your own style and your own voice will emerge.

Document the artists you are observing. Research and reflect on these artists, and make copies of their work or print out pages from their websites and blogs. Glue these into your journal as a way of remembering them and documenting their influence. Write about the things that you are drawn to, and analyze why their work speaks to you. Incorporate your heroes into your journey.

EXCURSION: TAKE YOUR JOURNAL FOR COFFEE

If you become accustomed to working in the journal in one place like the dining room table or in the studio, it may feel out of place to take the journal out into the world. Make a date with your journal and take it out for coffee or tea. Take a few portable materials—perhaps some pens, markers, scissors and a glue stick—and grab a cup of coffee or tea at your local spot. Nestle into a table or booth, pull out your journal and materials and begin to work. Write and reflect about your past. Explore some simple drawing.

Glue in your receipt or the menu from the shop. Fall into your compulsions and obsessions and simply doodle on your pages. Just do something and allow your journal to breathe in the atmosphere, and observe how you feel. Do you feel like people are looking at you? Or is no one paying attention? Does time slip by unnoticed, and before you realize it, your cup is empty and you have been working for quite a while? What is the experience like? What are you like in the experience?

ANATOMY OF A JOURNAL SPREAD

Image from Eric's driver's license

Collaged elements from an image of a piece of artwork

Lists of the *Roads Taken and Not Taken* from Prompt 2

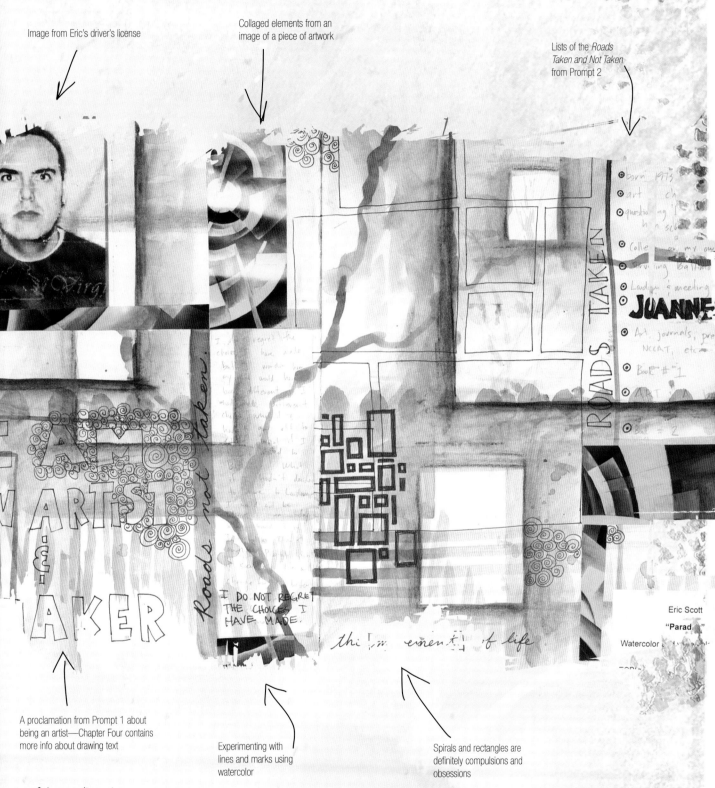

A proclamation from Prompt 1 about being an artist—Chapter Four contains more info about drawing text

Experimenting with lines and marks using watercolor

Spirals and rectangles are definitely compulsions and obsessions

Closing Thoughts

Hopefully as you have worked throughout this first chapter, you have explored who you are and experimented with the ideas, techniques and suggestions we have offered. You may not have supplied a complete life history, but you have at least begun the process.

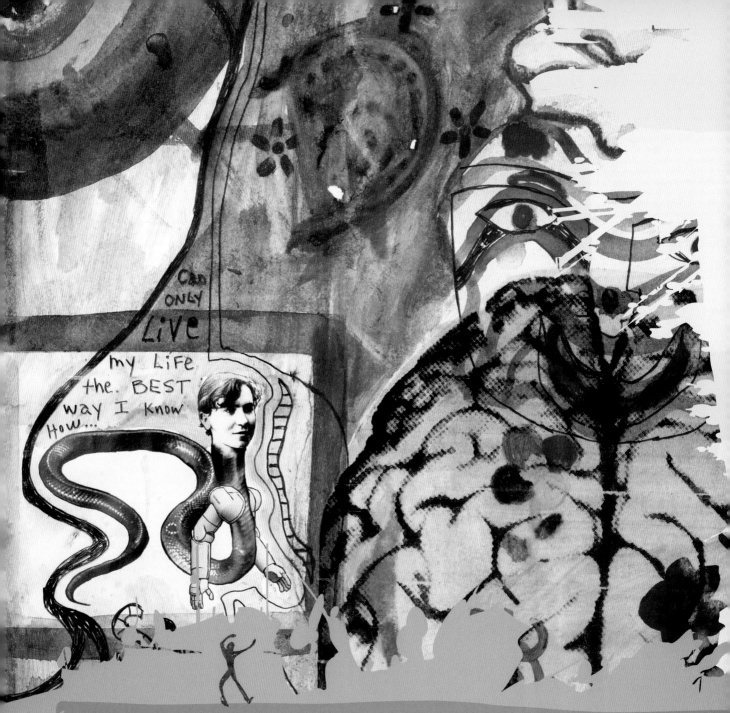

Can ONLY LIVE my Life the. BEST way I know HOW....

GATHER YOUR FORCES: RANDOM IMAGES AND REVISIONING JUNK MAIL

As chaos and randomness are introduced into your mode of working, give it permission to influence the way you look at potential collage fodder. Think about collecting a variety of random images and images that are not personal to you. Look out for intriguing images, colors and materials. Look through magazines, old artwork and old mementos, and select things based solely on intuition and not on some deep, personal memory or reason. Keep it as random as possible.

And what could be more random than junk mail? These unsolicited advertisements and correspondences wind up in our mailboxes, and often we just trash it or recycle it without much thought. Spend a little time sorting through your junk mail to see if anything has the potential for artistic value. Perhaps an envelope would make a good background shape. Perhaps there are images that beg to be used. Or perhaps there's something weird or funny that needs to be saved and used at some point. Because you choose and use these materials, you imbue them with a meaning that goes beyond the surface.

Randomness and Chaos

Life can be very random and chaotic, but many of us want our worlds neatly planned and structured. We feel pressure from ourselves and others to have a plan and to know exactly where our lives are heading. Life rarely unfolds like we plan, so open yourself and the journaling process up to some spontaneity as you allow a bit of chaos and random juxtaposition into your working method. The journal is nonlinear and allows for this freedom from structure, and it is a place to experiment and play. Emphasize the nonlinear quality and get messy as you experiment with new techniques to strengthen your investment in the journal.

Too often artists can freeze because they have an idea of what they want the piece to be—a picture-perfect image in their minds. They plan, plot, scheme and then freeze. They are afraid that things will not go according to plan, and they will mess up and fail miserably. However, it can be helpful to openly invite a bit of randomness and chaos into your working habits and to put the ideal of the finished page to the back of your mind. By purposefully cultivating spontaneous acts, you can set aside the fear of making mistakes and learn to embrace the surprises that arise from giving up a little control. You can discover beautiful images and themes as they arise from the chaos and that you could never have planned.

additional art-illery

Along with this fodder and your basic journaling kit, you will need an eyedropper and some string or yarn.

STRATEGIC PLANNING

Ideas and inspiration come from some unlikely sources, so don't become set in one mode of working and writing. Be on the lookout for absurd possibilities and random happenstance. The clutter and chaos can lead to the unexpected connections of words, ideas and images. Allow chance and unpredictability to seep in as you search unlikely places with the notion of harnessing the power and the creative possibilities that float in and out of your environment every day.

WRITING PROMPT 1: *Random Words*

Open yourself to chance by picking a random word to use as a source of inspiration. Grab a book or dictionary that you have close at hand, and open to any page and just point to a word. Don't like that word? Pick another. Not ready to be completely aimless? Pick a specific page, and choose a word that draws you in.

Don't use this process repeatedly in order to pick a word you already have in mind or one that fits your mode of thinking. Let chance take you in a direction that you are not ready to go. If you find the word challenging, let it challenge you and see how you can respond to it even if it's the silliest or the most unusual word. What does this word mean to you and your life at this moment?

WRITING PROMPT 2: *Operative Words*

Operative words are the essential words in a sentence, story, poem or script. Performers and spoken word poets stress or emphasize these words when performing to give them impact. We scour our writing for operative words and highlight or visually emphasize them to draw attention to them, so that we can come back later and quickly find and use these words as sources for further investigation and exploration.

Look over some of your writing, and choose important words or phrases and highlight them in some way. Circle them, make them bold, use a different color or different material. These are words and phrases that you are drawn to, so again, trust your instincts. Try to find at least three or four operative words or phrases in your writing, but feel free to find as many as you'd like. Pick one of these words to use as a source of inspiration. What does this word say about you, your life or your work? Why is it important to you?

WRITING PROMPT 3: *Chaos and Order*

Life can come fast at times, creating a lot of action, turmoil, upheaval and chaos. The to-do list gets long, and there doesn't seem to be enough time in the day. For some people, the day is scheduled, compartmentalized and structured. For others, the day is spontaneous, free-form and tumbled together. Reflect on your tolerance for chaos and your threshold for order. Do you make order out of chaos or chaos from order? How do you deal with order and chaos in your life? Are you structured or spontaneous? Are you balanced somewhere in between the extremes? How do you react when things don't go according to plan?

WRITING PROMPT 4: *Routines*

Contemporary life is hectic, and keeping up with the household chores, the responsibilities of work, the emails, the social networks, the text messages and the phone calls can quickly bury you under a pile of to-dos and must-dos. Take time to reflect on the organization and structure of your life. Think about everything from your mundane, daily routines to your big, special hopes and dreams.

How do you get things done? In what ways do you keep yourself organized (or even disorganized) physically, socially, mentally, emotionally and spiritually? What routines and rituals do you use in your daily life to make certain that everything that needs to get done does get done? Are your routines and rituals turning into ruts stalling your growth? When do you throw your plans out the window, and when do you stick steadfast to them?

WRITING TECHNIQUES

As you explore the prompts, try some simple brainstorming. You may want to write the prompt or the key words, and then jot down anything that comes to mind. The key to this is to be open and to write down everything. Don't judge your thoughts, but let them fly. Generate lists or scatter them around the page as quickly as they flash in your mind. Let the ideas storm and flash. You have a ton of thoughts, so write them all down. You never know where these brainstorms will lead. As scientist Linus Pauling said, "The best way to have a good idea is to have a lot of ideas."

Growing up we learned to read and write from left to right in evenly spaced lines. Even the book you have in your hands is formatted that way. But who says that you always have to write in such a way? Instead of writing in those neat horizontal lines, try drawing some random paths on which to write. These paths can curve, turn, slant, loop, zigzag and spiral.

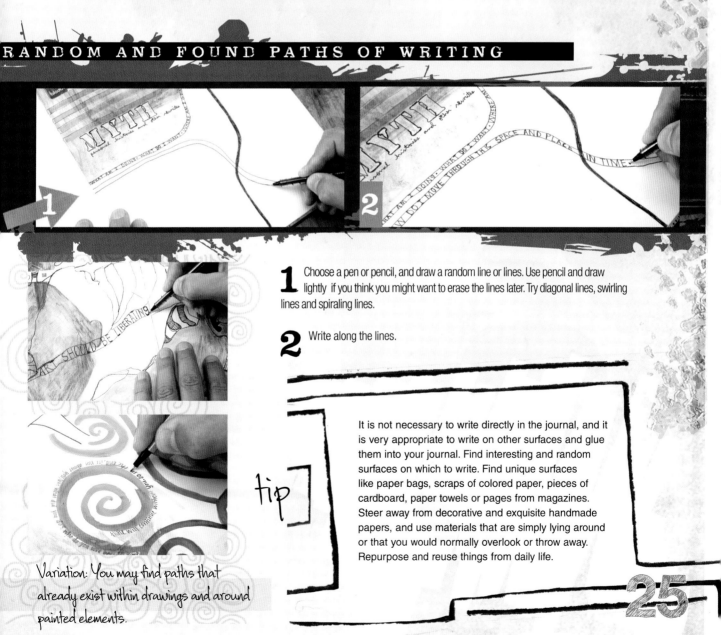

RANDOM AND FOUND PATHS OF WRITING

1 Choose a pen or pencil, and draw a random line or lines. Use pencil and draw lightly if you think you might want to erase the lines later. Try diagonal lines, swirling lines and spiraling lines.

2 Write along the lines.

tip

It is not necessary to write directly in the journal, and it is very appropriate to write on other surfaces and glue them into your journal. Find interesting and random surfaces on which to write. Find unique surfaces like paper bags, scraps of colored paper, pieces of cardboard, paper towels or pages from magazines. Steer away from decorative and exquisite handmade papers, and use materials that are simply lying around or that you would normally overlook or throw away. Repurpose and reuse things from daily life.

Variation: You may find paths that already exist within drawings and around painted elements.

UTILIZING YOUR RESOURCES

The art techniques center around the use of spontaneous acts and gestures that openly invite chance and chaos into your mode of working. Free yourself from thinking about finished pages and artwork, and detach yourself from the notion of having an end product. Get into the process to see where it can take you by intentionally using these techniques whose results are unpredictable.

DRAWING

RANDOM LINES AND SCRIBBLES

Random and scribbled lines are just two ways to explore this spontaneous mark-making. Open yourself up to randomness by beginning pages and adding to pages already in progress. For many, there is a great struggle between control and spontaneity. Random lines can be any type of line—straight, curved, jagged, looping or scribbled, but they are done without much thought or planning. These lines can be a lot of fun if you can get into the pure joy of mark-making. Try these techniques to break you out of your box.

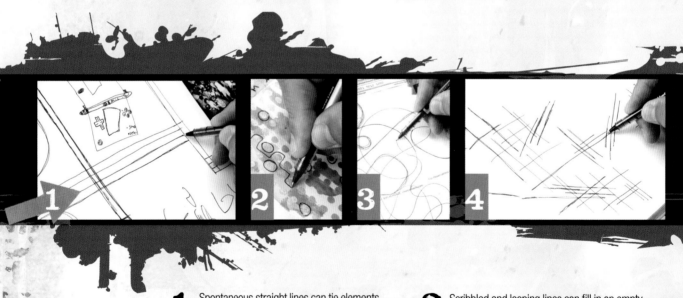

1 Spontaneous straight lines can tie elements together.

2 Lines can wander around a series of circles.

3 Scribbled and looping lines can fill in an empty space.

4 Random straight lines can begin a new page.

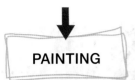

PAINTING

Watercolor paint is ideal for investing in the spontaneous in your work because the paint is highly unpredictable and somewhat difficult to control, and it is perfect for creating layers on your pages. The transparent nature of watercolor enables lines, colors, and images already on the page to show through. Once it is dry, you can draw, paint and glue on top of the watercolor as you continue building layers.

DRIPPING PAINT

1 Begin by creating a large pool of watercolor paint in the lid of the paint tray or on a palette.

2 Use an eyedropper to suck up some of the paint.

3 Drip the paint onto the page. Try to drip it from different heights.

Alternative

Load a paintbrush with paint. Hold the paint above the page. Squeeze the bristles to create a drip.

DROPPING STRING

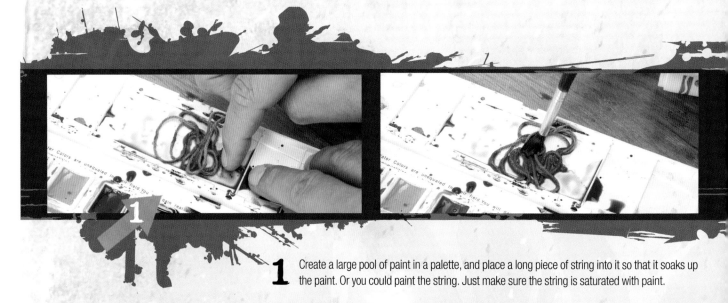

1 Create a large pool of paint in a palette, and place a long piece of string into it so that it soaks up the paint. Or you could paint the string. Just make sure the string is saturated with paint.

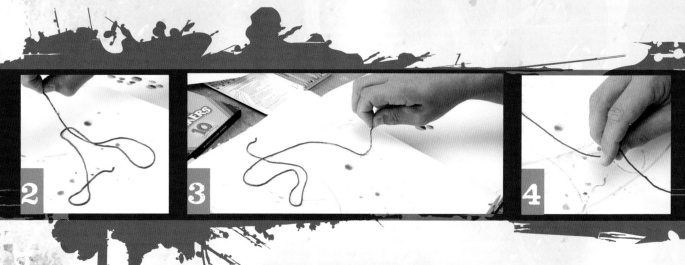

2 Drop the string onto a page. Repeat until you like the results.

3 Repeat with additional colors if desired.

4 For a more defined or predictable result, drag the string across the page.

Warning

These watercolor techniques can be quite messy, so be careful.

For an bonus **collage** tutorial, please visit: createmixedmedia.com/ journal-fodder-365

COMPULSIONS AND OBSESSIONS: ILLUMINATING TEXT

The compulsions and obsessions do not necessarily have to be random and chaotic but can supply ways of going back and strengthening some of the lines, shapes and words pulling random elements together.

With the introduction of operative words, it is the perfect time to discuss the idea of illuminating and embellishing text. For some very old examples, look at the illuminated manuscripts from medieval times like the *Book of Kells*. This embellishment transforms mere words into graphic and visual devices. They become part of the art, allowing the words to pop out and stand out from the rest of the text on a page. They provide a great way to bring focus to those operative words and phrases.

As you embellish and illuminate text, think about the boldness, color, material and style of the lettering. We will get into drawing and stenciling later.

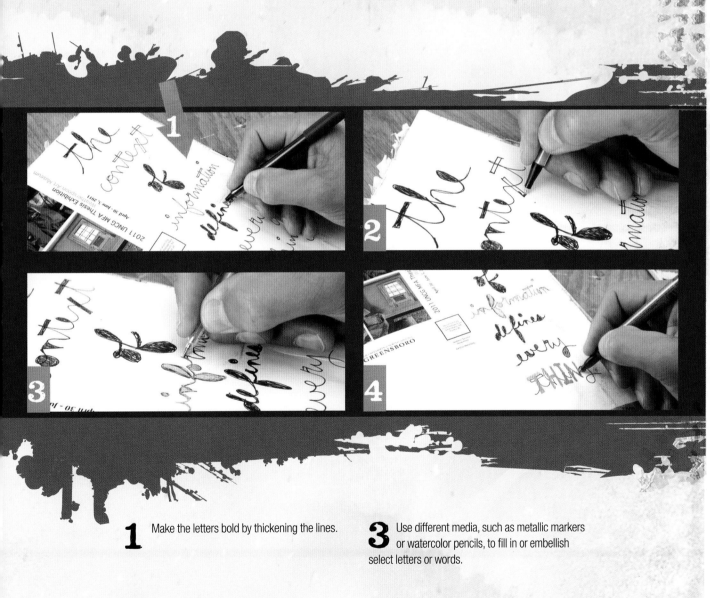

1 Make the letters bold by thickening the lines.

2 Change the color of letters and words.

3 Use different media, such as metallic markers or watercolor pencils, to fill in or embellish select letters or words.

4 Change the style of the lettering—try all caps or cursive.

OBSERVATIONS: RANDOM IMAGES

Take some time to look around your environment for more random images. Perhaps you will find brochures, business cards and advertising materials at local stores and restaurants, or maybe you will find intriguing fodder literally on the ground at your feet. Pay attention to the way you come into contact with these images and how they infiltrate your everyday. How do you react to these found images? Do you normally look with great attention, or do you overlook them completely? Do you really see all those images from billboards, posters, advertisements, and Internet searches? What catches your eye? What holds your attention? Find the images that speak to you and begin to incorporate them into your journal, reflecting on what it is about them that draws you in. Sort through these images, and write these reflections down in your journal as you dialogue with them.

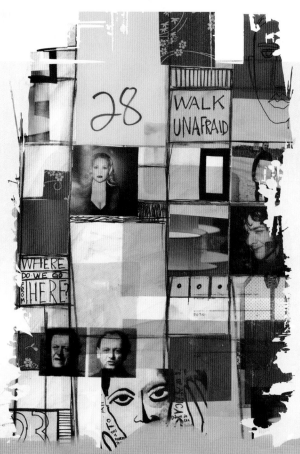

EXCURSION: TAKE YOUR JOURNAL FOR A WALK

Your journal could do well with some fresh air. So pack some simple journaling materials into your pockets or purse, shove your journal under your arm and head out the door. Go for a walk around your neighborhood, and pay attention to the randomness and the order of the world. Walk slowly and meander with no particular destination, allowing your feet to carry you. Just pay attention to the world. Then find a good place to stop—a wall, a curb, a piece of ground or a bench—and pull out your journal and supplies. Write, draw or doodle. Sit there for five minutes or an hour. How does it feel to be out in the world like this with your journal wide open? Do people walk by without noticing, or do they stop to see what you are doing? What is the experience like? Do you feel comfortable or do you feel awkward or vulnerable?

ANATOMY OF A JOURNAL SPREAD

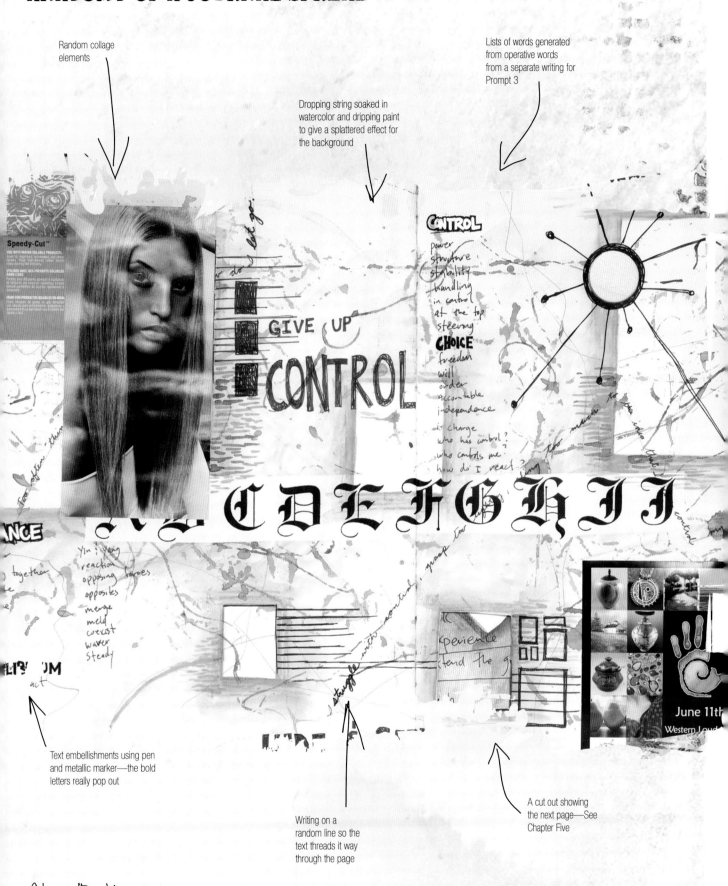

Random collage elements

Dropping string soaked in watercolor and dripping paint to give a splattered effect for the background

Lists of words generated from operative words from a separate writing for Prompt 3

Text embellishments using pen and metallic marker—the bold letters really pop out

Writing on a random line so the text threads it way through the page

A cut out showing the next page—See Chapter Five

Closing Thoughts

Remember to always keep yourself open to the possibilities that spring up from the unknown as you work in your journal. Embrace these unplanned opportunities as a way to break out of your comfort zone.

I struggle with duality - the urge to be raw the
urge to be focused and precise - the urge to be open
and the urge to be closed off and hidden. It is
I deal with in my art.

Struggle

Dualism

How do I (make) the different sides of me meet

RAW & VULNERABLE

CALCULATING & CO

I struggle with balancing these divergent urges

tip

Accidents and Imperfections

HOW DO I PREPARE MYSELF TO BE WRONG AND TO MAKE MISTAKES?

You are human and you make mistakes. That is certain. Many of us struggle with perfectionism and the feeling that everything has to be a very particular way. This thinking often immobilizes us. We fight with our ideas of what is good and what is bad, getting stuck on the notion of the end result. We forget the journey and forget to have fun along the way. Learn to cultivate the accidental as you reflect on your ideas about perfectionism, and use techniques and materials that will not end in "perfect" results. Discover how unintentional marks and creative accidents can open you to the beauty of imperfections.

The key is to not react against the mistake and tear it out of your journal, denying its existence, but to interact with it and make it a part of your creative journey. Get beyond those feelings of inadequacy and make the mess-up a challenge to deal with. Don't hide it, don't bury it and don't tear it out. Redefine what a mistake is and what perfectionism is. Acknowledge your humanity and move forward to accept these challenges.

GATHER YOUR FORCES: UNINTENTIONAL MARKS AND IMAGES—SPILLS AND MORE

As you gather your fodder, look for artwork that lies unfinished because you messed it up, smudged the paint, accidentally spilled something on it or otherwise could never bring it to a close. Look for scraps of paper where you have accidentally spilled, splattered or dripped paint, ink or coffee. Hold onto paper towels filled with crazy color textures from wiping up paint. All of these things are wonderful to use in the journal as you repurpose, reuse and re-imagine artwork and papers that might normally be trashed or recycled. These images also provide evidence of your working process, and they add instant texture and visual interest to pages. Find beauty in these types of images and marks.

additional art-illery

Expand your arsenal of tools and materials beyond your basic kit and use:

permanent marker
heavy cardstock or posterboard
plastic fork and knife
paint scraper

STRATEGIC PLANNING

Accidents, mistakes and mishaps are a part of life, and we sometimes are so quick to deny, dismiss and correct them that we never learn to accept them and deal with being wrong. Sir Ken Robinson said, "If you are not prepared to be wrong, you'll never come up with anything original." Figure out your threshold for accepting imperfections, and reflect on your ideas and beliefs about how you personally handle these challenges.

WRITING PROMPT 1: *Perfectionism*

What would happen if you took the word *perfect* out of your vocabulary? In our quest to do anything, whether it is art, relationships or cleaning the house, a sense of perfectionism can hold us back, cause us anxiety and consume a lot of time as we work to get things just right. We worry what others will think, fear that we will not be good enough, compare ourselves to others and doubt our own skills. The pressure to be perfect in art and in life can stop us before we ever begin or sidetrack us as we go along. What grip does perfectionism have on your life? Why does it matter what others think? Why is it that you can only see your faults and not your accomplishments?

WRITING PROMPT 2: *Personal Tragedy*

How do you respond when tragedy strikes? We get set in our routines and find comfort in our everyday rituals. Days, weeks, months and years can pass in relative peace, but every once in a while, we are jolted out of our comfortable lives when tragedy strikes. Personal tragedies can be huge, life-altering events, or they can be minor inconveniences. Either way, they disrupt our flow and movement, having the power to alter our direction. Reflect on your personal tragedies, big or small, and see how they have shaped and changed your life. What are some of your personal tragedies? How did you cope? How do these tragedies still ripple through your life? What strengths did you find that you didn't know you possessed? What lingering fears and doubts still pop up in your life?

WRITING PROMPT 3: *To Change or Not to Change*

How open or closed are you to change? Everything changes. It's a natural law that objects, people and situations are impermanent and are always in a state of flux. At times, change is lightning quick and takes place in a flash. Other times, it is continental-drift slow and seems imperceptible. Reflect on the role change has in your life and how you accept or resist it. How do you react to disruption in your life? Do you anticipate change and actively participate in the changing world? Do you deny change and passively ride along as things change around you? Do you invite change in? Do you resist it?

WRITING PROMPT 4: *Embracing Imperfections*

How do you embrace imperfection? Many of us exert a lot of energy in our quest for perfection, and when we embrace perfectionism, we cling to structure and control. However, when we are open to the organic nature of life, we learn to accept and embrace imperfection as a part of our growth. It can be quite a challenge as we let go of the control and learn to take risks, but it can be extremely liberating when we do. It frees us of a heavy load. If it's difficult for you to give up control, what is behind the difficulty? If it's easy for you, why is it so? In what small ways can you accept the accidental, the imperfect and the impermanent?

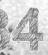

WRITING TECHNIQUES

As you ponder these prompts, how can you embrace the imperfections in your writing? Write in pen so that you cannot erase, and leave your misspellings, grammatical mistakes and scratchouts as evidence of your writing process. Don't edit and revise your work before committing it to the journal. Write directly in the journal and allow the revisions to be part of your page. Look at the artwork of Sabrina Ward Harrison, author of *Spilling Open: The Art of Becoming Yourself*, to see how she leaves these marks as evidence of her process.

As you work with these ideas, also consider that writing is a process in and of itself, and you can invite the accidental and the imperfect into the way you write. Try using water-soluble media, especially watercolor pencil or water-based marker, and write with your nondominant hand to slow your writing down and to purposefully write with less control.

WATER-SOLUBLE MEDIA

All water-soluble media can be used in your writing. The nature of these materials change in an instant when you add water. We all probably have accidentally dripped water, tea or coffee onto something that we had written and watched the ink or pigment bleed and smear. "Oh, I just messed that up," we think to ourselves. But can you adapt the idea as a valuable technique?

It is not always important that you can read what you wrote, and there will even be times when you want to hide or cover up some of your writing because it is too personal or too painful. This technique allows you to write about something—to get it out there and get it off your chest—while also allowing you to obscure or obliterate some or most of the writing. It is often more important that you have given voice to your thoughts. Try experimenting with a variety of water-soluble and water-based materials as you write.

1 Choose a water-soluble pencil or marker. If using water-soluble pencil, make certain to press hard so that there is a lot of pigment on the paper.

2 Paint clean water over the words, allowing the words to bleed and blend. Obscure the words as much as you like. Allow it to dry.

3 As an alternative to clean water, paint a contrasting color of watercolor paint over your writing. Make certain to rinse out your brush before getting more paint so that you do not contaminate your paint with the pencil or marker.

The majority of us write only with one hand, and we are either left-handed or right-handed. We have spent many, many years developing our control with that hand. Why not the other? When was the last time you wrote with your nondominant hand? It is difficult, and you will find that you will have to give a lot of thought to how to form certain letters, and what was instinctual with your dominant hand may not be with the other. Your writing slows down tremendously, and you immediately give up some of the control. If you pride yourself on your neat penmanship, this will challenge you to accept and embrace something not so neat and tidy.

UTILIZING YOUR RESOURCES

Some of us exert extreme control and care over our art materials while others create with reckless abandon with little thought to straight lines and even application. Often something happens by accident that we really like. We ask, "How did I do that?" And we try to do it again. We experiment, and we play. That is how we can take an accidental mark or mess-up and adopt it as a valuable and favored technique. Try cultivating art techniques that invite the accidental into your work and do not lead to predictable results. You may be surprised by the direction they take you.

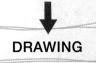

DRAWING

Many of us shy away from drawing because we think the only acceptable outcome is a perfect, super-realistic and highly detailed rendering of a subject. But the act of drawing is simply making marks that record and study what we see. To fully accept this, we have to suspend our usual judgments that see these acts as good/bad or ugly/ beautiful and have us pulling out the eraser. Automatic drawing, continuous contours and bleed-throughs are drawing techniques that invite the accidental and unintended into your artistic process, so experiment and experience these alternative drawing acts.

Automatic drawing is a technique developed by the Surrealists during the early part of the twentieth century that opens drawing to the recording of the unconscious. It focuses on spontaneous mark-making with no preconception of what the drawing has to be or will be. In art education, this technique is often called "Taking Your Pencil for a Walk." The idea is to draw spontaneously, allowing your pen, pencil or marker to meander around the page. Select a spot and allow your pen or pencil to move. Change direction abruptly and without thought. Change the direction again. Pick up your pen or pencil and place it down without much thought. Start moving it again. Move your hand fast and move it slow. Create as many or as few marks as you feel are necessary. The key is to give up control and the need to have a recognizable picture.

CONTINUOUS CONTOUR

Continuous contour is a technique in which you study the contour—the line that defines the edges of and within an object—in one continuous line without picking up your pen or pencil. It's not about the skill of drawing; it's about the careful observation of the object. Since you cannot pick up your pen or pencil, "mistakes" and disproportions will happen, forcing you to accept the results. The process dictates the need to backtrack over lines and create "bridges" to enclosed contours so that you don't lift your pen or pencil. If you do lift your hand, place the pen or pencil back down where you left off. This technique improves your observational skills that in turn enhance your ability to draw more accurately.

1 Choose an object to draw. You can even use a photograph. Place the object next to the journal so that it is as close to your drawing as possible.

2 Choose a place to start. This is pretty arbitrary. Begin to draw, allowing the pen or pencil to follow the contour of the object. Constantly glance back and forth between your object and the drawing. Do not pick up your pen or pencil.

3 If you come to a dead end or roadblock, backtrack along lines you have already drawn, and continue to the next closest feature.

4 To reach features that are not directly touching another feature, you must draw a "bridge" to that feature. You can alter the pressure if you want so that the "bridge" is lighter or thinner. Continue without picking up your pen or pencil. If you do pick it up, just place it down right where you left off.

When the art materials we use bleed through the pages, the unintentional marks lead to frustration and a desire for control. However, when we are open to these unintended marks, we can purposefully use bleed-throughs to connect various pages together and create unanticipated challenges. This technique works best with a journal that has fairly thin paper and a solvent-based marker like a Sharpie or Prismacolor marker. Be careful because the ink can bleed through several pages, but perhaps that presents another interesting challenge.

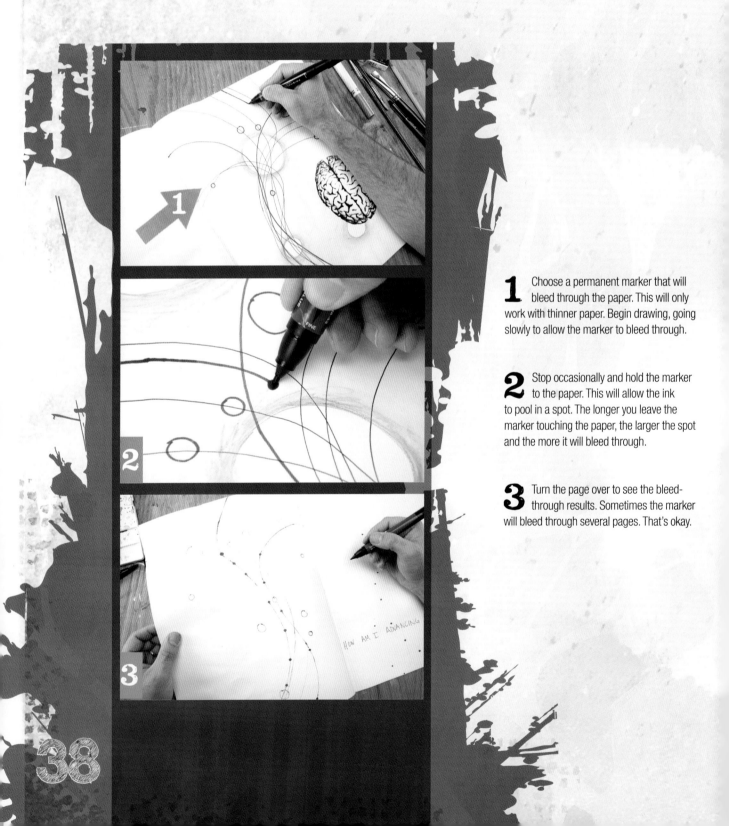

1 Choose a permanent marker that will bleed through the paper. This will only work with thinner paper. Begin drawing, going slowly to allow the marker to bleed through.

2 Stop occasionally and hold the marker to the paper. This will allow the ink to pool in a spot. The longer you leave the marker touching the paper, the larger the spot and the more it will bleed through.

3 Turn the page over to see the bleed-through results. Sometimes the marker will bleed through several pages. That's okay.

ALTERNATIVE APPLICATIONS

We often get stuck in the rut of using materials in a very comfortable, yet limited way. Open up your painting process by going beyond the paintbrush. You can create wonderfully spontaneous marks when you use alternative tools to apply the paint. Thick cardstock, plastic utensils and paint scrapers are three easy substitutes for the paintbrush. Experiment with the types of marks you can make with each, and remember that

these techniques can be messy and can often go amiss of your plans. This is exactly why you want to use them, so that you can invite the accident, the imperfect and the unintended into your mode of working in order to create surprise and to push you creatively.

Cards

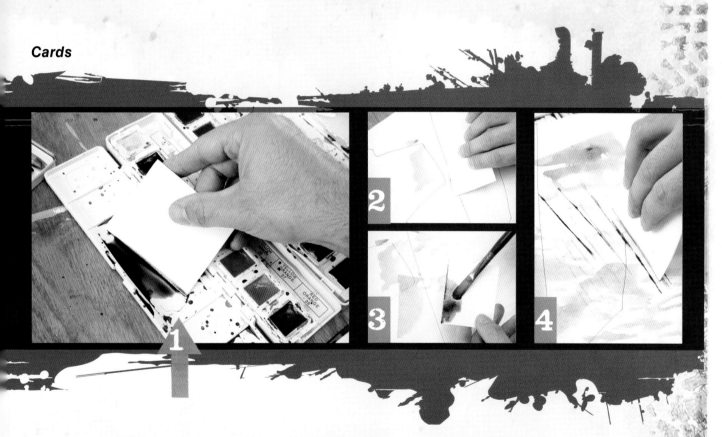

1 Cut a rectangle from stiff cardstock or thin cardboard. Create a large pool of watercolor on your palette. Dip the edge of the cardstock into the paint and hold it there so it will soak up some of the paint. You may want to turn the card over to get paint on both sides.

2 Drag the card across the paper. Repeat.

3 You can also paint watercolor on the surface of the card and drag it across the paper.

4 Stamp with the edge of the card to create thin lines.

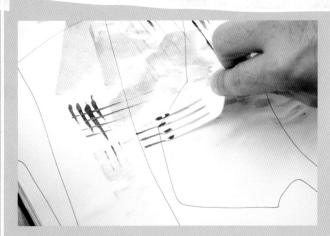

Plastic Fork
Drag or stamp.

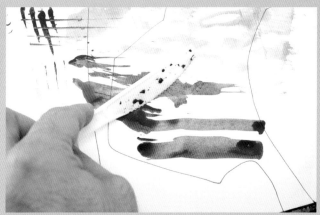

Plastic Knife
Drag the edge of the knife to create thin little lines.

Flat Paint Scraper
This yields a similar effect to using a card.

Notched Scraper
Drag the notched scraper to create parallel lines.

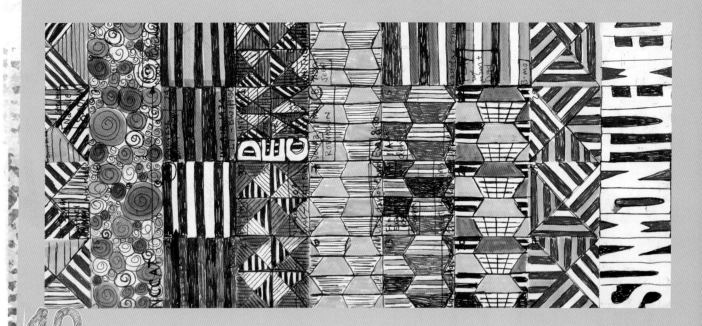

COMPULSIONS AND OBSESSIONS: TEXTURES AND PATTERNS

Similar to the repeating lines and shapes from Chapter One, visual textures and definite patterns can be added almost anywhere and at anytime in the journal. Like all Compulsions and Obsessions, these are intended to give your journal stylistic cohesion and continuity, but they also allow you to stay engaged in the journaling process. Throughout the month, try some of the textures and patterns below, but invent your own as well.

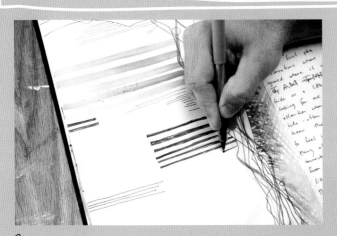

Stripes

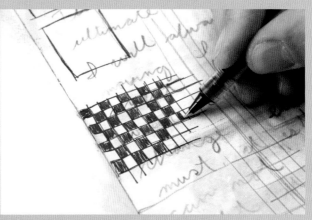

Checks

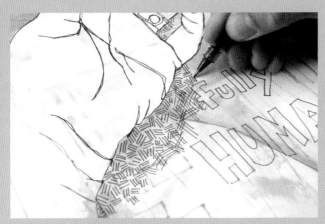

Hatching and Cross Hatching

Moiré Patterns

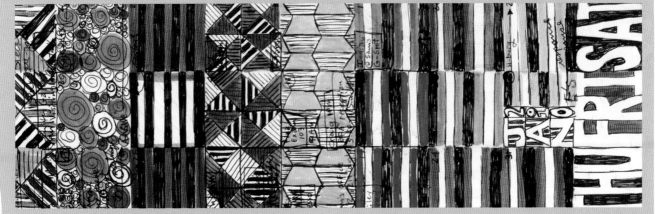

OBSERVATIONS: IMPERFECTIONS

As you purposefully interact and create the accidental and the imperfect in your journal, pay attention to how you feel. Observe not just the "imperfections" but also your reaction to them. Were you able to let go and enjoy the act of making marks and experimenting with materials? Did you struggle with the unpredictable nature of the techniques, wishing to exert more control? Look carefully at the marks and techniques that you used. How do you feel about them now? Can you find beauty in them? Can you embrace them? Or do they seem to glare at you and taunt you with their imperfections?

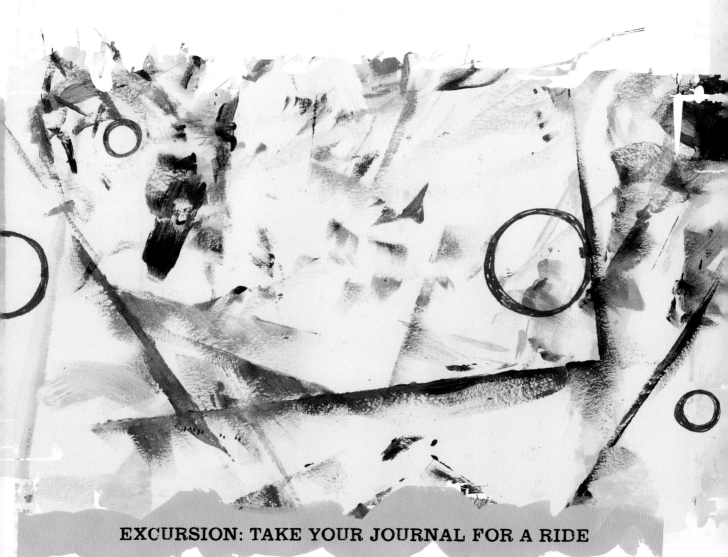

EXCURSION: TAKE YOUR JOURNAL FOR A RIDE

The visual journal does not need to reside at home or in the studio; it can go out into the world and become part of the adventure. Take your journal for a ride. We don't mean strap your journal into the passenger seat of the car or on the back of your bike and drive it around, although that wouldn't be unheard of. We mean find ways to be a passenger yourself in a car, on the bus, on the train, in a plane or in a hot air balloon, and pull out your journal and create within the pages. Allow the bumps, jolts and rattles of the ride to become part of the page. Don't fight these and try to make a controlled and contrived page. Allow your lines to shudder and shake. Allow your letters to streak and smear. Reflect on your feelings during this experience. What are you holding onto? What are you holding back?

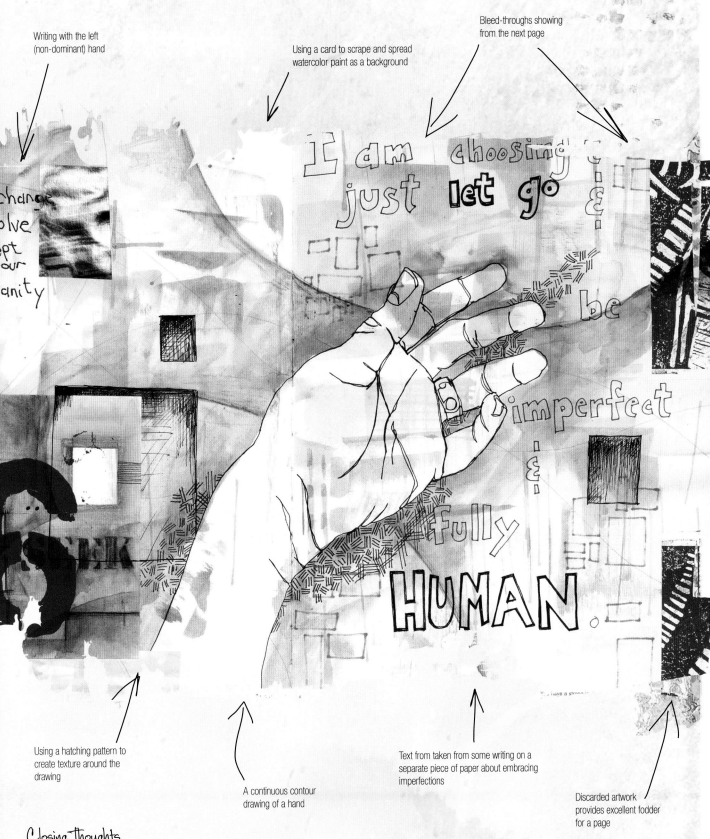

Writing with the left (non-dominant) hand

Using a card to scrape and spread watercolor paint as a background

Bleed-throughs showing from the next page

Using a hatching pattern to create texture around the drawing

A continuous contour drawing of a hand

Text from taken from some writing on a separate piece of paper about embracing imperfections

Discarded artwork provides excellent fodder for a page

I am choosing... just let go & be imperfect & fully HUMAN.

Closing Thoughts

As you work, accidents, wrong turns and misdirections are going to happen. Try not to see them as mistakes. Instead, embrace them as part of the process and learn to cultivate them into viable and valued techniques.

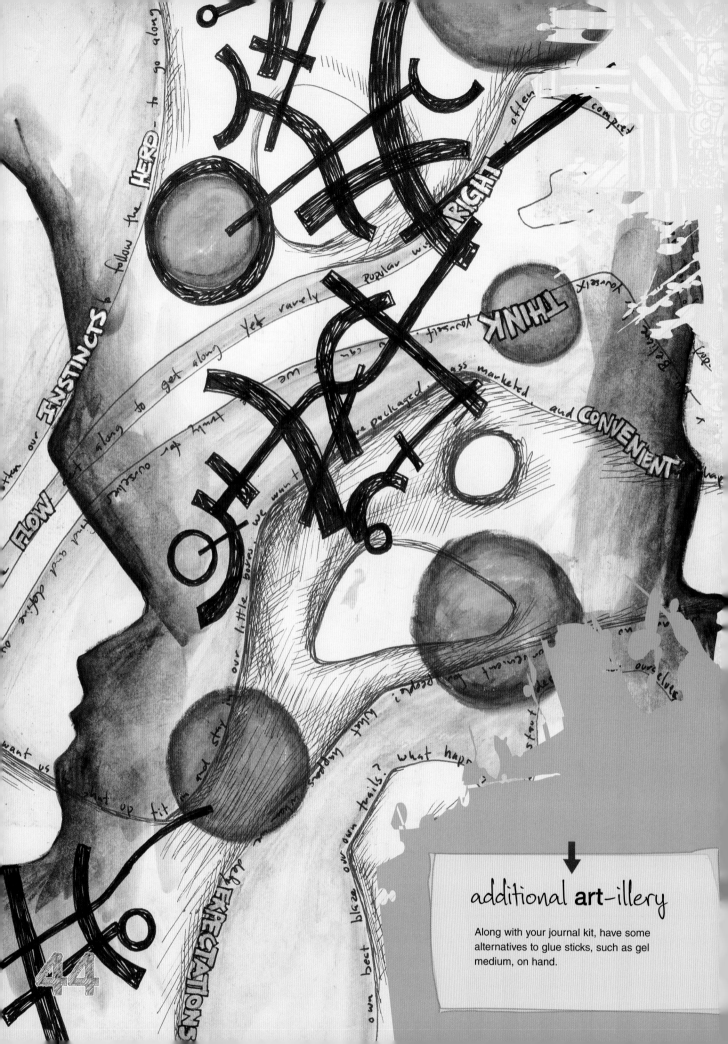

additional art-illery

Along with your journal kit, have some alternatives to glue sticks, such as gel medium, on hand.

Seeking Solitude and Finding Sanctuary

4

Often we share our vulnerable beginnings in the journal too early in our process. We need to spend time alone with our images and thoughts, allowing our work to strengthen with time and space, without the input and criticism of others. We tend to focus on the negative aspects of criticism and compare ourselves to others. You don't need anyone's approval, nor do you need their permission to be how you are or to become who you want to be. Give yourself the time to build ownership in your work, nurture your creative self and build your confidence to make your voice heard. Realize that you have important things to say and that any moment can be significant, no matter what someone else might say. Find your cave and start trusting your artistic voice. Grab a blanket and flashlight and stay for a while.

GATHER YOUR FORCES: IMAGES OF COMFORT AND SECURITY ENVELOPES

We all gravitate towards certain images when scanning a newspaper, magazine or the Internet, and then in turn, we appropriate concepts to infuse into our work. Why do we do that? Is it the sense of familiarity? Possibly a feeling of wonder? These images trigger a deeper connection for us and provide a comfort zone or a safe and secure space. Even if it is something we have never seen before or a place we have never visited, an image can still evoke the sensations of comfort and security. In some cases it is not even a naturalistic image that captures our attention; it is a color, a shape or a cluster of lines. Keep your eyes open, do not look away, find the images and designs that pull you in and be ready to take notice.

Along with these safe and comfortable images, hang onto some of the junk mail and envelopes that bombard your mailbox daily, especially the security envelopes that your bills and confidential mail come in. For years we have been utilizing the interesting and complex patterns found inside of these envelopes. Usually these sorts of things just get thrown out, but if you pay close enough attention, you will notice there are multiple styles of patterns used inside these envelopes. The patterns create a visual interference, so when the envelope is held up to the light, no one can tell what is inside. Of course, it is only a false sense of security because if someone really wanted to know what was in it, they would just rip it open. Nonetheless, the metaphor remains and the patterning offers many design opportunities to discover.

45

STRATEGIC PLANNING

Think about your private and secure places and spaces. As you explore your methods for seeking solitude and your path for finding a personal sanctuary, keep in mind how these concepts can inform the visual elements you encounter in the art-making activities.

WRITING PROMPT 1: *Solitude*

How do you react when you are by yourself? As humans we are social creatures, but there are times when we need to be by ourselves—to be alone, but not lonely. For some, solitude equates to isolation and despair, and to others it equates to reflection and time to be with our thoughts. Reflect on how you are when you are alone. Try to determine if you are comfortable or uncomfortable with being on your own. What does solitude mean to you? Is it isolation or is it reflection? Do you distract yourself with email, housework, text messaging or TV? Do you surround yourself with noise? Do you sit and reflect on all that has been going on, mulling it over in your head? Do you surround yourself with quiet? In what ways do you embrace solitude or push it away?

WRITING PROMPT 2: *Wants and Needs*

What do you want? What do you need? We all have our wants and our needs. They may seem like the same thing, but what we want is not always what we need. We often want things that are not good for us and that are sometimes outright harmful. Those wants can be influenced by so many factors. Friends, family and the media all can put direct and indirect pressure on us to desire the latest gizmos, gadgets and stuff, and to make unhealthy choices. Reflect on what you want and what you need. Stop zoning out in front of the TV and computer screen. See where you deprive yourself of things that you desperately need. Why do you want some things? Why do you need other things? What are things that you need, but do not give yourself? What if you only wanted what you needed? How would your life be different?

WRITING PROMPT 3: *My Sanctuary*

Where do you go when the world becomes too much or when you need to be by yourself? We all need a place to go where we can get away for a while and reconnect with ourselves. We need a cave, an island getaway or a mountaintop retreat where we can go to gain some perspective. Sometimes these are literal caves, islands and mountains, but very often they are closer than that—the studio, the gym, the garage or the library. What is your sanctuary? Where is that place of solace and comfort for you? What gets in your way of being there? How does it feel when you are kept from your sanctuary? If you do not have an actual sanctuary, where would it be? Where would you like to go?

WRITING PROMPT 4: *Making Personal Space*

Where do you go to find space for yourself and your thoughts? We all need a bit of personal space that we can call our own. It might be a lavish studio or a cabin in the woods. It might be the kitchen table or a big, comfy chair. It might be the backyard or a place in our bag for a journal or book. Whether it is a space with walls or not, whether it is large or small, it is ours—our own little corner of the world. How do you recharge and re-energize? How do you carve out a chunk of personal space? If you haven't, why not? Where would it be?

WRITING TECHNIQUES

The act of writing by hand is an act of drawing, and just as you allow lines to flow, overlap and layer in a drawing, you can allow your words to interact in a similar fashion. When you overlap text, you explore writing as a visual device and begin to obscure and hide the words within the writing. Experimenting with multiple writing styles such as cursive, print and all capitals can also add to the graphic nature of the text interactions.

Text can also act like a found object. By using letters and words cut from magazines, newspapers or a computer print, you can experiment with making ransom-note style messages with your own words. Furthermore, you add an interesting bit of mystery and the unexpected by collaging these bits of text together to create written ideas.

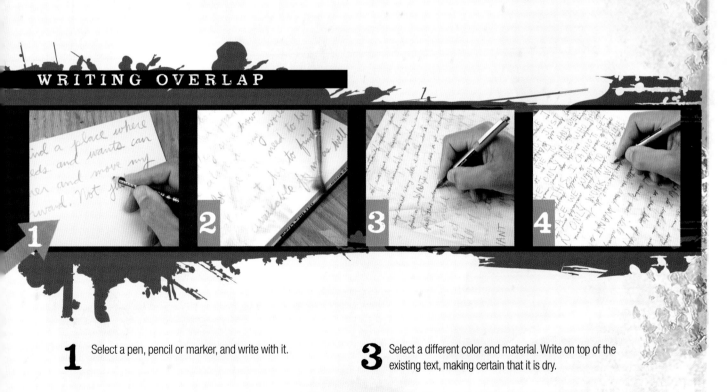

WRITING OVERLAP

1 Select a pen, pencil or marker, and write with it.

2 If it is water-soluble, perhaps brush over it and allow it to dry.

3 Select a different color and material. Write on top of the existing text, making certain that it is dry.

4 You can even write in the opposite direction. Do as many overlapping layers of writing as you want.

Your Own Writing

Computer Generated Text

Words From Magazines

Ransom Note Text

As you bring your ideas together, think about your private intentions, maybe even your secrets. Consider all of the things that make you feel safe and comfortable. A sense of solitude is something that comes from within, so pay attention to how your resources design and define the spaces you create.

DRAWING

LETTERS. WORDS AND TEXT—SIMPLE BLOCK TECHNIQUE

The characters used to spell out ideas are full of creative potential. You can embellish your writing and draw the letters in any stylistic fashion to push the graphic nature of the writing. In this way the written elements will interact more like an image with other aspects of your journaling. Use a basic technique to draw plain letters or intricate script. You can push it as far as you like.

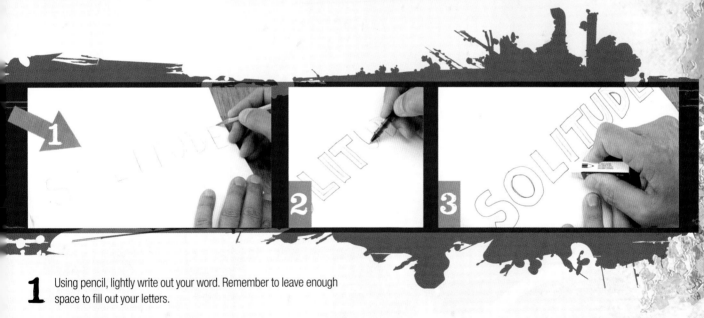

1 Using pencil, lightly write out your word. Remember to leave enough space to fill out your letters.

2 Draw the letter shape around the written letter. Don't forget to draw the inside of letters such as *o* and *e*. You can do this with pen or marker, but use pencil if you would like to be able to erase. Thren, if you used pencil, trace over your letters with pen or marker. Don't trace over the handwritten letters on the inside.

3 Once the pen or marker is dry, erase the handwritten letters so that you are left only with the letter shapes.

PAINTING

Drybrush is a watercolor technique that can provide a variety of textures to your pages. It can be applied to fresh pages to get things started, layered over the top of writing to begin obscuring, or added over painted areas to see how the paints interacts. Experiment with the direction or process in which you apply the paint. Swirling or scrubbing with the brush can open up a variety of texture possibilities. Consider the color combinations you employ and the layering of various techniques as you work. Explore painting into wet and dry areas, allow it to dry and repeat to enrich the spaces developed.

DRYBRUSH

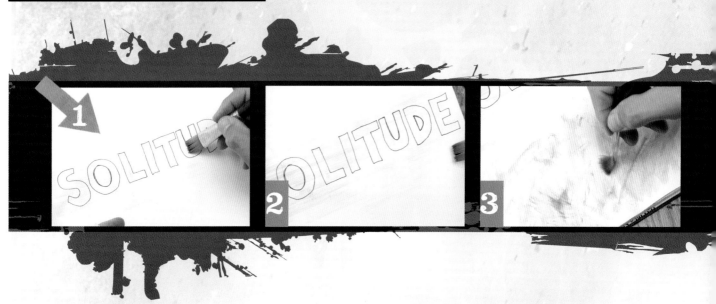

1 Load a brush with watercolor paint. Dab the brush on a rag or paper towel to dry the brush a little. Don't dry it completely.

2 Drag the brush across the page. The bristles should separate and leave "streaky" lines.

3 Try swirling the brush or scrubbing it on the paper.

For a bonus **painting** tutorial, please visit: www.createmixedmedia.com/ journal-fodder-365

ALTERNATIVES TO GLUE STICK

Because of its portability, the glue stick is the go-to adhesive for collaging cutouts and images into the visual journal. But it is not always the right glue for every piece of collage, and there are other materials that can be utilized. A clear acrylic medium works well as an adhesive for incorporating collage pieces, especially glossy or thick materials, and it can also be used to add a textural quality to your work.

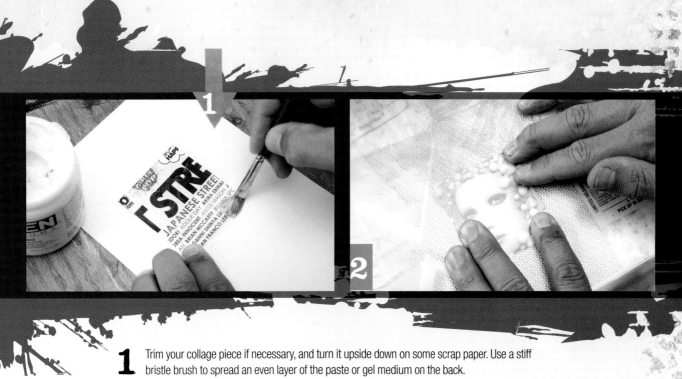

1 Trim your collage piece if necessary, and turn it upside down on some scrap paper. Use a stiff bristle brush to spread an even layer of the paste or gel medium on the back.

2 Place your collage piece on your page and rub gently. A piece of wax paper works great to keep the glue or medium from oozing all over your page or your hands. Rub gently to make certain the collage piece is fully adhered.

tip

Sometimes you may need to close your journal in order to hold the collage piece flat. Use wax paper to keep the pages from accidentally gluing together.

COMPULSIONS AND OBSESSIONS: SECURITY ENVELOPES

As mentioned earlier, security envelopes offer a wide range of patterns on their interior surfaces. Repurpose these components as sources for art-making, transforming the mundane envelope into a viable visual solution. Experiment with dismantling the envelopes in a variety of ways, such as cutting them into strips or shapes, and collage these pieces into your journal. You can use the glassine windows to frame elements, or you can even draw and paint on top of the pattern.

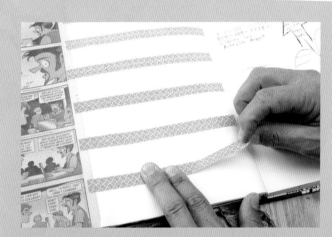

Strips and Dividers

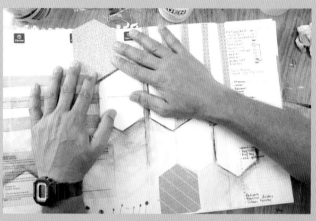

Shapes and Patterns

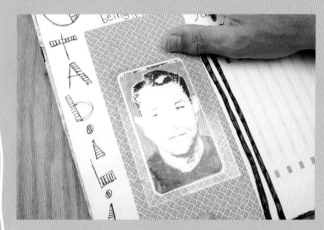

Windows and Frames

Layers and Backgrounds

OBSERVATIONS: PLACES AND SPACES

The places and the spaces we choose to work in can have an effect on our creative process. Think about how you react when you are confronted with the variety of environments that fill your every day. How do these places make you feel? Do they inspire you or just add to the confusion? Do you feel more alone by yourself, or do you feel the same isolation in a room of strangers? It is essential to come to grips with the idea that you don't always need someone else's opinion to move forward with your work. Find your space, your cave, and start trusting it for a while. What places and spaces bring you the comfort and security to be creative and free?

EXCURSION: FIND A CAVE

Finding a way to get away from the world can be difficult because of the obligations and complexities of contemporary life. However, it is important to find time for escape from diversions and intrusions in order to connect to yourself and to your creative process. Somehow we make time to go to the gym, take a walk, surf the Internet or read a book. We also need to free ourselves to find a cave, a creative safe space where we can engage our thoughts and impulses within the pages of the journal. Your cave can be in your home,

maybe that corner in the basement, the kitchen table or behind the "do not disturb" sign on your bedroom door. But many times, to fully escape, the cave needs to be away from home, at the back table in the coffee house or under a tree at the park. Perhaps it needs to be in a studio or in a cubicle at your local library. Wherever you choose, do yourself the favor of finding that personal sanctuary where you can fully encounter yourself.

ANATOMY OF A JOURNAL SPREAD

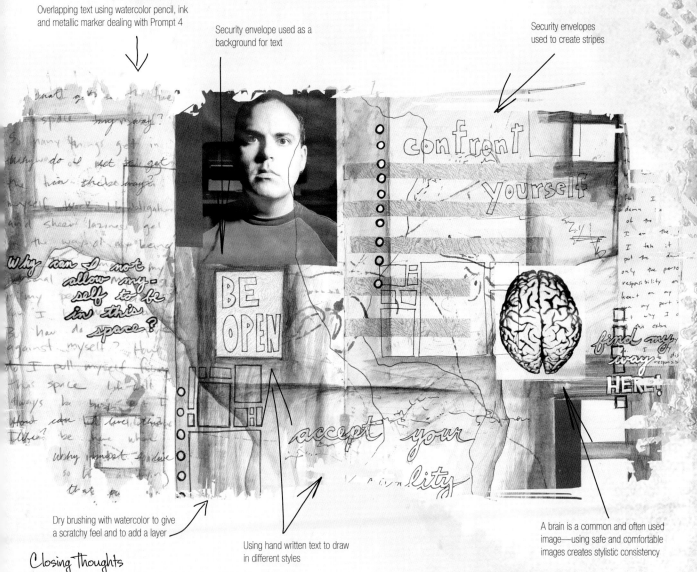

Overlapping text using watercolor pencil, ink and metallic marker dealing with Prompt 4

Security envelope used as a background for text

Security envelopes used to create stripes

Dry brushing with watercolor to give a scratchy feel and to add a layer

Using hand written text to draw in different styles

A brain is a common and often used image—using safe and comfortable images creates stylistic consistency

Closing Thoughts

Remember that we often need time alone to develop our ideas and develop our confidence, so spend time developing those safe places and those secure practices as you increase your comfort and further explore in the journal.

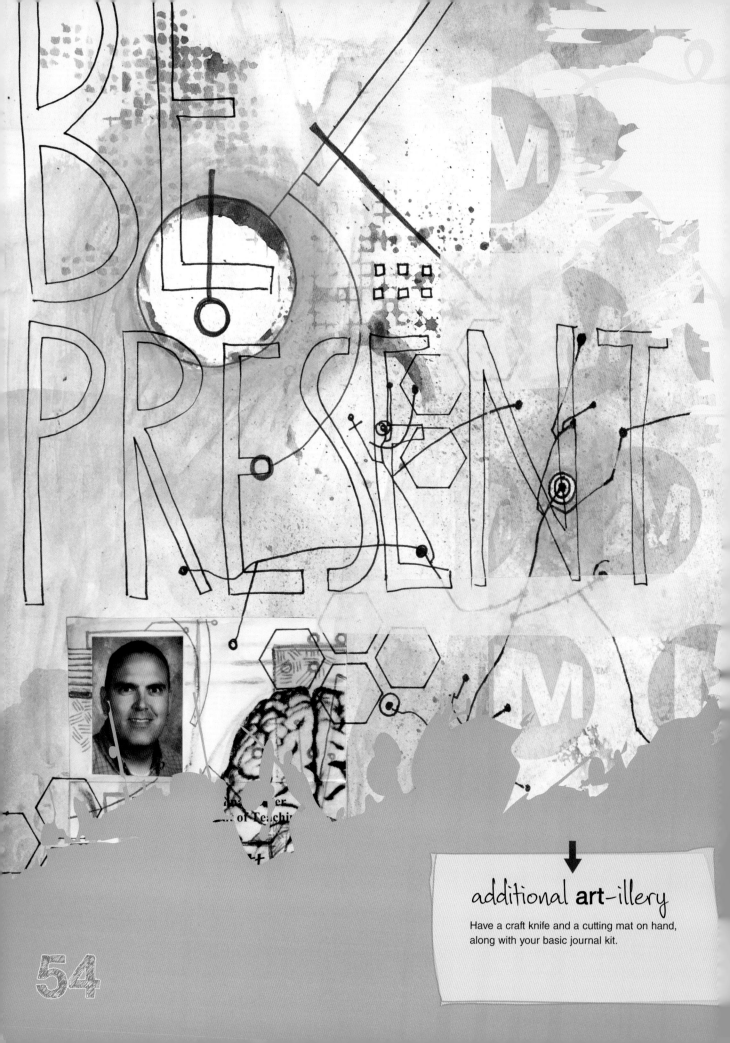

BE PRESENT

additional **art**-illery

Have a craft knife and a cutting mat on hand,
along with your basic journal kit.

54

Be Here Now

WHERE AM I AT THIS MOMENT? HOW CAN I GET THE MOST OUT OF TODAY?

We spend so much time caught up in worrying about the past and dreaming about the future that we often don't see what is right in front of us. Be an active participant in your own life, not a passive audience member, and learn to pay attention to others and engage your world. Turn off the noise, turn on to what is going on around you, and tune in to your creative potential. Spend more time looking around at your present situation, and reflect on how you can live more in the moment and dream about the now. This goes for your journal as well. As artist Chuck Close once said, "Inspiration is for amateurs. The rest of us just show up and work." So show up like magic and be present and fully engaged in your work. Stop complaining about not having enough time or musing about "someday." Now is the only time in your life that you can really act. Don't be your own worst critic, focusing on a few negative issues. Silence the self-talk, be proactive and begin to put intention behind your thoughts and actions.

GATHER YOUR FORCES: REMNANTS OF THE DAY

Going through our everyday activities, we accumulate a mountain of stuff, and at the end of the day we dismiss these remnants of our journey. Start saving the flotsam and jetsam of your day. Hold on to the receipts you get along the way or a menu from the local café, neighborhood coffee house or corner tavern. Keep the postcards you get from friends and relatives on holidays. Save the labels you peel off drink bottles or the tag you cut off those new jeans you just bought. These everyday bits and pieces are part of your individual experience and help tell your story. They give significance to an idea, image or concept when integrated into your journal. Reconsider using the fairies, vintage photos, clocks and people with pointy hats that are commonly found in some journals, because these are not your images. Someone else developed the significance and meaning of these, so why adopt someone else's concept when you have so much of your own to explore. As you encounter your everyday objects, keep your eyes and mind wide open for the creative potential of these items.

STRATEGIC PLANNING

How did we all get so busy? When did life become so much about competition? Why do we continue to place so much value on being in first place instead of being in our best place? Your life is not a race to be won, it is not a trophy to be awarded and it is not a medal to put around your neck. Your life is everything that happens along the way, and if you are not careful, you might miss it. Creativity is not something to acquire; it is something to express. Be here *now*.

WRITING PROMPT 1: *Being Present and Being Absent*

How are you being present or absent in your life? Nowadays, there are many things that distract us, amuse us and eat away at our time and our attention. We seem so fascinated by what happens to celebrities, by the latest reality show, by the latest gadget or gizmo, by apps and games and by texting and messaging, that time passes us by so quickly. There is a deceptively simple Buddhist concept: Be Present. By being present in every situation, from eating a meal to feeling your emotions, and not allowing your mind to run away from you, you can control your suffering and move toward your happiness. What is garnering your attention? How do you distract yourself and allow yourself to be absent from your life, your emotions, your friends and your family? What do you do to ensure you are living in the here and now?

WRITING PROMPT 2: *Self-Talk*

How does your self-talk pull you out of the present and cause worry or anxiety? As humans we think too much, and this dialogue that we have with ourselves about the past or about the future is our self-talk. Dr. Phil McGraw calls these "tapes" because we replay the same loop of thoughts and words through our head, focusing on the most negative aspects. Many of these tapes or scripts focus on the past, rehashing our failings and shortcomings. Others focus on the future, conjuring anxiety about what is yet to come or about waiting for "the other shoe to drop." Still others are general thoughts of self-denigration and chip away at our sense of worth. This self-talk takes us out of the present and has us worrying about things that we cannot change, that we have no control over, or that are not grounded in truth. Reflect on the tapes that you have looping through your thoughts.

What is your self-talk? Do you fill your mind with thoughts about lack, failure and your own worthlessness? Do you relive the past, wishing you could have done something differently? Do you think about the endless possibilities of the future, worrying about what has yet to come?

WRITING PROMPT 3: *Come Out and Play*

When was the last time you simply played and had fun—not competed, but played? When we were children, there was nothing more necessary than play. School, church, dinner, baths and sleep were never as important. We counted down the minutes to recess where we could tear around the playground, swing as high as possible, play favorite games like Four Square and Red Rover, or make up our own games. Then we grew up, and too often we have stopped playing. However, play brings us into the moment, forcing thoughts about the past and future from our minds as we focus on the task in front of us. Reflect on how you can come out and play—how you can disconnect from the TV, the computer and the phone, and enjoy yourself without worry. When was the last time you headed outside, ran, romped and carried on? Is someone calling you to come out and play?

WRITING PROMPT 4: *Show Up Like Magic*

Who in your life, right now, needs you to show up like magic? There are times when we need a little support, when we need to be lifted up and when we need the help of someone else. We look back and remember times when someone showed up for us as if by magic. It may have been in a dire hour or it may have been when we just needed someone to take us out for a cup of coffee. Hopefully we can remember times when we have been there for someone else. How have you been there for others when they needed it the most? How have you supported and done small things for those who have needed you? How can you show up like magic?

WRITING TECHNIQUES

We jot down reminders to ourselves about things not to forget, shopping lists, to-do lists and all sorts of others notes and lists. We organize our lists and daily self-messages in different ways. Sometimes we use random scraps of paper or maybe sticky notes or file cards. No matter the form, we all engage in this daily practice at one time or another. But what do we do with the evidence of those moments? Consider the narrative and record you create of your daily process in all of these disparate writings, and add them to the document you are formulating in your journal. These kinds of messages work like mileposts or markers in your story. When you look back over your journal, they conjure a particular time and fill in the daily details.

TO-DO LISTS. NOTEPADS. STICKY NOTES

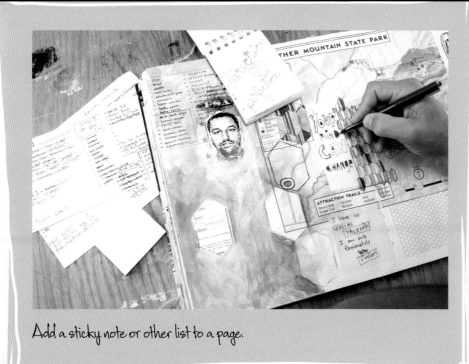

Add a sticky note or other list to a page.

UTILIZING YOUR RESOURCES

What captures your attention? What do you stop to observe? Even something seemingly ordinary can be significant depending on how you choose to document your encounter with it. Take notice of the objects and moments of your day, and spend some time experimenting with materials and techniques as ways to engage the journal and document your experiences.

➡ DRAWING

DRAWING ORDINARY OBJECTS

While at home, in the office or anywhere you might go throughout your day, take a look around and see what is normally unnoticed. Focus on the ordinary and mundane objects that fill your surroundings. Maybe it is the coffee mug on the table, the stapler on your desk or the lamp in the corner. Go ahead! Take a good look around, find something to zero in on and just draw it. Draw what you see, just as you see it. It could be on a scrap piece of paper or in a specific spot in your journal. Use a pen so that you cannot erase and so that you have to accept the results. Taking the time to enjoy the process is what is most important. Don't get caught up in the judgements about the drawing. Get caught up being present with the object.

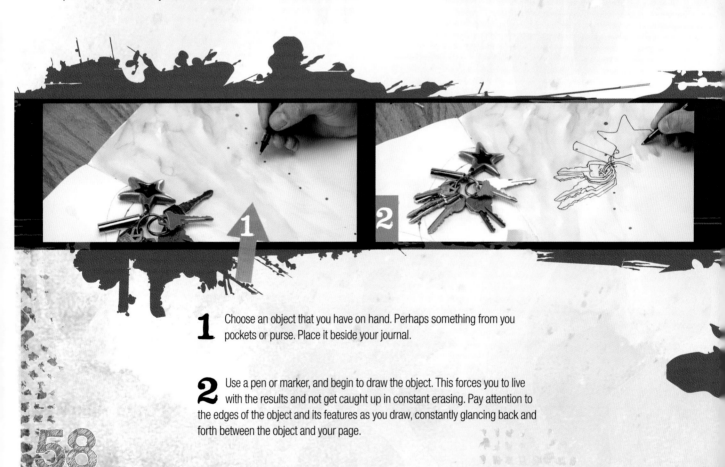

1 Choose an object that you have on hand. Perhaps something from you pockets or purse. Place it beside your journal.

2 Use a pen or marker, and begin to draw the object. This forces you to live with the results and not get caught up in constant erasing. Pay attention to the edges of the object and its features as you draw, constantly glancing back and forth between the object and your page.

PAINTING

Don't be concerned with a naturalistic or realistic image to represent. Allow the paint to flow, play with the material and look for new color combinations as you mix and blend with watercolor paints. If you have specific go-to colors, break free and purposely mix in some colors you don't work with normally. Lose yourself to the process as the colors interact. Just be careful, as certain color combinations can quickly turn muddy.

MIXING AND BLENDING WITH WATERCOLOR

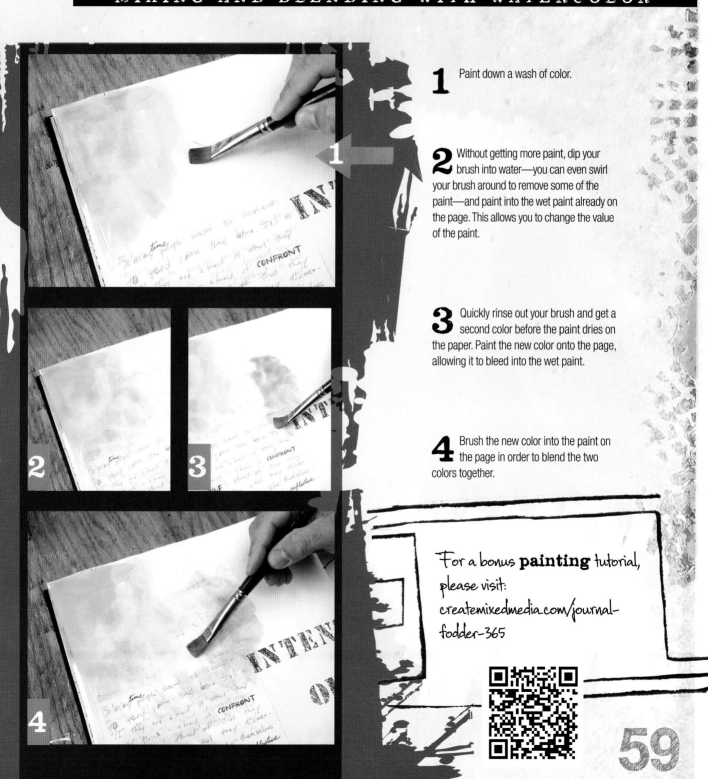

1 Paint down a wash of color.

2 Without getting more paint, dip your brush into water—you can even swirl your brush around to remove some of the paint—and paint into the wet paint already on the page. This allows you to change the value of the paint.

3 Quickly rinse out your brush and get a second color before the paint dries on the paper. Paint the new color onto the page, allowing it to bleed into the wet paint.

4 Brush the new color into the paint on the page in order to blend the two colors together.

For a bonus **painting** tutorial, please visit: createmixedmedia.com/journal-fodder-365

PAGE CUTS

We live one day at a time, documenting only that day. But it is possible to look back and see ahead in the journal by cutting out spaces at the edge of pages or by cutting windows through pages. It doesn't have to be big shapes or large areas that create transitions between pages. You can cut small areas that give hints of where you have been and where you are headed next, or you can cut a page in half vertically to create a larger view. You can even cut a recognizable shape like a face profile from the edge. By creating a series of page cuts, you intersperse even more interaction and interplay.

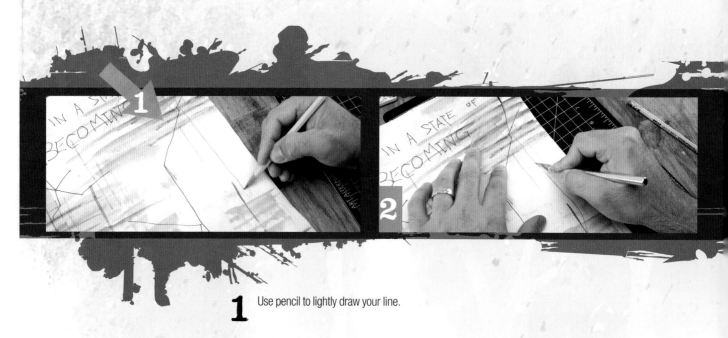

1 Use pencil to lightly draw your line.

2 Place a cutting mat beneath your page. Use scissors or a craft knife to cut along the line.

ADDITIONAL PAGE CUTS TO TRY

Cut a series of pages.

Cut complex shapes like a profile of a face.

Cut windows through a page.

COMPULSIONS AND OBSESSIONS: FILLS AND SURROUNDS

We have the overwhelming need to embellish the spaces that occur within and in between the elements of our pages. This impulse seems to come into play mostly when we want to fill the white space and emphasize other spaces. We semi-sarcastically attribute this need to a condition known as *horror vacui*: fear of the vacuum. In art-making, we take it to mean the fear of empty spaces. When given a space to work, we tend to find ways to fill it. Not that it is bad to have some free-roaming white space, but if you start getting the itch to go completely baroque, embellish the empty spaces within or surrounding images and thoughts you may have revealed in your pages.

tip]

There may be a way to over-embellish, but we haven't hit maximum density yet. So, when the urge hits you, just go for it and see if there is a limit to fully engaging a space.

FILLS

Solid Color

Patterns

Random Lines and Shapes

Watercolor Pencil and Yellow Marker

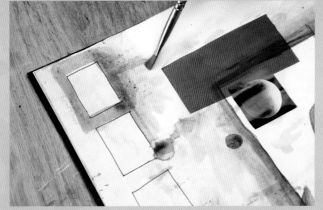

Value Change with Watercolor

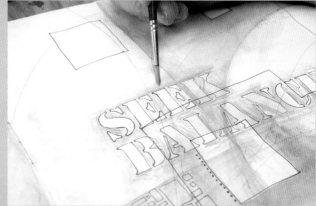

Value Change with Watercolor Pencil

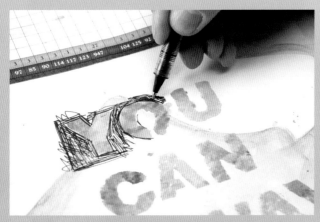

Ink

Patterns

OBSERVATIONS: FREEBIES—EVIDENCE OF YOUR DAY

Be on the lookout for free fodder that you pick up and use in your journal to record the activities of your day. Look for neighborhood bulletin boards in the library or supermarket, as well as the window ledges and cash register areas in bookstores and coffee houses. Save menus, receipts and labels as evidence of the places you have been and the items you have purchased and consumed. Also look for promotional materials such as postcards, business cards, brochures and stickers. What items do you find lying about in your daily life that are free for the taking? What is the evidence of the places and the spaces you visit? What story does this ephemera narrate?

EXCURSION: A DAY IN THE LIFE

What would it look like if you took the time to meticulously chronicle your day? Take your journal along with you, and make certain that you have a glue stick so you can conveniently integrate the remnants of your day to create a document that illustrates the events you experience. Write about the places you go and the people you meet. No matter how large or small the moments are, the significance of these activities is defined by you. They are your moments; proclaim the preciousness of each and every one by using them as your inspiration for art making. What did you do today? Where did you go? Who and what did you see?

ANATOMY OF A JOURNAL SPREAD

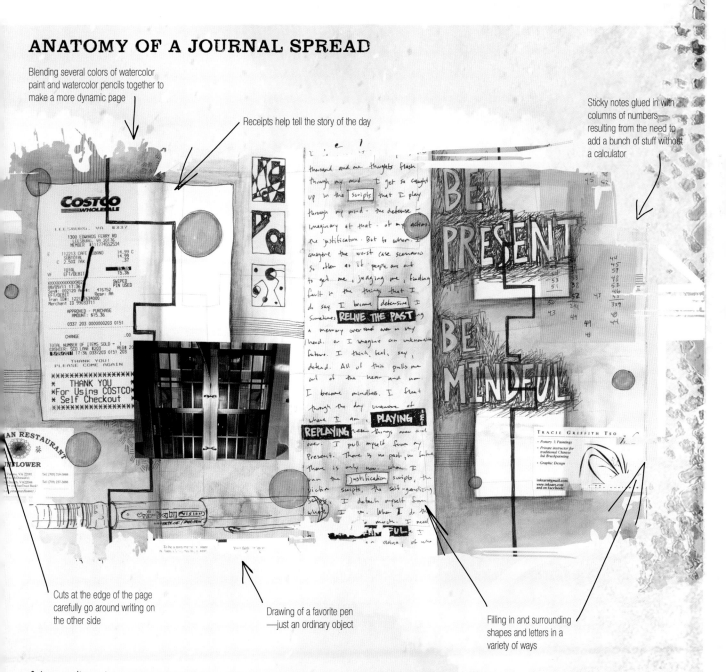

Blending several colors of watercolor paint and watercolor pencils together to make a more dynamic page

Receipts help tell the story of the day

Sticky notes glued in with columns of numbers—resulting from the need to add a bunch of stuff without a calculator

Cuts at the edge of the page carefully go around writing on the other side

Drawing of a favorite pen —just an ordinary object

Filling in and surrounding shapes and letters in a variety of ways

Closing Thoughts

As you continue to deal with the distractions of your day, the journal allows you to take notice of so much and to not look away from what's in front of you. So look closer at the present moment, and don't worry about the past or look too far into the future. And remember not to keep your nose buried in the journal too much. The world may pass you by if you don't look up every so often.

GROW

In everyone's life, at sometime, our inner fire goes out. It is then burst into flame by an encounter with another human being. We should be thankful for those people who rekindle the inner spirit.

Albert Schweitzer

additional art-illery

Along with your kit of materials, gather the following:

letter stencils
packing tape
a burnisher such as a bone folder or wooden spoon
a craft knife
a cutting mat

Connections and Relationships

As humans, relationships with others are an integral part of life. We search for ways to build relationships and make connections with others. These bonds provide us with a sense of well-being and belonging. Take a good look at who is in your life, because everything we do and how we do it is influenced by the connections we develop with other people. Explore the ways in which you connect and reconnect with yourself and others, and look carefully at how this influences your relationships. Knowing yourself and who you are is the basis of true and lasting relationships. Who contributes to your well-being and sense of self? How do you connect to the real world?

There are so many things that we encounter in our lives that disconnect us from who we are, and it seems like people are looking for further ways to disconnect from the real world. With Facebook, Twitter and other social networks, we turn to the virtual world where we may deny who we are in reality and seek hollow connection. Are all your Facebook friends actually your true friends? Do you really have 2,073 friends?

We also move forward and outgrow many relationships through divorces, break-ups and losing touch with old friends. Unfortunately this is an inevitable part of life, but it all can be dealt with while you engage in the process of your journaling practice. You may also need to outgrow and let go of your relationship to certain images, techniques and materials that are a part of your journaling. Figure out who inspires and challenges you, and honor those relationships that lead to your personal growth.

GATHER YOUR FORCES: IMAGES OF CONNECTION

What evidence do you have of your relationships and connections to other people? What do you do with the variety of correspondence you exchange with the people in your life? Some of us put it up on the refrigerator or office bulletin board for a while, and others stash it in a box of mementos. But these images of connection have even greater potential. Using postcards, letters and emails from friends, or even parts of the mailing packaging as collage material for your journal, is an easy way to physically bring your relationships into your art-making. Look for the ephemera and the evidence of how you keep in touch with others, and document these personal connections in your journal.

STRATEGIC PLANNING

We all have many people we come in contact with on a daily basis; some of those interactions are positive and some are not so positive. As you focus on your writing, keep in mind the wide range of influence others bring into your world. No matter what kind of energy they generate, these relationships affect aspects of our daily decision making. Examine the good, the bad and the ugly, and reflect on how you deal, cope and move forward with these different situations.

WRITING PROMPT 1: *Connections, Misconnections and Disconnections*
How have you connected and misconnected with people in your life? We seek connections, and many of us have spent an amazing amount of time seeking a spouse, a significant other or a soul mate. We may have found that person or may still be searching, but whether we have found that special link or not, our lives are still filled with family, relatives, friends and coworkers. Sometimes we connect and sometimes we misconnect with these people. What do these connections and misconnections mean to you? How can you deepen the important relationships and disconnect from the not so important ones?

WRITING PROMPT 2: *Inspirations and Nudges*
Who inspires you and nudges you? We can't do it all alone, and at times, we need a little nudge to get us going. It is good to have collaborators and accomplices in anything that we do, but especially in our creative endeavors. These people support us, encourage us and, at times, pick us up and carry us when we need them the most. These are our everyday heroes. Who shows up like magic when you need them the most? Who has your back and is always on your side? Who is your hero, your mentor, your collaborator, your accomplice?

WRITING PROMPT 3: *Challengers*
Who is challenging you? We all have people in our lives who challenge us. These are people who push and provoke us, who may be downright mean and rude and who don't elicit any warm and fuzzy feelings from us. These are our challengers and at times our arch-nemeses. It might be a mother-in-law, a brother, a nosy neighbor, an office bully or our boss. We may even believe these people to be our enemies whose main purpose in life is to torment us, but can we flip our script. Buddhists believe that our enemies are our greatest teachers because they provide us the opportunity to show compassion and understanding and to grow. How can you regard your enemies as your teachers? Why are they challenging to you? What can you learn from these people?

WRITING PROMPT 4: *Inner Connections*
How can we connect with others if we don't connect with ourselves? Much of contemporary life seems to be aimed at doing anything and everything so that we are not left alone with our own thoughts. We seem to find a million and one distractions. Perhaps we are afraid of what we will discover if we are alone with our thoughts. Perhaps we are afraid of the self-talk, the never-ending loop of negativity and put-downs. When was the last time you sat in complete silence, alone, and connected with yourself? How do you distract yourself from meaningful dialogue with yourself? How do you find the quiet space to hear your authentic inner voice?

WRITING TECHNIQUES

Explore all of the different writing implements and tools you have at your disposal as you add text to your pages. Don't be afraid to mix it up. Maybe start with stenciling large key words to infuse into the passages you compose. These letters could be painted, left open and bold, or filled with embellishments. Reveal some of the page underneath by cutting out some of the letters or words. If you find you always write in the same fashion, purposely change or mix styles. Write in cursive, printing or all capital letters. Be innovative, and invent a fancy handwritten style all your own.

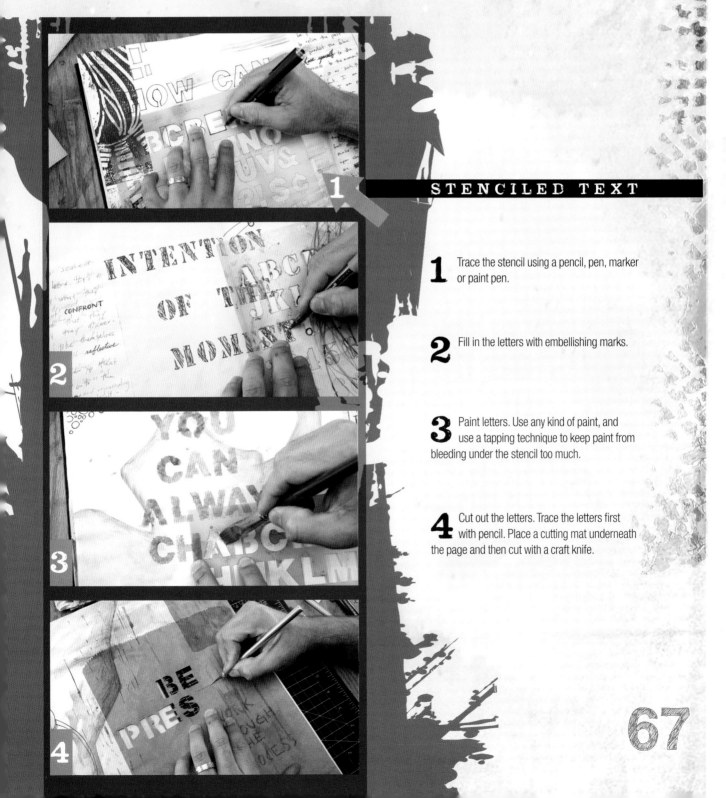

STENCILED TEXT

1 Trace the stencil using a pencil, pen, marker or paint pen.

2 Fill in the letters with embellishing marks.

3 Paint letters. Use any kind of paint, and use a tapping technique to keep paint from bleeding under the stencil too much.

4 Cut out the letters. Trace the letters first with pencil. Place a cutting mat underneath the page and then cut with a craft knife.

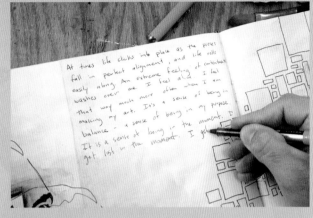

Printing

Cursive

All Caps

Fancy Print

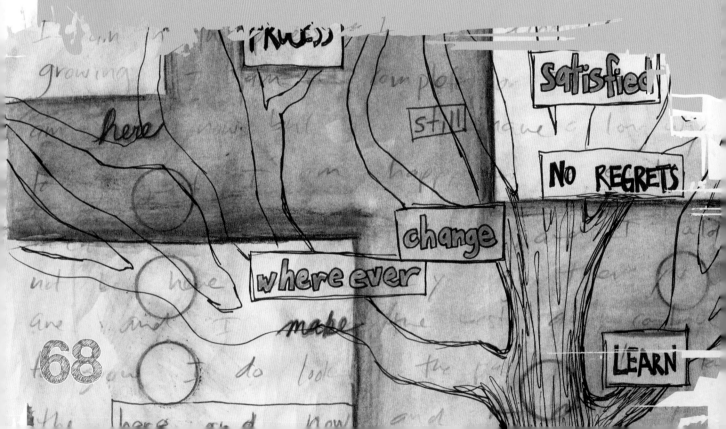

UTILIZING YOUR RESOURCES

Look at your collection of fodder that concerns the people, places and things that you deal with. Figure out ways to employ these items to map out the personal stories about these relationships. The real-life fragments that you collage or transfer into your pages can enrich the narrative and strengthen the connection between you and your experiences, as well as between the art-making and the writing.

➡ DRAWING

MAPPING MARKS

Considering that a map is simply a system of structure for organizing information, what kinds of marks do you see when you look at maps? Maps are a concrete example of our connection to places and to people, and the graphics can supply us with ideas for our art-making. The lines you make when you write or draw are like the highways and byways on a map. Sometimes the line is straight, many times it curves or is wavy, and it can even loop and zigzag. The lines you make also create boundaries and borders or show contours.

As you explore the idea of mapping, look for alternative types of maps such as subway maps, bus route maps, topographical maps, treasure maps and theme park maps. All of these varieties offer you forms to explore in your mark-making and drawing. You might even want to draw a map of your town, city or neighborhood as a way to bring a personal touch to your mapping.

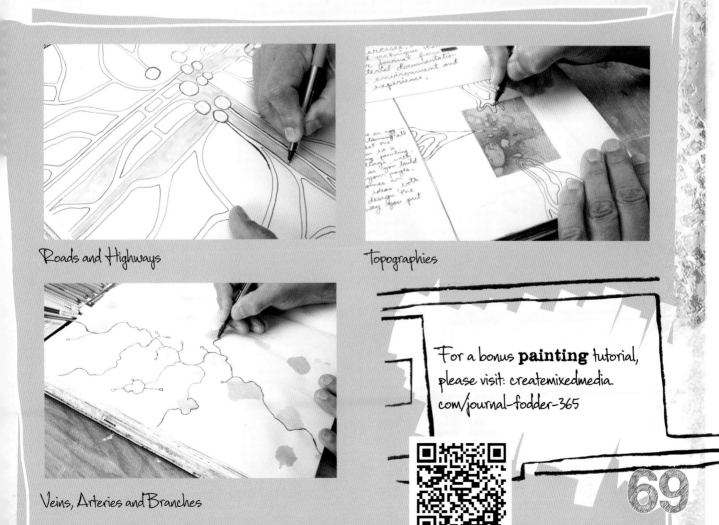

Roads and Highways

Topographies

Veins, Arteries and Branches

For a bonus **painting** tutorial, please visit: createmixedmedia. com/journal-fodder-365

PHOTOCOPIES

Before you cut up that one-of-a-kind photograph or image, consider making some photocopies of it first. This is an excellent way to build your fodder reserves with images that resonate with you, but it also lends itself to different types of experimentation with your images. While at the photocopier make several copies of the image, enlarge and decrease the size of the image and make lighter and darker versions. You can even put several on a single page to make a multitude of copies.

Collage is not the only way to incorporate photocopies; they lend themselves to many kinds of transfer processes, such as packing tape transfers. These transparent images are strongly suited for use as top layers on a page because it is difficult to add anything to the glossy surface of the tape. When using a photocopied or other type of printed image for tape transfer, check to make sure that the image was printed with a toner-based material. The common desktop copier-printer you use at home is most likely an inkjet style printer that uses actual ink to reproduce the image. Only toner-based images work effectively with tape transfers.

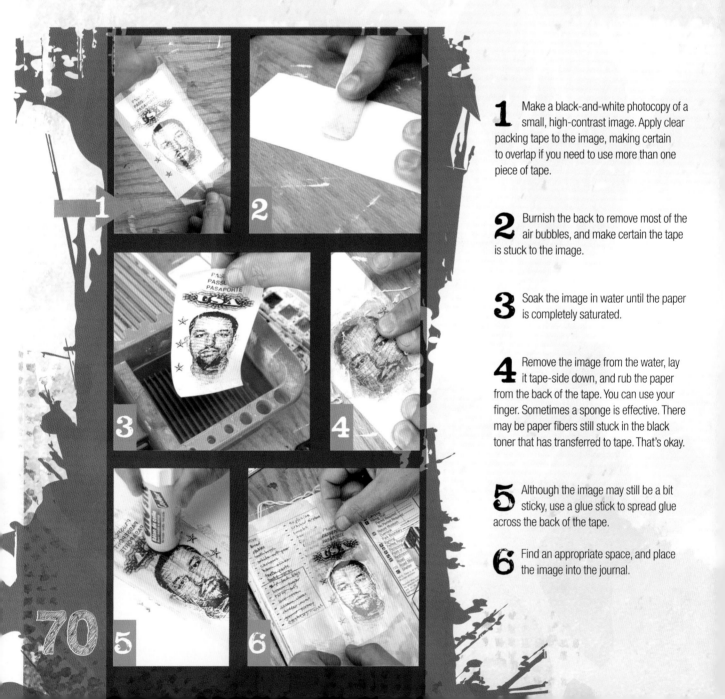

1 Make a black-and-white photocopy of a small, high-contrast image. Apply clear packing tape to the image, making certain to overlap if you need to use more than one piece of tape.

2 Burnish the back to remove most of the air bubbles, and make certain the tape is stuck to the image.

3 Soak the image in water until the paper is completely saturated.

4 Remove the image from the water, lay it tape-side down, and rub the paper from the back of the tape. You can use your finger. Sometimes a sponge is effective. There may be paper fibers still stuck in the black toner that has transferred to tape. That's okay.

5 Although the image may still be a bit sticky, use a glue stick to spread glue across the back of the tape.

6 Find an appropriate space, and place the image into the journal.

In chapter five we discussed different kinds of page cuts to explore in your journaling process. Now focus on utilizing cutouts and windows to create specific connections between pages in your journal. Before you cut out a space, take the time to think about what that space will reveal on the page in front or behind. Sometimes it is exciting to cut out and be surprised by the relationship that is created with this process, but it can lead to unintended connections and results. Be more strategic, and set up the pages for pathways into and out of the spaces.

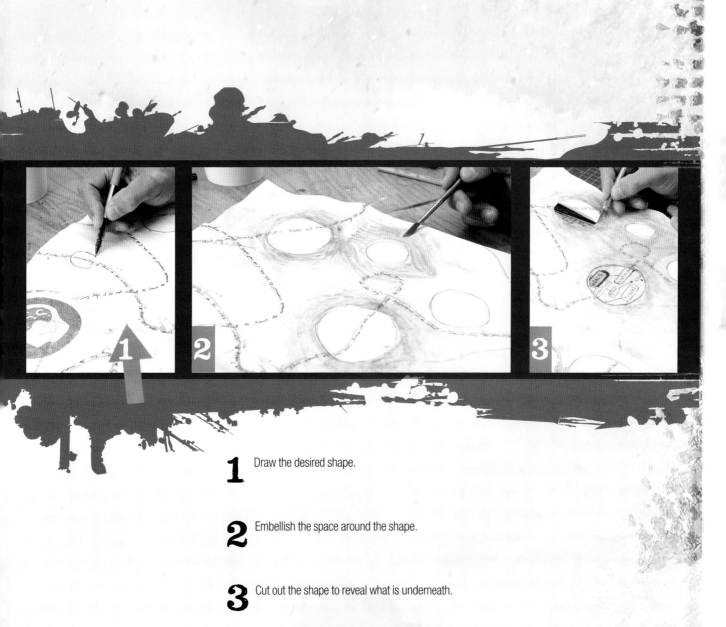

1 Draw the desired shape.

2 Embellish the space around the shape.

3 Cut out the shape to reveal what is underneath.

COMPULSIONS AND OBSESSIONS: DOTS AND DASHES

Many times the lines we draw become uniform and can lack a sense of variety. Break out of your routines and purposely change the qualities and characteristics of the lines. Infusing the line with dots or dashes creates a different directional feel, adds some mystery, builds borders and boundaries and makes other forms of visual tension. Bunch and cluster these marks to explore an array of textures and tonal qualities. Experiment with the scale and size of the dots or dashes to investigate a variety of compositional opportunities.

Dotted Line

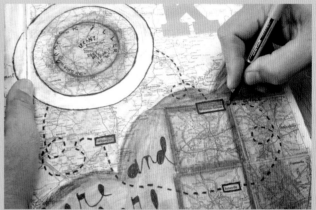

Dashed Line

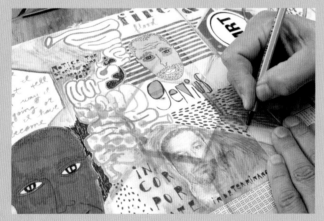

Clusters

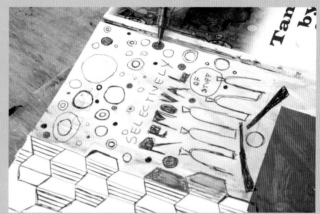

Different Sizes

OBSERVATIONS: RELATIONSHIPS

Everyone has a variety of relationships. Some are long lasting, and some are short lived. Some are experienced on a daily basis, and some for just a moment in time. Observe and examine the different types of interpersonal relationships you have, and identify the ones that are positive and constructive. Find ways to feed on that connection and get the most out of the interaction. At the same time, make yourself aware of the ones that are negative and destructive, and come to grips with why you still hold on to that stressful and draining connection. What are the relationships in your life? Are there connections you need to cultivate more proactively? Is it time to give up other connections? Who is lifting you up? Who is bogging you down?

EXCURSION: PARTY TIME

The next time you have a social engagement, take your journal with you to that party or celebration and see what kinds of interactions it encourages. Explore the opportunities to use your journal as a way to bridge the gap between you and others. Share some of your private world and invite them to view some of your pages. Or better yet, engage the journal as a public space, and invite people to actively participate and add something to your book. Use your journal as the sign-in book for an art exhibit, a place to write down the recipe to the dish a friend brought to the potluck dinner or as a way to introduce yourself to new friends. What is it like when others are engaged by your journal?

ANATOMY OF A JOURNAL SPREAD

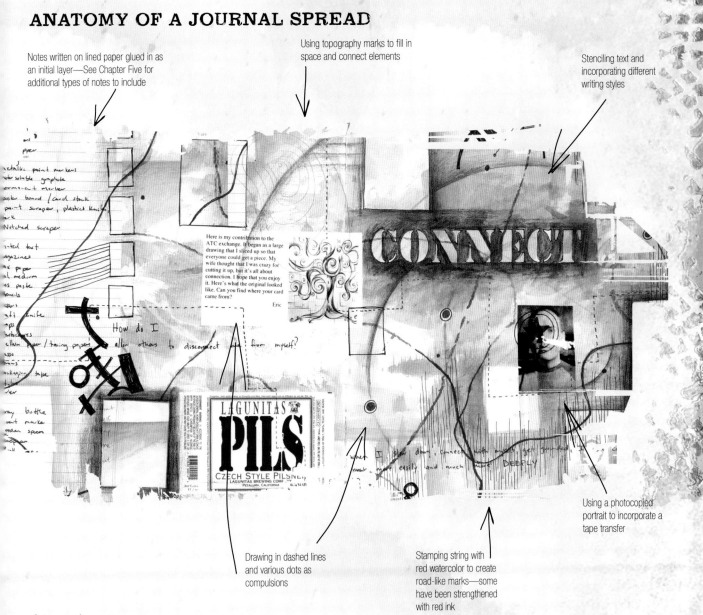

Notes written on lined paper glued in as an initial layer—See Chapter Five for additional types of notes to include

Using topography marks to fill in space and connect elements

Stenciling text and incorporating different writing styles

Drawing in dashed lines and various dots as compulsions

Stamping string with red watercolor to create road-like marks—some have been strengthened with red ink

Using a photocopied portrait to incorporate a tape transfer

Closing thoughts

Work to strengthen your connection to your journaling practice and allow the journal to aid you in figuring out the importance of the relationships in your life. Cultivate those connections that lift you up and spirit you on, and abandon those that drag you down and diminish your light.

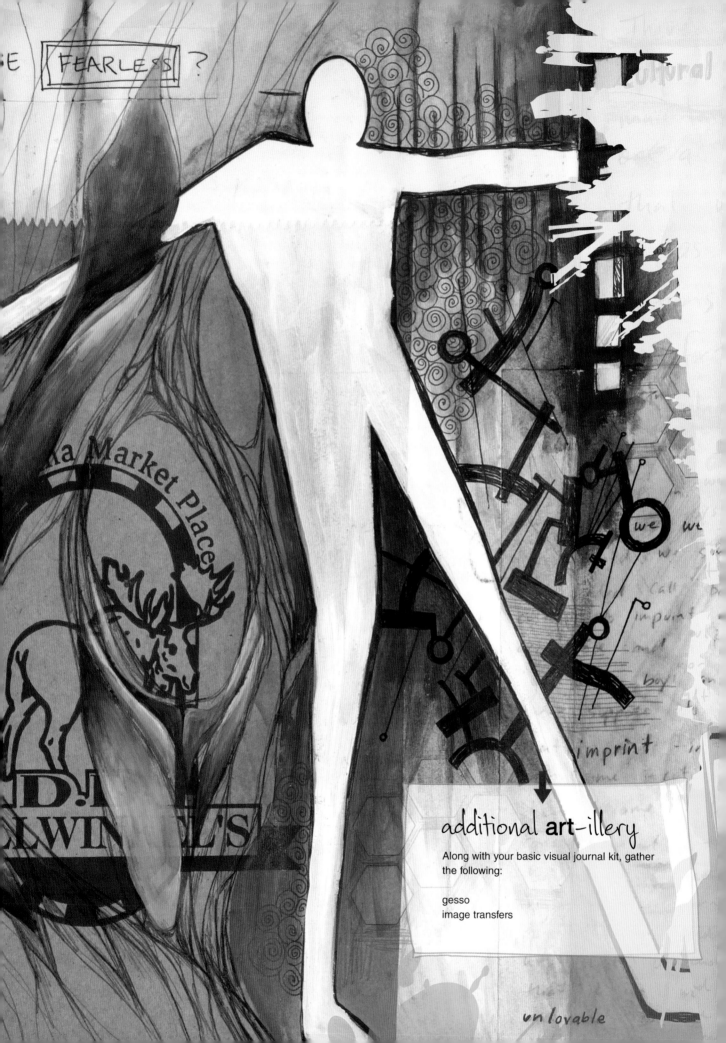

FEARLESS ?

Market Place

we we

imprint

un lovable

additional art-illery

Along with your basic visual journal kit, gather
the following:

gesso
image transfers

Facing Doubts and Just Letting Go

WHAT IS HOLDING ME BACK? WHAT IS KEEPING ME FROM MOVING FORWARD? HOW CAN I STEP UP AND PROCLAIM WHO I AM?

We all carry baggage, and these doubts and fears keep us stuck and spinning our wheels. We doubt the existence of our creativity to the point that we lack confidence in our skills and intentions as artists and as humans. Identify the fears that hold you back, and confront them. In the end, you cannot change what you do not acknowledge, so don't stay in a situation and merely cope with the cards that you are dealt. Change the situation or find a way to move on. The life you want to live is out there waiting for you, but it won't be handed to you. You often have to fight for what you want, and most of the time that is a fight you have to pick for yourself.

What are the important things? What is just weighing you down or getting in the way? Lighten your load as you analyze and discard that which truly does not matter. Purge your life and your thoughts of the extra baggage that you drag along. Think of your life as a four-day journey and pack what is essential. What is filling space and why do you continue to let it clutter up your environment? Take control, step up and proclaim who you are and what you want to do and where you want to go. As you move forward, leave the old business behind, and keep in mind that nothing *is what it is*. Push past such reactive sentiments, and take charge of the change you want to make. So get out there, take a more proactive stance and fully engage in the world to make of it what you choose.

GATHER YOUR FORCES: IMAGES OF RELEASE— BE A COLLECTOR, NOT A HOARDER

There is a fine line between being a collector and being a hoarder. We are all guilty of saving too much stuff. The mementos and daily remnants we accumulate get in the way and bog us down. Empty out your fodder pocket, envelope or box, and start using the ephemera in your journal. Trade some of it with a fellow fodder junkie, or just give it to someone who is fodder deficient. If you still don't find meaning or value in the objects you have saved, then it is time to get rid of it. Stop the hoarding, and just let it go.

STRATEGIC PLANNING

There are always things that trip us up or weigh us down, but in order to move forward and find our footing again, we have to embrace the doubts and find ways to free ourselves of these burdens. If we don't confront the fears and negativity, we become paralyzed by the power and control we give them. Delve deep into the things that trouble, concern and torment you, and face your demons as you begin to emancipate yourself of the emotional and psychological hold they have on you.

WRITING PROMPT 1: *Getting It All Out*

What emotional baggage do you need to unpack? We all have things eating us up inside. There are moments when someone does something to us and we want to give them a piece of our mind, but we hold our tongues. We bury the pain and hurt deep within ourselves. Bottling up these negative thoughts and feelings can be very unhealthy. When something is bothering you, just get it out, vent and dump the emotions. View your writing as a conversation with a close friend or a way to get a full release from these energy-draining burdens. Unburden your soul, and get it all out. What do you have pushed down and buried deep within? What negative thoughts are you harboring? What frustrations do you need to uncork and pour out?

WRITING PROMPT 2: *Hopes and Fears*

What are the fears that are holding you back from living the life you hope for? We have dreams about where we want to be in five years, ten years or maybe even twenty. However, the things that we want most are sometimes the things we are most afraid to go after. We wish for big things, but are afraid they will not come true. There is always a reason we put off receiving the joy and the happiness we deserve. Many times it is other people telling us why our dream is too lofty, and sometimes it is our own self-talk that gets in the way. Subdue the fears and focus your energy towards realizing your dreams. What do you envision for your life? What are your biggest hopes and dreams? How can you achieve them? What are your worst fears and nightmares? Are they legitimate or imagined?

WRITING PROMPT 3: *Bury the Doubt*

How can you bury the doubt and champion your hopes, dreams and aspirations? We are our own worst critics, focusing on the negative things about our work and about ourselves, especially when we stumble and fall. However, we can be our own biggest cheerleaders by seeing mistakes and disappointments as opportunities for growth and perseverance, but we must silence the nagging doubts. Pick yourself up when you have fallen and overcome the misgivings and uncertainties. In order to rally towards greater achievements, learn from your defeats, bury your doubts and move forward. What are you doubting? What inadequacies are looming in your mind? How have you persevered through the rough patches and uncovered your self-confidence?

WRITING PROMPT 4: *Just Let Go*

How can you step out of your scripts and just let go? We encounter many things in life that make us stand still—a lost love or a broken heart, getting laid off or being skipped over for a promotion, or falling victim to bad advice or broken promises. We can't control these situations, but we can control how we react to them. We run these things through our minds over and over, as fears of inferiority and inadequacy invade our thoughts. We struggle with thoughts of how we don't measure up to others, getting caught up in our scripts and self-talk. Don't give in and allow the doubt to take over your decision-making. Let go of your hesitation, and understand that you can do anything that you dedicate your energy to fulfilling. Do you constantly compare yourself to others? Do you still hold on to the idea that *perfect* exists? Do you always seem to find a way to talk yourself out of the things you want most? What scripts or self-talk do you most want to let go of? Can you find ways of letting go?

WRITING TECHNIQUES

When writing in our journals about our most private and intimate moments, we may feel the urge to censor ourselves if we invite others to look at our work. Fear that they may read these passages and pass judgment on us can scare us into holding back and bottling up. In the spirit of letting go, write whatever you need to write, but as you dump the reserves and put it all out there, consider obscuring the text to protect your private thoughts. Think about ways the words could purposely get smeared or covered over in order to hide some of the deeper, more personal thoughts you may not be quite willing to put on full display. This way you don't keep the things you need to say buried inside, and you can release them and move on. Consider using water-soluble materials, collage, paint, gesso and image transfers as ways to deliberately obscure your writing. Remember that it is not important that you can read your writing in the end. It is important that you get things out and release the troubles and anxieties.

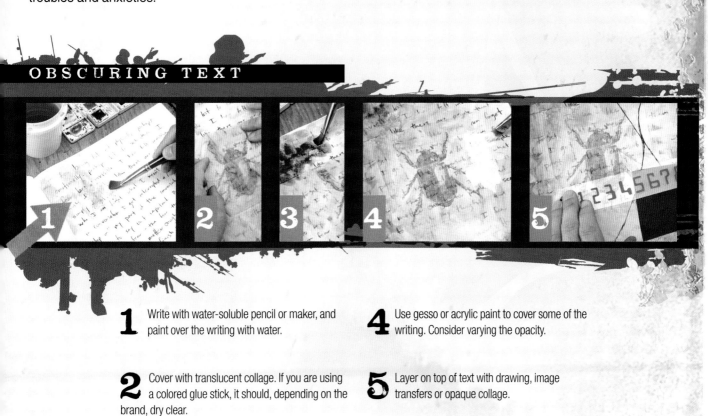

OBSCURING TEXT

1 Write with water-soluble pencil or maker, and paint over the writing with water.

2 Cover with translucent collage. If you are using a colored glue stick, it should, depending on the brand, dry clear.

3 Use paint and vary the value and opacity.

4 Use gesso or acrylic paint to cover some of the writing. Consider varying the opacity.

5 Layer on top of text with drawing, image transfers or opaque collage.

77

UTILIZING YOUR RESOURCES

As you work with your materials and experiment with techniques, step outside of your comfort zone and build confidence with art supplies and techniques that you normally shy away from. Maybe these media scare you because you have limited experience with them. Maybe you doubt your skill with them and feel you will only "mess up." Let go of the fear, and allow yourself to fully embrace the freedom of experimentation. This is your document and there are no rules or limitations except the ones you place upon yourself. Anything goes here, and there are no mistakes. Push beyond the doubt, and give yourself permission to go with the flow and make fearless marks.

DRAWING
STYLIZED FACES

Many people doubt their skill and ability to draw faces, but when you give yourself permission to work in a stylized way, you can quiet the nagging voice that says, "You can't draw." Don't allow your misgivings to keep you from using drawings of faces and people in your journal. You don't have to render them in a realistic way, so try to capture the emotional energy of the expression. You can still start with the basic proportions and features and then embellish and elaborate from there. Mix things up by exploring different shapes for the heads and experimenting with various stylized modifications for illustrating the facial features and expressions. Give up the idea that there is only one "right" way to draw a face.

What kinds of expressions do you see people wearing on their faces? What kind are you wearing? How do their facial expressions affect how you approach and deal with these people? In your drawing exercises this time around, focus on the faces you encounter on a daily basis. Record the faces you see, and think about the emotional quality of their expressions.

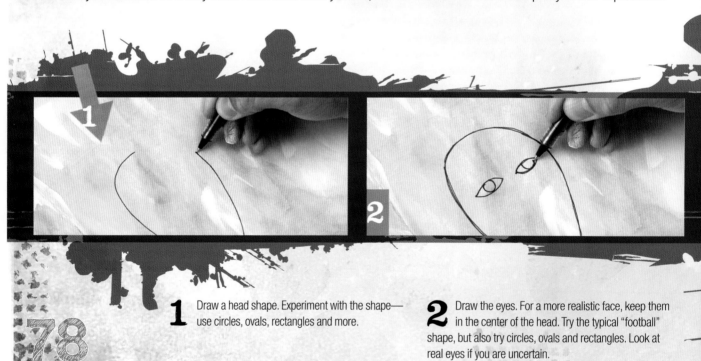

1 Draw a head shape. Experiment with the shape— use circles, ovals, rectangles and more.

2 Draw the eyes. For a more realistic face, keep them in the center of the head. Try the typical "football" shape, but also try circles, ovals and rectangles. Look at real eyes if you are uncertain.

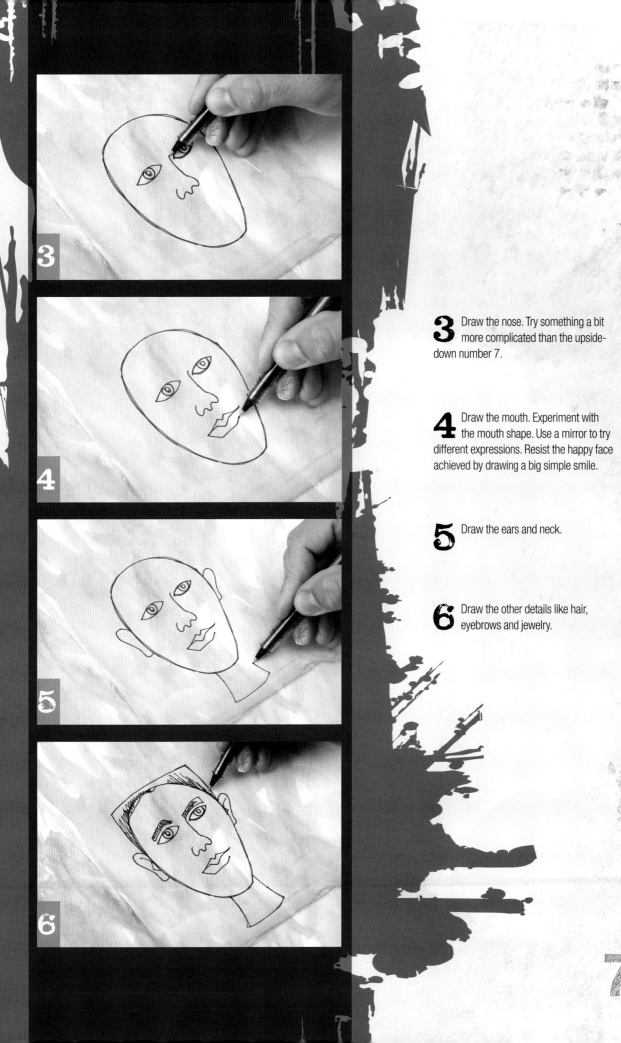

3 Draw the nose. Try something a bit more complicated than the upside-down number 7.

4 Draw the mouth. Experiment with the mouth shape. Use a mirror to try different expressions. Resist the happy face achieved by drawing a big simple smile.

5 Draw the ears and neck.

6 Draw the other details like hair, eyebrows and jewelry.

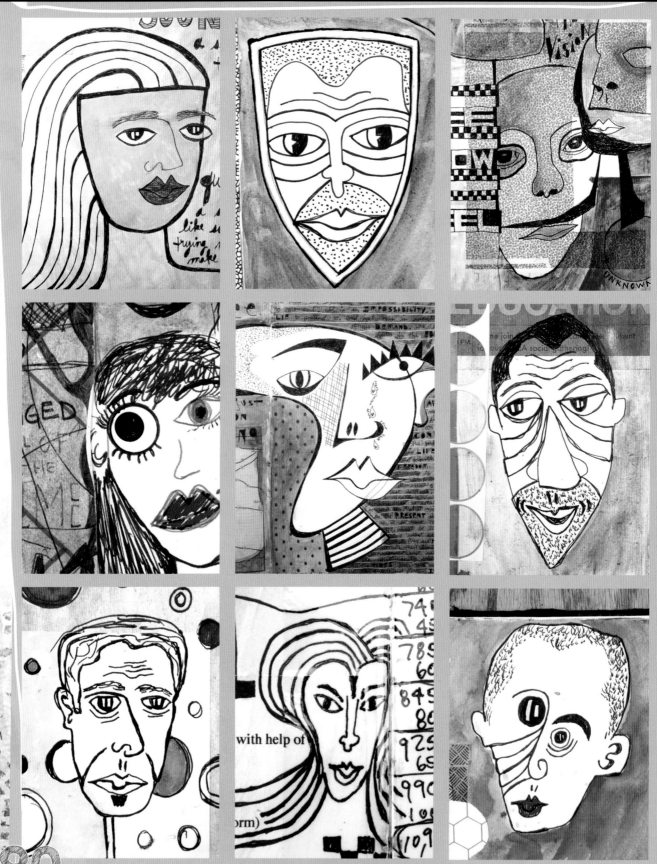

To fully engage our journals and explore our concepts, it's sometimes necessary to expand the surface area on which we work. You can create more workable surfaces in a number of ways, but adding paper as a foldout to the edge of a page is the simplest way to expand. The foldout covers a particular page or part of a page, and then exposes the space beneath when it is unfolded, creating an element of surprise and a feeling of revelation. Experiment with the size, shape and quantity of foldouts to discover the ways you want to interact with your pages.

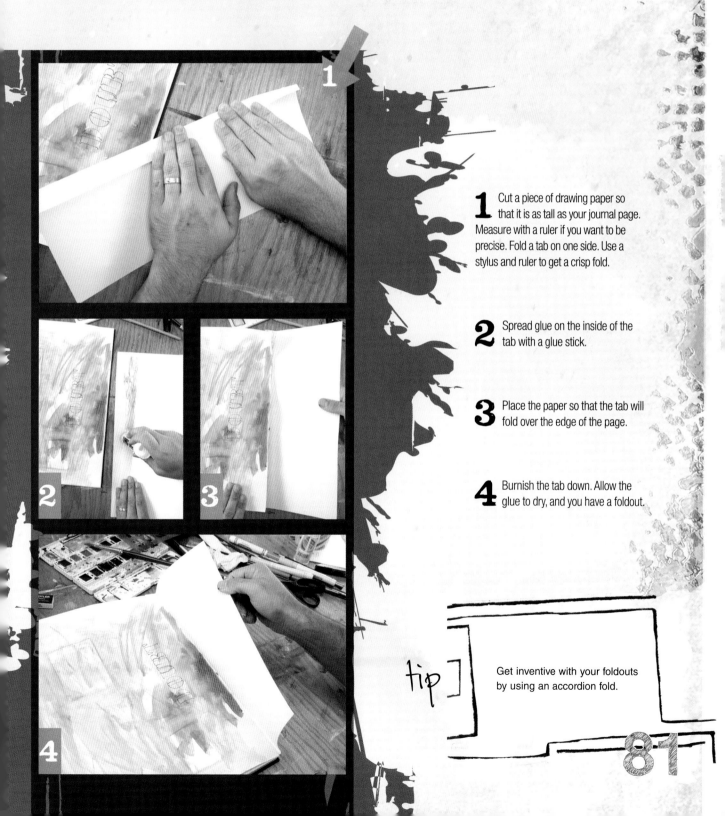

1 Cut a piece of drawing paper so that it is as tall as your journal page. Measure with a ruler if you want to be precise. Fold a tab on one side. Use a stylus and ruler to get a crisp fold.

2 Spread glue on the inside of the tab with a glue stick.

3 Place the paper so that the tab will fold over the edge of the page.

4 Burnish the tab down. Allow the glue to dry, and you have a foldout.

tip] Get inventive with your foldouts by using an accordion fold.

COMPULSIONS AND OBSESSIONS: INTEGRATING COLLAGE

We have particular notions of the proper ways to utilize our techniques, and collage is no different. We can fall into the rut of gluing collage onto the page and then doing little else with it. However, the journal page is not simply a fancy frame for the image and does not need to be created like a scrapbook layout. Once the collage element is in your journal, it does not mean that your creative process has to stop there. Consider how you want the image to connect with the page that surrounds it. Look at ways to add to or expand the image with additional drawing or paint, and experiment with ways to re-contextualize the collage on the page through purposeful layering.

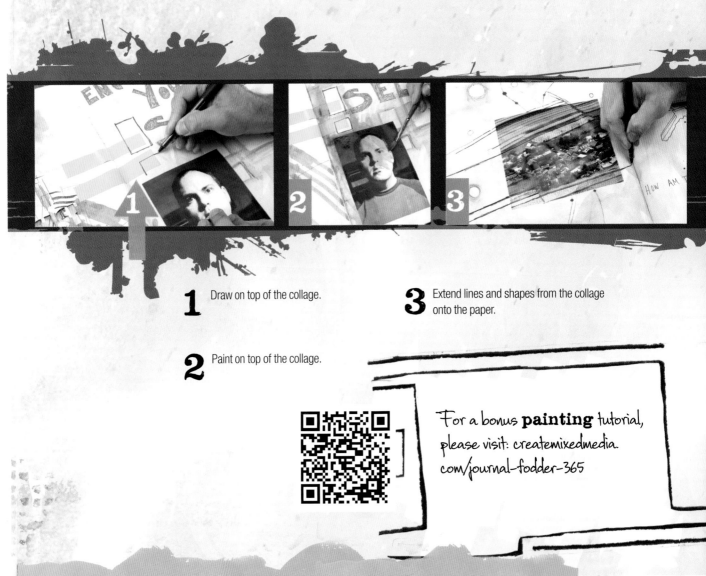

1 Draw on top of the collage.

2 Paint on top of the collage.

3 Extend lines and shapes from the collage onto the paper.

For a bonus **painting** tutorial, please visit: createmixedmedia.com/journal-fodder-365

OBSERVATIONS: INNER OBSERVATIONS

Get introspective and uncover your fears and doubts, as well as your confidences and strengths. Record these discoveries in your pages just as you would any observation. This documentation might take the form of images or words, but most likely it will become a combination of both. Take a few moments from time to time and observe what occupies your inner space. What scripts are looping through your thoughts? What misgivings, anxieties and uncertainties ebb and flow over time? What confidence and strength do you find? What fears and doubts are you clinging to? What are you trying to let go of?

EXCURSION: TAKE YOUR JOURNAL TO A MUSEUM OR A GALLERY

Make your next trip to the art museum or Friday night gallery walk more interactive and memorable by taking your journal along for the experience. Write reflective comments about the works you see, jot down the names of artists that intrigue you and who you want to research further, or find a spot to sit down and draw from the artwork on exhibit. Engage in a dialogue with the work to take away more useful and enlightening ideas. Fully document your encounters with the work and with the space. How is this encounter different than previous museum trips? How do you feel as you sit and dialogue with a piece or a space? Do others interact with you? Are they curious about what you are doing?

ANATOMY OF A JOURNAL SPREAD

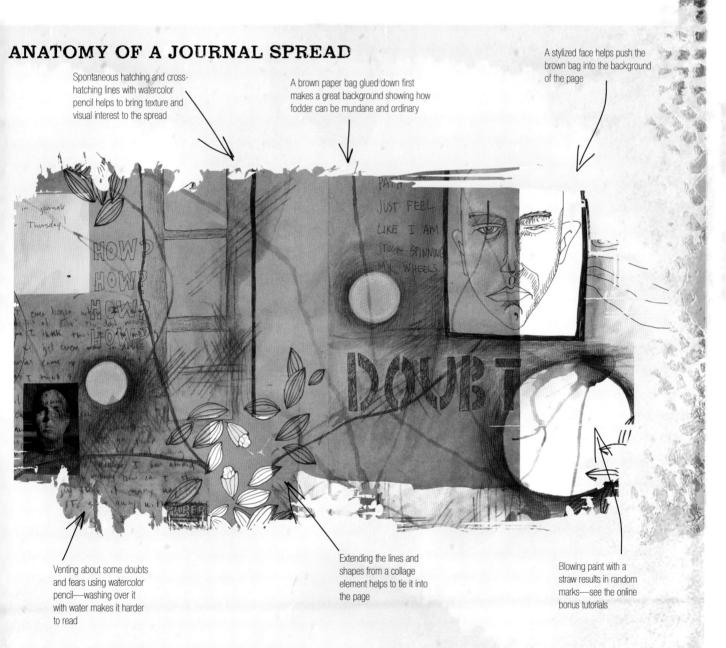

Spontaneous hatching and cross-hatching lines with watercolor pencil helps to bring texture and visual interest to the spread

A brown paper bag glued down first makes a great background showing how fodder can be mundane and ordinary

A stylized face helps push the brown bag into the background of the page

Venting about some doubts and fears using watercolor pencil—washing over it with water makes it harder to read

Extending the lines and shapes from a collage element helps to tie it into the page

Blowing paint with a straw results in random marks—see the online bonus tutorials

Closing Thoughts

As your investment in your journal grows, allow the journal to become a place to encounter your uncertainties, your doubts and your fears as you work through your issues and stop carrying all that baggage. You'll be relieved when you stop bottling it up inside and instead dump it out into the journal.

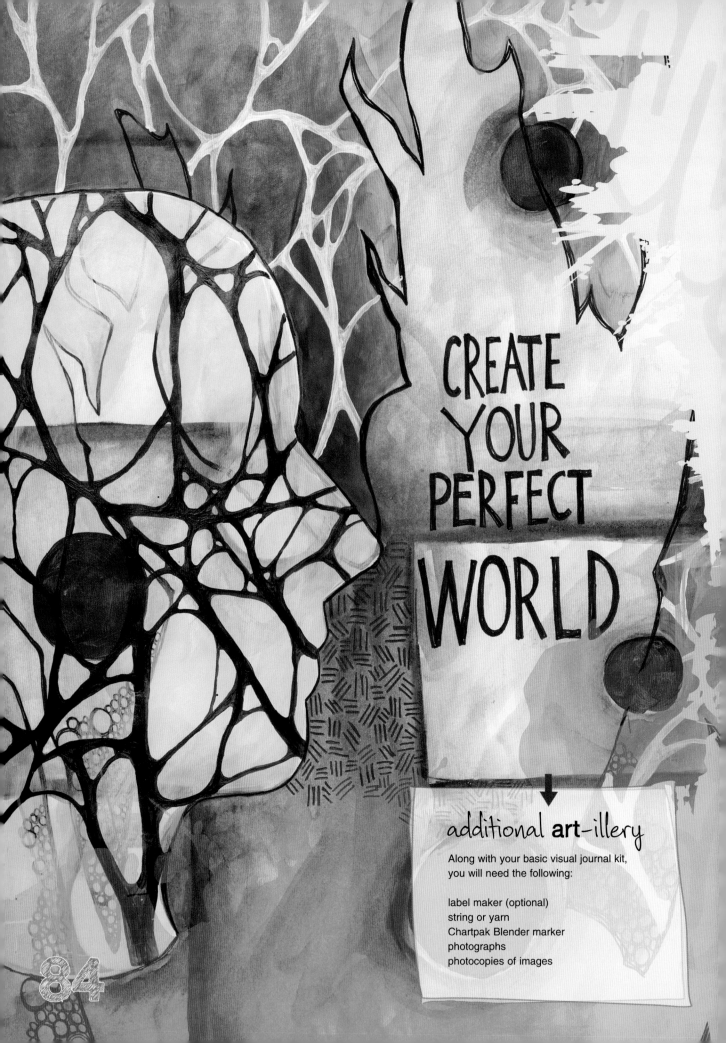

CREATE YOUR PERFECT WORLD

additional art-illery

Along with your basic visual journal kit,
you will need the following:

label maker (optional)
string or yarn
Chartpak Blender marker
photographs
photocopies of images

Dreaming and Visioning

What do you want to be when you grow up? This is a question that we ask kids when they're little. But how many adults have actually grown up to be what they dreamt about as children? We all have hopes and dreams for a rewarding and prosperous future. Did we grow up to be what we wanted to be? Or are will still dreaming? It seems like we start out chasing our dreams but end up accumulating a lot of stuff because our family, our friends, the media and big companies all have dreams for us as well. We say to ourselves, "One day when the kids are grown, the debts are paid and the stars align just right, then I'll start living my dream." But why wait? Start making the plans and laying the groundwork to grow those dreams into a reality. Fill your journal with the ideas and intentions that will grow and bloom throughout your life.

GATHER YOUR FORCES: IMAGES OF INTENTION— EVIDENCE OF PERSONAL GROWTH AND DREAMS

If we stop growing, we must be dead. So start gathering the evidence of your growth and your dreams as you begin collecting fodder for the month because evolving into the people we dream of being is a difficult process. Be sure to look out for things that speak directly to your dreams and resonate with your spirit. Find articles online, in magazines or in newspapers. Perhaps there are images that can represent and symbolize your dreams. Maybe you aspire to be like someone, so find images of that person. Perhaps you dream of taking a class, shifting careers or traveling to a special place, so collect information, brochures and pamphlets. Save the catalog from your local community center or adult education program, or request a catalog from an art center like Penland School of Crafts or Arrowmont School of Arts and Crafts. There are many classes and opportunities out there. What are you dreaming of doing?

Whatever you gather, try to focus on things that you can do, and not on the material things that you want. Stuff is easy to get, but experiences are unique and special. You can begin to set your intention by assembling these images of your dreams and beginning to interact and use them.

STRATEGIC PLANNING

In order to attain your goals, you need to acknowledge and verbalize your dreams, and analyze the reality and feasibility of each one. Enlarge and clarify the dreams so that you can develop the strategies and the courage to make them happen. Start living the dream instead of dreaming to live.

WRITING PROMPT 1: *Dream Journal*

What are you dreaming about? We all have dreams, actual night visions that dance through our sleeping minds, as well as our hopes and aspirations. Document both kinds of dreams. Keep your journal, or at least some paper, next to your bed, and when you wake throughout the night or first thing in the morning, jot down your dreams before you forget them. Elaborate on these visions, and reflect on their contents and meanings. Keep pen and paper close at hand during the day, and write down your dreams, your hopes, and your aspirations. Reflect on these thoughts and musings. This type of documentation becomes fertile soil for your intentions. What are you dreaming about at night when you sleep? What are the details and the nuances of the dreams? Do you have reoccurring dreams? What are you dreaming about when you are awake? What are those aspirations? What do you dream about and hope for?

WRITING PROMPT 2: *Daydreams*

What thoughts, ideas and scenarios flash through your mind throughout the day? Our thoughts can very easily float away from us. We may be sitting in a meeting, and our minds may wander because the meeting doesn't hold our attention. We may daydream as we drive to work or to the store, or we may just sit and think, allowing thoughts and ideas to come and go at will. Pay attention to these times, and record and embrace these meanderings of the mind. They seem like whims, but they are peeks and glimpses into what we want and need the most. Pay attention to the fleeting thoughts that pop up throughout your day, and document them so that you don't forget. Where does your mind go when it isn't actively engaged? What are your daydreams? Do they hold clues about your bigger dreams and hopes?

WRITING PROMPT 3: *Dreams and Nightmares*

What do you fear most about trying to achieve your dreams? Along with dreams come nightmares. These may be nightmares that we have while sleeping, or the worst-case scenarios that we experience when we are awake. For many of us, it is impossible to imagine our dreams without imagining the nightmare. We think of all the reasons why it won't and can't work out. We balk at the fear, trip ourselves up and hold ourselves back. Acknowledge your dreams and nightmares, and shine light into your darkness. Don't let the possible nightmares squelch your dreams. Confront the negativity as a means to overcome it and move beyond it. What are your dreams? What are the corresponding nightmares? What are your worst-case scenarios? How can you overcome your nightmares?

WRITING PROMPT 4: *Visions of Myself*

Do you see yourself living your dream or living a life of want, longing, and regret? A synonym of the word *dream* is *vision*. Often our vision of ourselves can directly affect whether or not we achieve our dreams. We have a clear picture in our minds of ourselves, but unfortunately that picture is often distorted by self-talk, doubts, fears and personal mythologies. Interrogate these visions of yourself to see if they hold up to scrutiny. Stop getting in your own way, and start visualizing yourself living the life you dream about. How do you see yourself? What can you do to see yourself in a more honest and authentic light? How could a clearer, truer vision of yourself help move you toward that dream?

WRITING TECHNIQUES

As you reflect on ways to live your dreams, create a mind map as a visual way to brainstorm and organize your thoughts and to begin developing a plan. The key to the mind map is to start with an overarching idea, and to branch out with different and more specific information as you go. Although this central idea is often and predictably placed in the center of a page, don't be afraid to span a two-page spread or place it anywhere you wish, like in a corner or at the bottom. As you branch out with your specific themes, use symbols and key phrases to represent your ideas. Your mind map can be as visually plain or elaborate as you wish. Use color and embellishments to create emphasis and to transform your map into a visual experience.

MIND MAPS

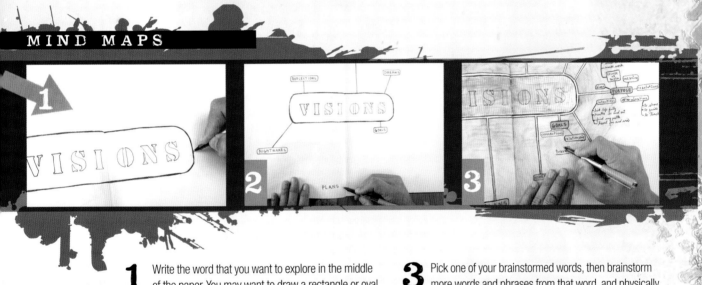

1 Write the word that you want to explore in the middle of the paper. You may want to draw a rectangle or oval around the word.

2 Brainstorm other words that you associate with your chosen word. Write these words around your first word. You may want to draw ovals and/or rectangles around these words. Connect these words to your original word with lines.

3 Pick one of your brainstormed words, then brainstorm more words and phrases from that word, and physically connect them. You can repeat this with any or all of the words that you now have.

LABEL MAKER

It can be effective to quantify your hopes and place a label on your dreams. This labeling can be more than a figure of speech because you can use an actual label. A label maker isn't ideal for writing large chunks of text, but it is an easy way to call attention to those operative words and phrases that need some emphasis. Whether you have a simple handheld embossing label maker or a deluxe electronic one, explore the possibilities of using a label maker to create words and phrases. The embossing label maker that presses letters into plastic tape even creates a tactile sensation as the raised letters add actual texture and dimension to your page. But don't rush out and buy one if you don't have one. Think instead of how you might otherwise create labels and incorporate them into your pages.

UTILIZING YOUR RESOURCES

As you work to make art, keep your dreams and visions close at hand. Use some of your photographic fodder as inspiration for the image making you explore, and set your intentions as you work with paint and text as graphic devices. Allow your dreams to emerge through your art as well as through your words.

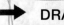 DRAWING

DRAWING FROM PHOTOGRAPHS

Use some of your dream images because they make perfect subjects for drawing. Don't stress out. Let go of your doubts about drawing. We've led you through a couple of simple drawing techniques, and this is no different. Don't get caught up in trying to make the drawing look like the photograph. Just draw what you see. It is okay to use pencil and to erase, but suspend your judgment so that you're not erasing, starting over or tearing out pages in an attempt to get it just right and "perfect." Lean into the frustration, and see where your skills have improved and grown. Understand that the more you draw, the better you get because the learning is in the doing.

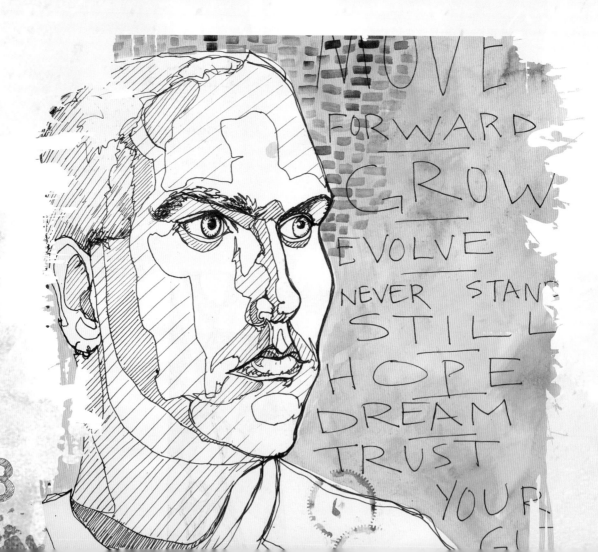

SYMMETRICAL STRING DESIGNS

Like seeing images in the shapes of clouds, we often see something emerge from a random line, paint splotch or juxtaposed shape. Similar to the way inkblot tests help gain insight into someone's personality, we gain insight into our own hopes and dreams as we tap into our subconscious, allowing visions to emerge from the lines, colors and shapes we place on a page. We may begin to see our dreams more clearly, or our nightmares may begin to manifest from the resulting imagery. Whether these techniques give you glimpses into your subconscious or are just be fun visual games to play, they open up new possibilities for dreaming in the journal.

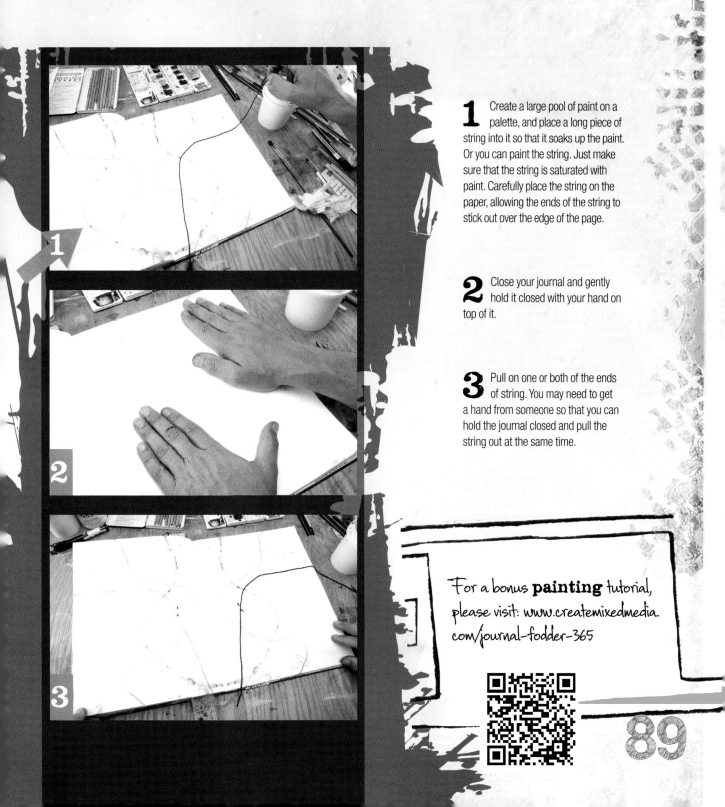

1 Create a large pool of paint on a palette, and place a long piece of string into it so that it soaks up the paint. Or you can paint the string. Just make sure that the string is saturated with paint. Carefully place the string on the paper, allowing the ends of the string to stick out over the edge of the page.

2 Close your journal and gently hold it closed with your hand on top of it.

3 Pull on one or both of the ends of string. You may need to get a hand from someone so that you can hold the journal closed and pull the string out at the same time.

For a bonus **painting** tutorial, please visit: www.createmixedmedia. com/journal-fodder-365

SOLVENT MARKER TRANSFERS WITH A PHOTOCOPY

Make multiple photocopies of images and precious fodder to use throughout your explorations, and enlarge or shrink the images for different applications, such as solvent marker transfers. Just like packing tape transfers, these transfers provide a quick and easy way to transfer images into your work. This technique only works with a toner-based image, and works equally well with small black-and-white or color images that have been photocopied or laser printed. A word of caution: Although labeled AP non-toxic, Chartpak Blender markers contain volatile solvents and should be used in a well-ventilated area. It may also bleed through several pages, so consider putting a blotter paper behind your working page to limit accidental transfers.

tip

This technique may not work with other brands of blender markers. Also, this technique is labor intensive, so limit the size of the image to something smaller than your hand.

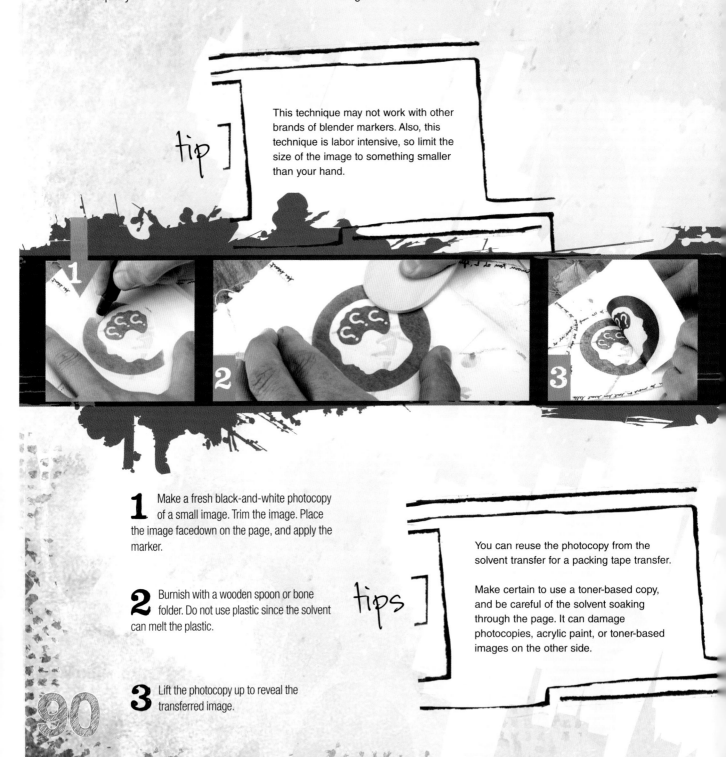

1 Make a fresh black-and-white photocopy of a small image. Trim the image. Place the image facedown on the page, and apply the marker.

2 Burnish with a wooden spoon or bone folder. Do not use plastic since the solvent can melt the plastic.

3 Lift the photocopy up to reveal the transferred image.

tips

You can reuse the photocopy from the solvent transfer for a packing tape transfer.

Make certain to use a toner-based copy, and be careful of the solvent soaking through the page. It can damage photocopies, acrylic paint, or toner-based images on the other side.

COMPULSIONS AND OBSESSIONS: SHADOWS AND OUTLINES

As you hone in on your dreams, bring them to the forefront by finding new ways to embellish, decorate and emphasize your writing and your words. Create outlines around letters as a way to establish your commitment and your intention to a dream. Use shadows to make the words pop off the page and bring special notice to them. Change up the materials by using a variety pens, markers and colors to open up more possibilities.

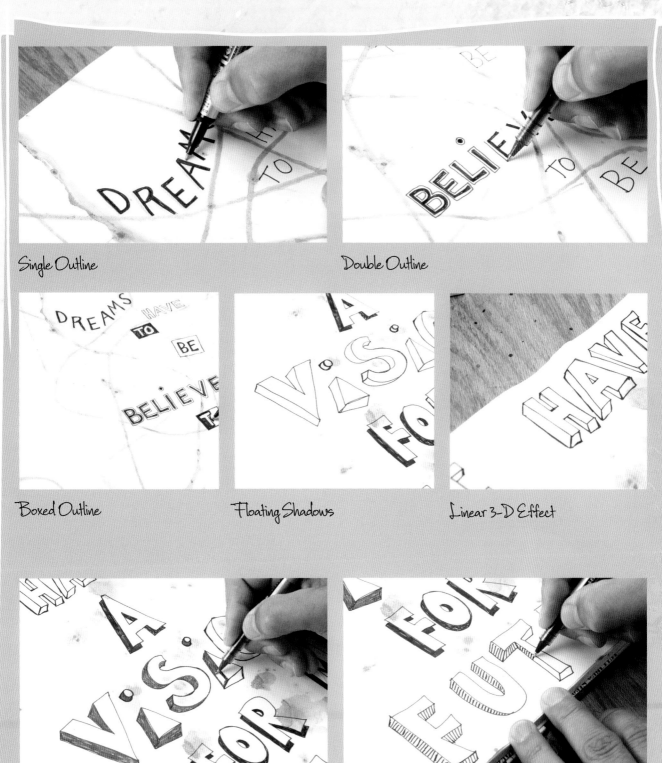

Single Outline

Double Outline

Boxed Outline

Floating Shadows

Linear 3-D Effect

Filled 3-D Effect

Embellished 3-D Effect

OBSERVATIONS: DREAMS

Spend some time as an outside observer of your dreams—not just your nighttime visions, but your big, life-altering hopes and aspirations as well. Be objective and detached as you look at the reality of your goals. You may be dreaming of the day that you hit the multimillion-dollar lottery, but those odds are stacked against you. But there is so much that is within your reach. You can still dream big, but you have to be able to see a viable way to obtain that dream. As you contemplate your future, set the logical steps for reaching and attaining your goals. Be realistic and honest with yourself. What are you dreaming about? Are they "pie-in-the-sky" dreams, beyond all hope of being reached and fulfilled? Are they realistic and plausible? How can you proactively lay out the steps that you need to take?

EXCURSION: VACATIONS AND WEEKEND GETAWAYS

Dreams are never nearer the surface than they are when we get away from our normal lives. It is easier to get in touch with our hopes, our aspirations and our dreams when we are on vacation. How many of us have given serious consideration to living at the beach as we lounge and relax near the surf, or to being a river guide as we canoe down a lazy river? You and your journal deserve a vacation or, at the least, a weekend holiday. Even if you don't have it planned for this month, the next time you take a trip, tuck your journal and some favorite materials in your luggage. Document not only your travels, but also your thoughts as you distance yourself from your daily routine. Pay attention to where your thoughts drift and to the daydreams that sneak in. Listen to and record your feelings during these times away when you are closer to your visions and dreams.

ANATOMY OF A JOURNAL SPREAD

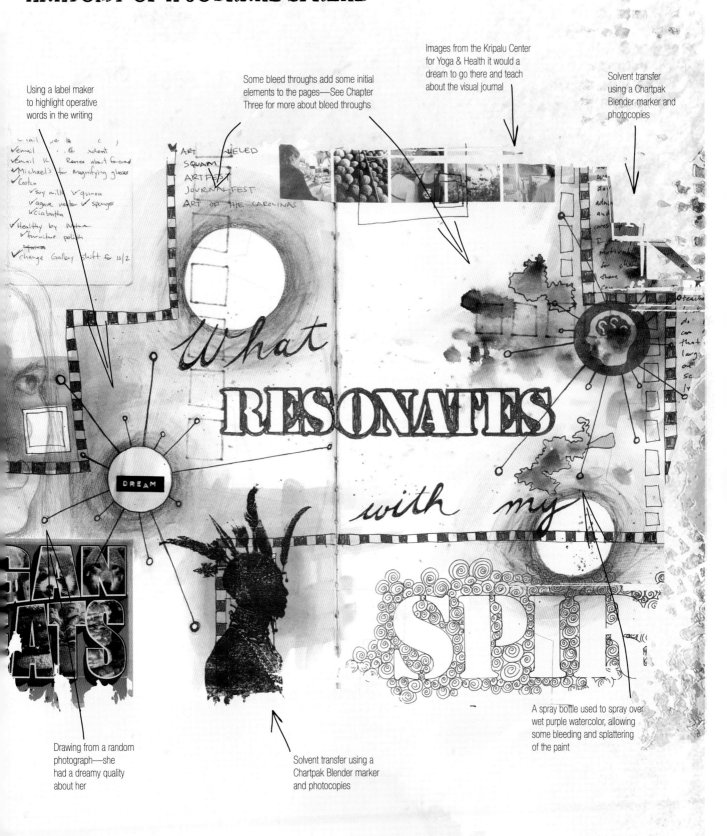

Using a label maker to highlight operative words in the writing

Some bleed throughs add some initial elements to the pages—See Chapter Three for more about bleed throughs

Images from the Kripalu Center for Yoga & Health it would a dream to go there and teach about the visual journal

Solvent transfer using a Chartpak Blender marker and photocopies

Drawing from a random photograph—she had a dreamy quality about her

Solvent transfer using a Chartpak Blender marker and photocopies

A spray bottle used to spray over wet purple watercolor, allowing some bleeding and splattering of the paint

Closing Thoughts

As you go through your days, allow the journal to be a place where you can hope and dream. Too often, your dreams get pushed back due of everyday survival and coping needs. The journal can allow you to bring them to the forefront as you start setting your intentions and living the dream.

GATHER YOUR FORCES: SYMBOLIC IMAGES—EVERYDAY SYMBOLS, LOGOS AND PERSONAL ICONS

To begin thinking about symbols, gather those corporate and product symbols that speak to you, and find the logos of the brands that you own and use. Perhaps you are a "Mac guy," and you just don't understand PCs. Perhaps, you are a "Honda girl" and you've never owned another kind of car. Are you loyal to brands? What do these symbols and brands say about you? What are you saying with them? Collect tags, stickers and images that contain the symbols that are important to you.

What about your own personal symbols or icons? Do you identify with your car, your house or your pet? In what other ways do you identify yourself? Gather your own photographs and drawings with the sole intent of transforming them into symbols. Take ownership of anything to use that can represent you.

Symbolically Speaking

With our first symbolic language, we learned and expressed ourselves as we drew pictures to tell stories and used pictures to learn our first letters and words. Later we began learning through more defined and specific symbols known as letters and words. We now use these symbols, both images and letters, to communicate our ideas, reactions and emotions. We take complex issues and ideas and reduce them to simpler terms, and we make better sense of our world and convey that to others in symbolic ways that are easier to grasp and read. How are you using your symbolic language?

Symbols surround us in other ways, and we confront them every day. Every company and brand has its logo and symbol (think of Nike's swoosh or Apple's bitten apple), and we use these logos and symbols to say something about ourselves as we adorn our bodies with clothes and our homes, offices and garages with products. What are you saying about yourself with the brands that surround you? Other symbols are designed to be universally recognizable and easily remembered, and they provide us with quick and important information. Think about the street signs that guide us and warn us, the buttons and icons on our computers and cell phones, and the signs in the airport that keep us moving in the right direction. All of these symbols help us stay safe as we maneuver in our environments. What symbols do you encounter daily? How do they direct and impact you?

When we first started making art, we most likely used cliché images or mimicked other people's symbols. We appropriated and repeated them in our own art because they appealed to us and helped us tell our stories. But if we keep using these images and symbols and never develop our own, we are just copying and not innovating. If it's not your symbol, why are you using it? How can you invent your own, authentic symbols without resorting to mimicry or cliché? Pay attention to the lines, shapes, colors and images that keep coming up in your journal, and discover the visual markers that have significance for you. Develop your own symbolic language and codes to help you understand the movement of your life.

STRATEGIC PLANNING

It might be difficult to think symbolically about your life because it's not something that you consciously do every day. The prompts in this chapter help you think about the ways that you see, describe and identify yourself. When you begin to think metaphorically about your unique characteristics, it allows you to create your own personal codes and meaningful symbols.

WRITING PROMPT 1: *Attributes*

What are your key attributes and characteristics? In order to invent our own symbols, we must understand how to give visual representation to the attributes and the characteristics that are most important to us. Companies attempt to communicate a deliberate message or a particular feeling with their logos. Many of these symbols have been reworked and redesigned over the years to covey new and different directions. Begin to look at your own attributes and characteristics that signify an important aspect of who you are. Imagine that you are the product. How do you want to be represented? What do you want to communicate? What defines your personality? Are you strong or creative or clever or shy? How would you symbolize that?

WRITING PROMPT 2: *Twilight Imagery*

What are you focusing on and trying to bring into symbolic form? Often it is difficult to find and select the symbols that most represent us and the changing conditions of our lives, but using a technique that allows you to tap into the symbolic nature of the unconscious is a place to start. Developed by Ira Progoff for his Intensive Journal workshop, twilight imagery is a state between waking and sleeping that allows you to quiet your mind as your unconsciousness directs the imagery and symbology.

Sit in a quiet space and close your eyes, allowing yourself to slowly relax into the stillness. Focus on one aspect of yourself or your life. Perhaps it is a dream or a fear. Perhaps it is your job or your personality. Try to feel that aspect with your whole being, but don't try to control or direct your thoughts. Allow the general sense of this concern to pervade you as dreamlike images and ideas begin to float and form. When an idea is formed enough to be identified, record what you "see" in your journal or on a piece of paper. Don't elaborate. Get just the essentials. Close your eyes and return to that state, and keep recording your visions. What emerges from your twilight imagery? What forms, scenarios and emotions are stirred? How can you use these as symbolic forms for you and your life?

WRITING PROMPT 3: *Moods and Emotions*

What metaphors about your experiences and emotions speak to you? We have an innate sense to communicate and understand emotions visually, and our language is full of these visual allusions. To be sad is to be blue, and to be angry is to see red. If you are depressed, you are said to be in a deep hole or hitting bottom. If you're excited and ecstatic, you are said to be sky high or walking with your head in the clouds. Begin to make conscious connections between your emotions and visual representations. It is easy to get caught up in the clichés, so be original with your thoughts and your words. Steer clear of these tired old sayings. What moods or emotions define you? Are you exuberant and cheerful? Are you pessimistic and glum? What are your prevailing emotions? What colors and images resonate with you and say something about your personality and your feelings?

WRITING PROMPT 4: *Personal Symbols*

What are the symbols that signify your life? Lines, shapes and images that we use repeatedly hold significance for us even if we sometimes don't know why. Perhaps there is something within in these recurring marks that is symbolically speaking to us. Look back through your journal, and pay attention to the things that you return to time and again. Begin to identify your lines, your shapes and your images. If you have appropriated someone else's symbols and images (fairies, clocks, angels), ask yourself, "Why?" What are you drawn to in them, and why do you cling to them? What images, colors, lines and shapes do you keep repeating? What do these forms say about you?

WRITING TECHNIQUES: *Similes, Metaphors and Analogies*

As you draw out your attributes and begin to think more symbolically, several writing techniques can help you a great deal in developing your own iconic language. Think back to high school English class, and remember the differences among simile, metaphor and analogy. A simile is a simple comparison between objects using "like" or "as." Dave is like a bear. Eric is as slow as a sloth. A metaphor is a comparison made by saying that one thing is another thing. Dave is a bear. Eric is a sloth. An analogy goes much further and provides more detail and more information. In some ways it begins to explain the metaphor or simile. Dave is like a bear because he can be grumpy first thing in the morning. With these comparisons, you connect concrete, visual representations to abstract ideas and characteristics. Given the above example, a bear might become a symbol for Dave. What comparisons can you develop for yourself?

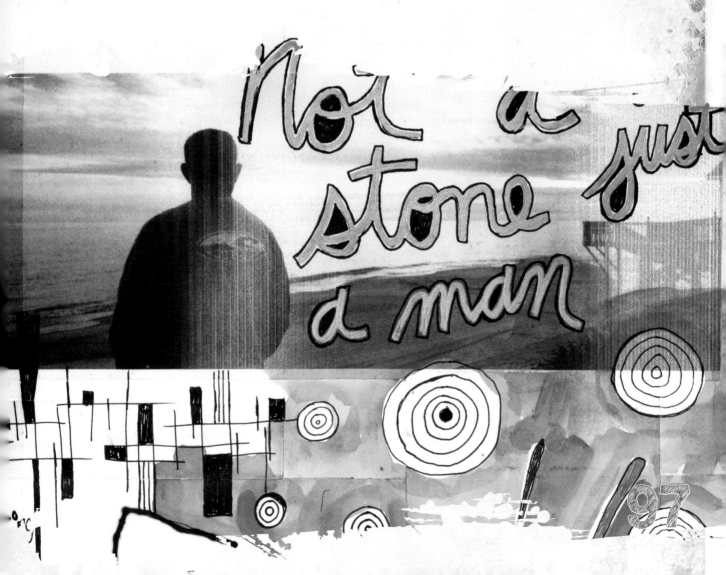

UTILIZING YOUR RESOURCES

Now that you have thought about visually representing the symbols that can identify you and your life, begin to develop your own symbolic language. Use some of your own images and color choices as you explore your personal iconography.

→ DRAWING

DEVELOPING SYMBOLS

Developing symbols might be as straightforward as using a visual metaphor, such as a bear representing Dave, but more often our symbols sneak up on us. We are drawn to certain shapes and marks that consistently show up in our work. At first, these marks may be mere whims, but we habitually come back to them again and again. These visual elements hold a lot of potential for you as a source for developing your symbols. What do they mean to you? What do they say about you?

Another way to develop personal symbols is to use your own photographs. Perhaps a photo of your dog, your car or your house can be used to personalize the process and make icons that are authentic to you without appropriating them from others. Avoid using images and symbols from magazines and the Internet. These are not yours, but with a little work, you can transform your own images into archetypes to be used again and again in your work.

You will need a physical print of your photograph and access to a photocopier for this technique.

Look it up

See Angeles Arrien's *Signs of Life: The Five Universal Shapes and How to Use Them* to learn about the meanings of five common shapes: the circle, the square, the triangle, the spiral and the equidista cross, and how to apply them in your life

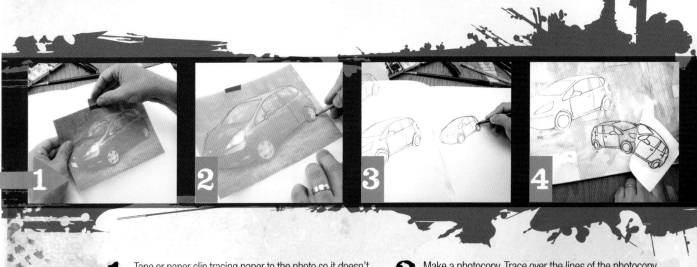

1 Tape or paper clip tracing paper to the photo so it doesn't shift around.

2 Trace the photo onto the tracing paper.

3 Make a photocopy. Trace over the lines of the photocopy to make them more solid and thicker so this copy can be copied many times.

4 Use the tracings for transfers, collage and stenciling.

STENCILS

CUTTING YOUR OWN STENCILS

As seen already, stenciling is a convenient way to add text to your journal, but it is also an effective way to include shapes and images. Craft and office supply stores have a multitude of shape and letter stencils that can be used for a wide range of applications that you can adapt to your work. But these have been designed and created by someone else, and you can be much more inventive. Have you thought about making your own stencils? Using one of the photocopied images, you can create your own stencil to use repeatedly. You can even cut your own letter stencils to personalize the drawing of letters and words. For alternative ways to create stencils, search the wealth of ideas and tutorials online.

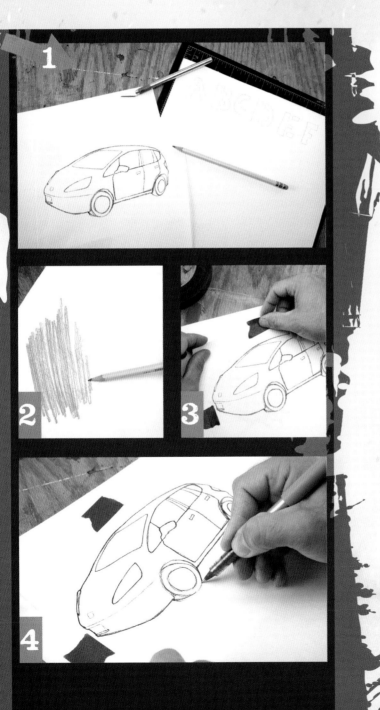

1 Create a design on a thin piece of paper—printer paper works well. You can draw simple shapes, patterns, or even your own letters. You can also use a photograph printed from the computer. Look up stencil making on the Internet for more detailed information about creating a stencil from a photograph.

2 Use a regular pencil or a soft drawing pencil—a 2B or 4B works well—and cover the entire back of the image with a dark layer of graphite. This will allow you to transfer your image to a thicker piece of paper or cardstock.

3 Paper clip or tape your paper to your stencil paper or cardstock. Make certain to use a stiff material. Poster board, cardstock and old file folders work well.

4 Use a ballpoint or rollerball pen to trace your image. Press hard enough to make certain the graphite transfers onto the stencil paper.

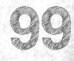

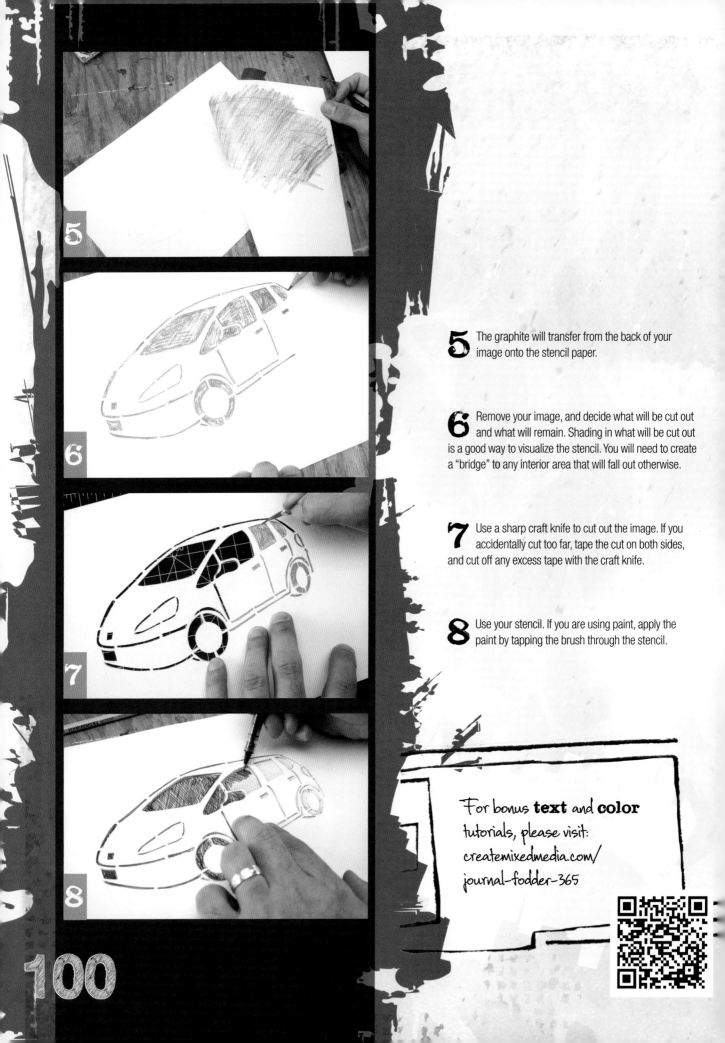

5 The graphite will transfer from the back of your image onto the stencil paper.

6 Remove your image, and decide what will be cut out and what will remain. Shading in what will be cut out is a good way to visualize the stencil. You will need to create a "bridge" to any interior area that will fall out otherwise.

7 Use a sharp craft knife to cut out the image. If you accidentally cut too far, tape the cut on both sides, and cut off any excess tape with the craft knife.

8 Use your stencil. If you are using paint, apply the paint by tapping the brush through the stencil.

For bonus **text** and **color** tutorials, please visit: createmixedmedia.com/journal-fodder-365

COMPULSIONS AND OBSESSIONS: STYLIZED OBJECTS

Stylized images and objects offer you an alternative to universal symbols and common clichés. If you are uncertain, begin with some of the images—the trees, faces and houses—that you drew as a child, but push yourself to be more original, to develop your own symbols for these objects by looking at the actual objects and simplifying them. Try some of the examples shown below and invent some of your own.

Stars

Trees

Figures

Clouds

Houses

OBSERVATIONS: LOOKING AT OBJECTS

When was the last time that you really looked at the objects around you? We look at objects every day, but true seeing and observation go beyond these shallow glimpses. When you carefully consider the visual information inherent in an object, you see it as it truly is. What does your car really look like? What is the shape of the tree in your front yard? Carefully examining an object or scene slows you down and allows you to appreciate your world more. Look carefully at the objects that fill your world. What objects and items do you surround yourself with? What do these things have in common, and why have you selected these things? What do they say about you? What are you trying to say with them? Record your observations in the form of writing or observational drawings.

EXCURSION: TAKE YOUR JOURNAL TO A MEETING

Most of us have to sit in a meeting at some point or another. For many it is a routine part of our jobs, and for others it is a rare occurrence. Find a way to take your journal to a meeting. Perhaps it's a conference with your child's teacher or a session with a financial adviser. Maybe it's a general staff meeting at work or a get-together of a book club. What better way to document the encounter? Before the meeting write questions and concerns you have. During the meeting, take notes and find ways to incorporate symbols and drawings to make the notes visual and more memorable. Highlight key ideas and important issues with color or various materials. How was this experience different than previous meetings? How did you feel? Were you nervous and apprehensive? Were you asked about your journal? Did you get unexpected or even unwanted attention from others?

ANATOMY OF A JOURNAL SPREAD

An analogy comparing life to a process of growth gives this spread its theme

Various greens of watercolor paint and watercolor pencil emphasize the theme of Growth

Hand-cut stencils of letters and Eric's wife bring a personal connection to page

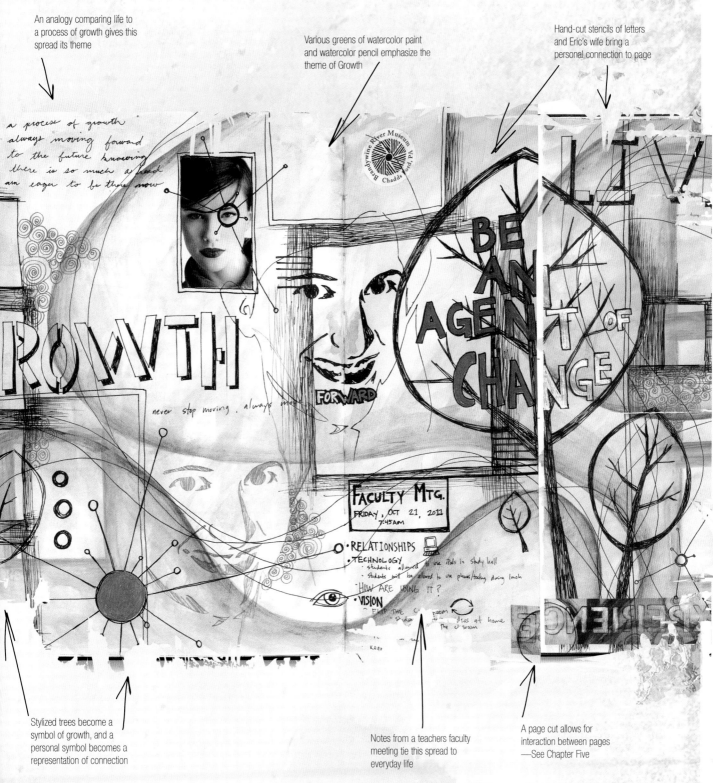

Stylized trees become a symbol of growth, and a personal symbol becomes a representation of connection

Notes from a teachers faculty meeting tie this spread to everyday life

A page cut allows for interaction between pages —See Chapter Five

Closing Thoughts

As you look at the images and ideas that keep popping up in your work and that are becoming a part of your personal visual language, be sure to pay attention to how they might start translating into iconic and archetypal forms of expression. But don't hold on too tightly, because you always want to leave yourself open to additional concepts and new directions.

additional **art**-illery

Along with your basic kit, gather some materials that will help you find quiet and deliberate focus. You want to have the following materials on hand:

a compass for drawing circles
stickers
a graphite pencil
a colored pencil

Deep Breath.
Shoulder Roll.

HOW DID EVERYTHING GET SO HECTIC?
HOW DO I COME BACK TO CENTER?

Life moves quickly, and finding quiet times to sit with our thoughts and reflect on life is difficult. We are pulled in many directions as multiple things jockey and vie for our attention, and life quickly swings out of balance as we get caught in a cycle of overwhelming negativity. But like a circuit breaker, stillness and focused reflections break the connection to these negative and nagging feelings. Quiet moments help us tune out the noise and tune in to our authentic voice as we bring ourselves back to center and feel balanced and grounded. Head to your cave and experience the quiet space as you explore your authentic voice in the context of the journal. Uncover ways that the journal helps you find and keep your balance as you reconnect with yourself.

GATHER YOUR FORCES: IMAGES OF CENTEREDNESS—TOUCHSTONES

Certain images, lines and colors have a resonance for us, and we are drawn to them. An image of a beautiful sunset at the beach conjures up peaceful thoughts as we are transported to that space in our minds, so gather photographs of the tranquil and peaceful places. Certain shapes and patterns act as focal points and allow us to quiet and focus our minds, and images of specific people allow us to reflect on their personal qualities and the impact they have had on us and the world. Find photographs and images of your spiritual heroes and places of sanctuary that inspire and comfort you. Gather stickers as well, but maybe look for stickers with quotes and sayings that can be seen as mantras for focus and attention. We may not be able to fully express why we are drawn to these visual elements, but they can be touchstones for us, a way to bring us back to center, a way to calm ourselves.

STRATEGIC PLANNING

Reflect on the chaos in your life that diverts attention from the important things, and discover how you can take time to get back in touch with yourself. Focus on how you get still, get quiet and go inside. Reach for the quiet states where you can hear your true voice ringing in the silence.

WRITING PROMPT 1: *Breath*

How can you come back to center? Breath holds the essence of life, and without it, there is no life. It also holds the essence of concentration and balance. When focused on our breathing, we attune ourselves to a natural rhythm of the body, calming and clearing our minds. Take a moment to place your attention on your breathing. Sit in an upright and comfortable position. Close your eyes and allow your arms to rest at your side or in your lap. Slowly and deeply inhale, and slowly exhale. Continue this deep breathing, and focus your attention only on this rhythm. Allow your mind to clear and your body to relax. If your mind wanders, let go of the thought, and bring yourself back to focus on your breathing. Once you can no longer focus, rouse yourself, stretch if needed and reflect on the experience. How does your mind and your body feel? How does it feel to be in balance even for a moment? How do you fall out of balance physically, emotionally and mentally?

WRITING PROMPT 2: *Brain Dump*

What thoughts, notions and self-talk block your mind and keep you off balance? In *The Artist's Way*, Julia Cameron encourages the reader to wake early and write three pages longhand every morning. She calls this writing a "brain dump" because it clears the brain of the miscellaneous rabble that prevents productivity. When you feel weighed down with thoughts and there's a lot on your mind, unblock your creative energy with a brain dump. Let the thoughts flow from your mind to the page. When your emotions seem to be too much, dump it all out. Let the anxieties, fears, misgivings and worries flood the page. You don't have to do it every morning, and you don't have to write three pages, just whenever you need it. What is worrying you and causing you anxiety? What thoughts are swirling and flying through your mind? How can you purge your mind?

WRITING PROMPT 3: *Stillness and Motion*

What is it like to slow down and embrace stillness? In our high pace world, we are always in motion with so much to do. Errands pile up and the to-do list just gets longer. It seems that everyone else's priorities have become our own. Emails, text messages and phone calls come flying fast and furious begging for our immediate attention and our prompt reply. We distract and pull ourselves out of balance. But we need to stop moving and get still. We need to surround ourselves with silence, and listen to the quiet. What is causing undue motion, effort and stress in your life? How can you break yourself away from the life that begs for your constant attention and movement? How can you get still?

WRITING PROMPT 4: *Meditation*

How are you reconnecting with yourself? With quiet contemplation and reflection, you put things into perspective and figure out what is important. We get so wrapped up in life that we are pulled from self-reflection. Meditation, whether formal or mere quiet time to ourselves, provides us with a way to reconnect with ourselves. Find the time to sit in quiet meditation or reflection. Perhaps set up a time early in the morning or right before bed where you can build a routine for peaceful introspection. Get in touch with yourself and your thoughts. What elements are most conducive to quiet contemplation for you? Where can you go to get in touch with yourself? How can you find the time, the place and the environment? How can you commit yourself to this alone time?

WRITING TECHNIQUES: *Writing with Paint*

Painting text infuses your journal with another unique visual form of writing, so find ways to use paint to explore words that create your definition of stillness. The techniques and marks you create help you slow down and focus. Consider finding resources on hand lettering, and remember that the size and shape of your brush will greatly affect the shape of your letters. You can use a liner brush to create smooth, flowing script, and you can use a flat brush to create a calligraphy effect. Don't be afraid to experiment with painted text at any stage of page development.

POETRY:

You may not consider yourself a poet, but poetry can capture the essence and beauty of a situation or scene. Investigate a variety of forms to tackle a different way of writing, and don't get caught up in the mechanics and rules of the poetry. Allow the verse to flow like water as you tap into your inner depths. Try some of the types described here, and research some others to give yourself an even wider range of possibilities.

Rhyming Couplets

A rhyming couplet is a set of two lines that end in words that rhyme. This is one of the simplest, most common forms and what many people think of when they hear the term *poetry*. You can leave the poem as a two-line stanza, or you can string together a longer composition from several rhyming couplets. The rhyming scheme can be varied as well to create different rhyming patterns and rhythms.

Haiku

Haiku is a Japanese poetic form that contains just seventeen syllables in three lines. There are five syllables in the first line, seven in the second and five in the third. Although nature is a common subject for haiku, any subject is acceptable. The idea of "cutting," the point where the work is split into two independent yet related ideas or sections, is important. This juxtaposition of ideas brings depth to such a compact poem, allowing the reader to complete the thought of the verse and leaving room for multiple interpretations. Seasonal words are also important in haiku, denoting the time of year. They don't have to be the words *spring*, *fall*, *October*, etc. They can allude to the season, such as *baseball*, hinting at summer, and *snow,* suggesting winter.

Acrostic

Acrostic is poetry where the first letter of each line spells out a word or phrase, and the subject is often the word spelled out. The lines in acrostic poetry can rhyme, but don't need to. Acrostic easily lends itself to visual representation since you want to emphasize the first letter of each line. Embellish and illuminate these letters in a variety of ways to bring them visual importance. Consider using the name of a person or object as a starter.

Delightfully he pulls people into his sphere,
And shares with them the process of the
Visual journal and all of its possibilities.
Impressed with the potential, these converts
Delve into the depths of their soul.

Eager to connect to the world he
Reaches out through all that he does
Instinctively sharing himself, and
Challenging others to expose their vulnerabilities.

Free Verse

If the limits and rules of the above forms are a bit too confining and traditional, try free verse. This more contemporary style lacks a predetermined form like haiku or acrostic and uses no rhyme or meter. However, it retains some poetic form and is usually broken into lines, but these lines can vary in length and cadence.

UTILIZING YOUR RESOURCES

The art techniques this month are geared to help you gain and maintain concentration and find your element. When you let go of the thoughts churning in your mind and focus strictly on the techniques, you fall into the process and find meditation in the marks. Your mind clears as you zero in on the task before you. Yet all the while in the back of your mind, the gears turn and your subconscious mind makes connections, sorts through the chaos, and works through a lot of "stuff." As you work with the art making this month, it is the inner world that is most important, so lose yourself to the mark and feel the outside world melt away.

DRAWING
MANDALAS

The word *mandala* is Sanskrit and means circle, and one form of the mandala is the sacred art form in Hinduism and Buddhism. The concentric design of these mandalas is a visual representation of the cosmos, and they are used as the focus for meditations. Elaborate sand mandalas are sometimes constructed by Buddhist monks during certain rituals and occasions. Although these intricate mandalas take several monks many hours to complete, in the end they are most often swept up and ritually dumped in a nearby body of water as a way to signify and symbolize the impermanence of this world.

Psychologist Carl Jung used mandalas both personally and professionally as a means to access the unconscious. He saw mandalas as symbolizing wholeness and completeness. Like inkblots, the symbols, shapes and colors reveal much about the maker and the potential for growth. The contemplative and methodical practice of creating mandalas quiets and focuses the mind and unconsciously expresses your personality, identity and self. Use lines, shapes, colors, patterns and images to understand your emotions and feelings better as you focus on your own world while you create mandalas.

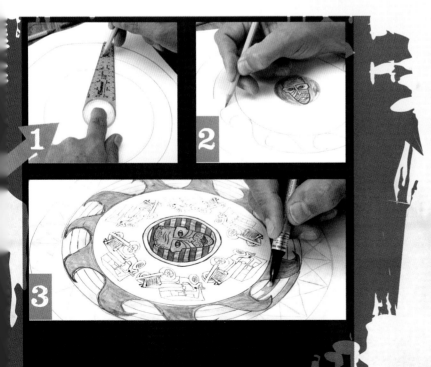

1 Use a compass to draw a series of concentric circles. The Safe-T Compass is easy to use and transport and has no sharp point.

2 Fill each circle or ring with any desired shapes or patterns using any material. You may want to draw with pencil first. Many geometric shapes have very specific symbolic meaning. See Angeles Arrien's *Signs of Life: The Five Universal Shapes and How to Use Them.*

3 If you like, outline your mandala, and then add color to it or layer on top of it.

WASHES

The watercolor wash is a very basic technique usually used to get color on a page as a quick and simple layer. However, we want you to approach it with a different intention as you get very present with the technique. Slow down, feel the movement of the brush, and focus all of your attention and energy on the paint. Just as you focused on the rhythm of your breathing earlier, focus now on the rhythm of the brush. Pay attention to the paint, be very deliberate with your movements as you apply the watercolor. Move slowly but confidently. Don't rush. Allow yourself to get lost in the process.

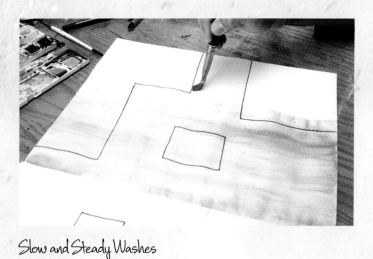

Slow and Steady Washes

PAINTING

MEDITATIVE MARKS

You can also become very meditative with the types of marks you make with pen, pencil, marker and watercolor paint. Enter a quiet and focused state of mind as you work very purposefully with these materials, and push all other concerns from your mind. Draw or paint a line, moving your hand very slowly and methodically, but don't exert too much control. The idea is to slow down, yet allow the motion to flow with confidence. As you draw or paint, focus your attention on repeating small marks and the movement of your hand. If you find your thoughts drifting to other things, take note of this, but let go of the thought so that you can refocus your attention on the materials. The rhythm of repeating marks brings focus and clarity.

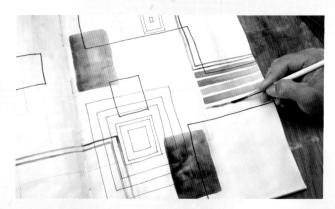

Deliberate Lines and Shapes

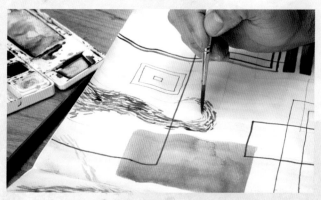

Small Marks

STICKERS

Using stickers is an easy way to collage both the outside and inside of your journal because there is no need for adhesive. It may not be obvious how stickers can aid in calming and focusing the mind, but if you find stickers with images and sayings that speak to this intention, they can be successfully integrated. Perhaps they are spiritual sayings and images. Maybe they can act like mantras and remind you to slow down. If you aren't certain where to place your stickers, pop them into your fodder pocket until you discover an appropriate place for them.

COMPULSIONS AND OBSESSIONS: SHADING AND VALUE CHANGES

Shading is a repetitive action, and as you purposefully overlap your marks and apply the material to create tonal changes, you can reach a very meditative state. Don't think of shading as "coloring" or "scribbling," as these terms conjure images of a little kid scribbling in a coloring book. Shading is a very deliberate attempt to create value change and to add the dynamic illusion of space and three dimensions to the flat journal page. Objects, letters and shapes begin to pop out from the page, float above the page or appear buried within the page. Take some time this month to slow down and focus on using shading and value change as a means to create the illusion of depth and space, and as a way to reconnect with stillness.

PEN AND PENCIL

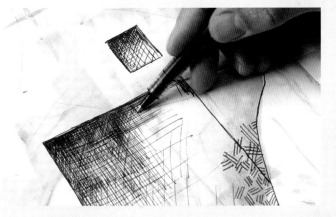

Shading with Ink—Pen and Marker
To lighten the value with ink, increase the amount of space between your marks. The closer and tighter the marks, the darker the value will appear. The further apart the marks, the lighter the value will appear.

Shading with Graphite and Colored Pencil
Allow the value of the pencil to change by the pressure you use. The more pressure you use, the darker the value. So as you shade, lighten and increase your pressure to change the value.

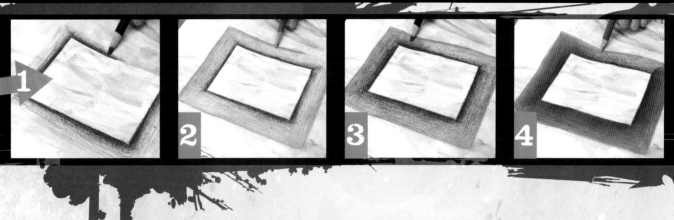

1 Create a value change with a colored pencil, shading from dark to light with one color and varying your pressure.

2 Use a second color to shade from dark to light in the opposite direction, allowing the new color to overlap the first.

3 Use the first pencil to apply more color, overlapping where you've already shaded. This creates a better transition.

4 Do the same with the second color, but apply more pressure so that the colors blend together, creating a smooth transition from one color to the other. This technique is known as burnishing.

OBSERVATIONS: OBSERVING THE STILLNESS

What does stillness feel like? As you find the time and commitment to get still, get quiet and go inside, observe your reactions to these attempts, and take notice of your feelings. How does quiet envelop your body? What is it like to stop moving and turn off all the noise? Note the reactions and feelings of others as you try to free some quiet time and space. Do they feel isolated or ignored? Do they want to gobble up your time? Reflect on how you deprive yourself of this much needed time. What is your biggest struggle as you try to have less movement and more stillness?

EXCURSION: SUNSET OR SUNRISE

Sunrise and sunset are magical times of the day, and many poems and songs have been written about these ethereal events. Make a date with the sunrise or sunset, and take your journal along. Record your observations, thoughts and impressions. Be in the moment, and witness the sun as it slowly ascends or descends in the sky. Linger for a while and witness the sun engaging the horizon as the world is waking up or going to sleep. What do you notice? What do you feel as you sit there? What thoughts flash through your mind? How can you melt into the sun rising or setting?

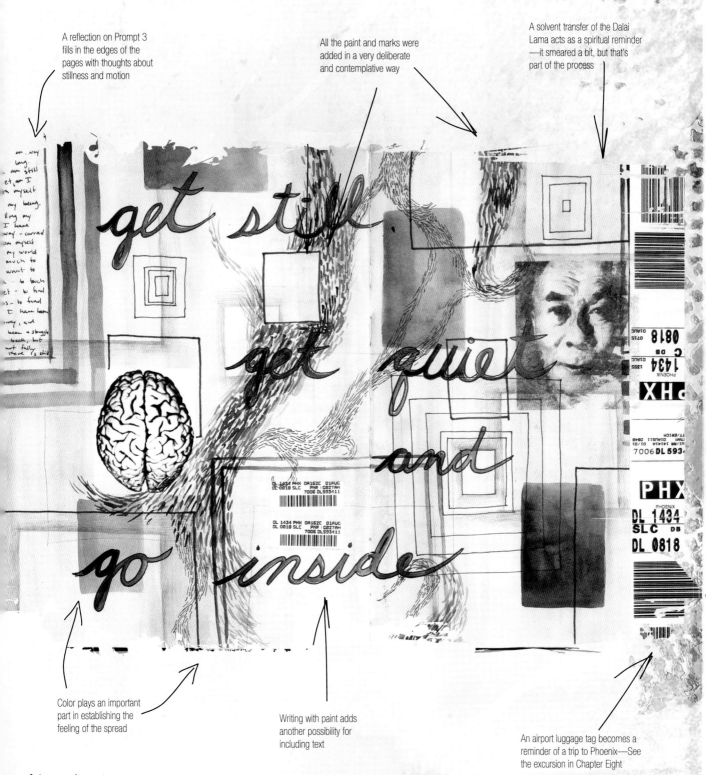

A reflection on Prompt 3 fills in the edges of the pages with thoughts about stillness and motion

All the paint and marks were added in a very deliberate and contemplative way

A solvent transfer of the Dalai Lama acts as a spiritual reminder —it smeared a bit, but that's part of the process

Color plays an important part in establishing the feeling of the spread

Writing with paint adds another possibility for including text

An airport luggage tag becomes a reminder of a trip to Phoenix—See the excursion in Chapter Eight

Closing Thoughts

As you deal with the noisy world that demands your attention, finding the time and place to be yourself can be daunting. Just as you make space for yourself to get to the gym or enjoy a cup of coffee, you need to carve out alone and quiet time. Don't feel selfish about proclaiming a need for this solo space; just find the time and space to allow the journal to establish quiet and concentration—to establish a refuge. Learn to embrace the quiet as you work and get to know yourself again.

THE PERSONA

The mask, conformity, facade, get along with people. Some inflate the persona and get away from their true selves.

THE EGO

THE SHADOW

THE ANIMA/ANIMUS

Helps understanding of the opposite sex.
man: his feminine side - Anima
woman: her masculine side - Animus
unconsciously projected onto opposite sex

THE SELF

who we are - all that makes us

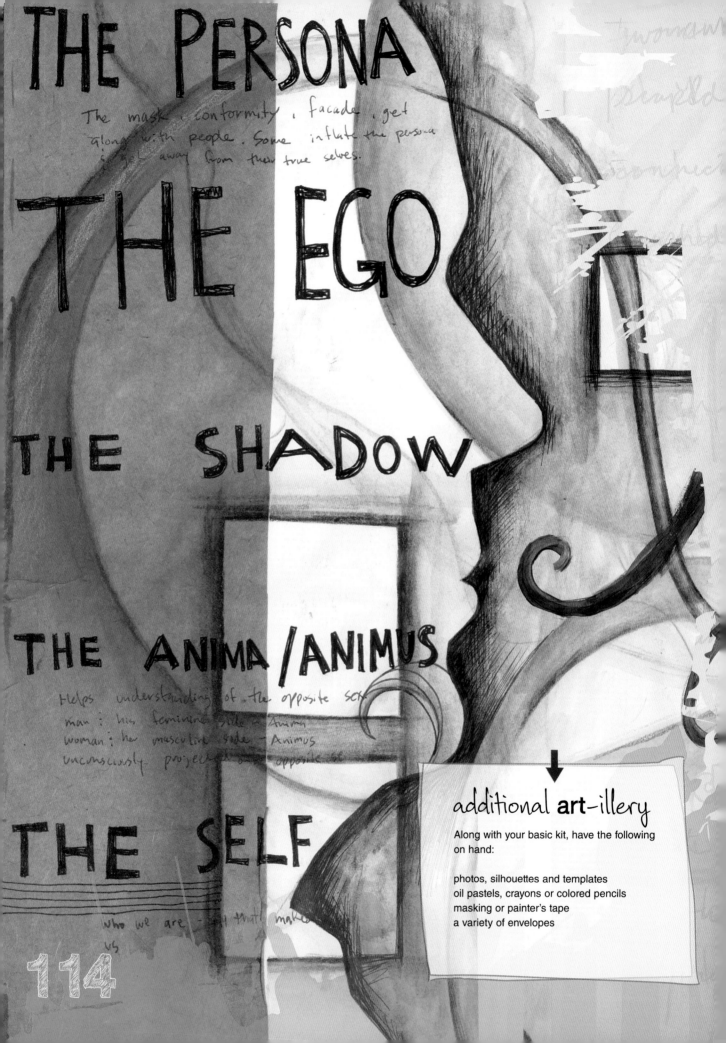

additional art-illery

Along with your basic kit, have the following on hand:

photos, silhouettes and templates
oil pastels, crayons or colored pencils
masking or painter's tape
a variety of envelopes

Owning Your Shadow

We must take ownership of our lives, chart our own course and proclaim who we are. If we don't step up and define ourselves, we answer to the definitions created by others. We learn from an early age to celebrate our victories and accomplishments and to ignore our defeats and downfalls. By no means should we dwell on these negatives, but we need to recognize them as opportunities for growth and come to terms with them so that we can move forward. We must accept our responsibilities and hold ourselves accountable, but we must also find personal strength for overcoming our obstacles.

In his book, *Owning Your Own Shadow*, Robert Johnson discusses how we all have darkness and light within our psyche. In the darkness, we find the things that society frowns upon and says are wrong. In the light, we find things that society deems proper and says are right. We tend to bury the negative things that we don't want people to know about (the dark) and share the positive things that will make us stand out (the light). Do you agree with what is socially acceptable, *normal* and right? Do you agree with what is deemed taboo, socially unacceptable, *abnormal* and wrong? Are you defining yourself? Or are you being defined by others? Embrace all aspects of yourself, especially as you look into your vulnerable recesses, and shine light on the things you wish to hide. There is strength in your shadow, so discover what you are hiding there.

GATHER YOUR FORCES: IMAGES OF CITATION—LEARNING TO SHINE

Although we learn to let the positive shine, our culture frowns upon those times when we toot our own horns a little too loudly, and many of us prefer to stay under the radar. We are taught that it's vain, arrogant and sheer bragging and that others see us as self-absorbed or egocentric when we seek such attention. It's okay for someone else to recognize us with some kind of accolade, but we don't go out of our way to seek the spotlight. However, we need to learn that it is all right to shine. We all have aspects of our being that are worthy of such notice. As you formulate your pages, look for things that document and honor the highlights, accomplishments and milestones in your life. What are you most proud of? What are the milestones you wish to celebrate? What images, fodder or memorabilia honor your accomplishments?

STRATEGIC PLANNING

Stop hiding, get out there and confront the issues that are involved in your life. No doubt some are good and some are bad, but they need your attention. We construct defense mechanisms and develop ways to cope with the parts of ourselves we don't wish to face.

Approach these concerns head-on in your journal. Honor the light and the dark, track down the daily dilemmas and forge ahead using your creativity as your fuel.

WRITING PROMPT 1: *Hidden Spaces*

Where are the spaces that you tuck away the secrets of your life? We all hide various aspects of ourselves, and we squirrel away our secrets. Some of our hiding places are psychological, like "in the back of our mind" or "deep in our hearts." Some are physical, like a dresser drawer or an old shoebox. As difficult as it can be to enter these spaces and face the secrets, we must find the energy and willpower to dig through the darkness that dwells there. Find the gold buried there, and leave what needs to be left behind. Identify your hiding places and hidden spaces so that you can examine the contents of your shadow. Are these safe spaces or dangerous spaces? Is there pride or shame hidden in these places? What are you hiding in your secret spaces?

WRITING PROMPT 2: *Dark and Light*

What do you expose to the light, and what do you hide in your darkness? We have stories that we tell ourselves and different stories we tell others. Some stories are perpetuated when we tell them over and over again, and others are buried when we tell only certain people. Some of these stories paint us in a positive light and others in a negative light. We all have shameful tales of loss, mistake and embarrassment, as well as triumphs that fill us with a sense of accomplishment and pride. Give adequate time to explore both the dark and light aspects of your experiences. What are your glorious victories? What are your agonizing defeats? Do you give these events equal attention? What stories do you perpetuate? What stories do you bury?

WRITING PROMPT 3: *Standing in Your Shadow*

Who is standing in your shadow? There are people we overshadow and outshine as if life were a competition. It might be a sibling, a colleague or even a spouse, and these people quickly get lost even though they are important parts of our lives. In order to understand both the dark and light sides of our lives, we must make ourselves fully aware of who is hidden in the shadows. Examine the events of your life to see how you have stepped on others or stolen the spotlight that wasn't rightfully yours. By recognizing these moments and seeing clearly who was in your shadow, you are able to see both sides of the issues and see how you shine at the expense of others. What are you most proud of in your life? Did you outshine others at the time? Who do you need to lift out of the shadows? What can you do to pull them into the limelight and show them how important they are?

WRITING PROMPT 4: *Owning Your Shadow*

How can you fully embrace both the light and the dark? When we find peace with the ups and downs we have experienced, we fully assimilate our light as well as our shadow and lead a thoughtful life. There is always conflict, and we always have to make decisions and often choose sides. But if we strive to be fully aware and make the best of our choices, we discover we have the power to be more accepting and tolerant. Recognize the darkness you have inside, the fear, the secrets and even the gold, and reflect on how you can embrace all aspects of yourself. In what ways do you deny your darker parts? What are you hiding in your shadow, and who are you hiding it from? What gold do you have buried inside of you? How can you own your shadow and define yourself?

WRITING TECHNIQUES

Just as we break down and deconstruct the two sides of the psyche, we can look for ways to dismantle and deconstruct our writing. Examine how you can take the writing apart and build it back into a new form. Perhaps tear the writing apart, cut it into strips, break it into a puzzle or cut out individual words. Also, look for ways to treat the text like an image, and bring the text into the realm of a graphic device. Explore embellishing your writing with paint, marker and pen as a way to pack more punch into your words.

DISMANTLING TEXT

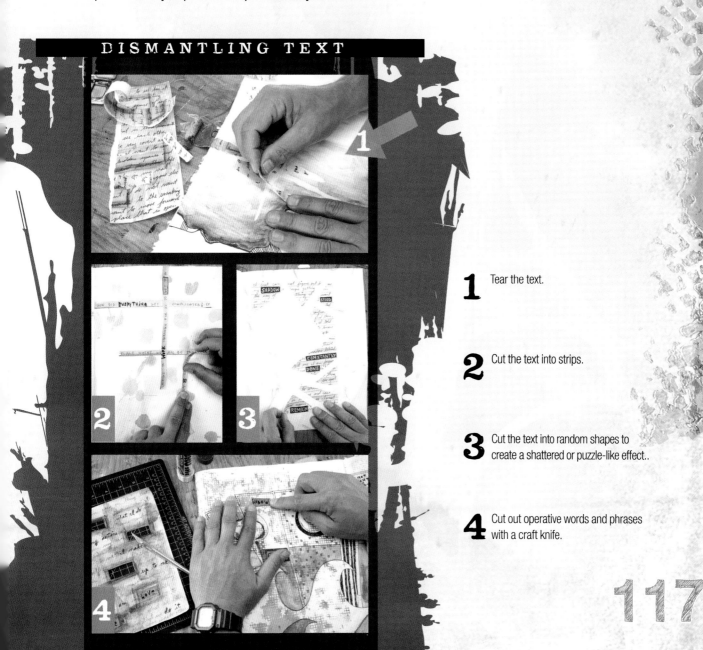

1 Tear the text.

2 Cut the text into strips.

3 Cut the text into random shapes to create a shattered or puzzle-like effect..

4 Cut out operative words and phrases with a craft knife.

UTILIZING YOUR RESOURCES

How do the materials and processes we work with define who we are? Consider the metaphoric nature of the images, techniques and media you employ as you reflect on shadow, light and dark. Explore how the material quality of your resources communicates and defines who you are, and examine both the light and the dark side of line, color and images. Figure out how to embrace your shadow and make your light shine with the materials you use.

→ **DRAWING**

IN YOUR SHADOW: SILHOUETTES AND TRACINGS

As human beings we cast many shadows, some are more literal and some more abstract in nature. Examine the different features of your body as means for creating images and tracings. Think about using your hand, your entire body or just your profile. You can easily make "shadows" within your pages by using photographs or photocopies to create templates to trace by cutting out the silhouette of the object or person you want to trace. What other forms or structures exist in your world that cast shadows or have distinctive contours? How can you bring these concepts into your pages?

Profiles

Hands

Figures

Houses

PAINTING

Some parts of life are well-earned achievements while others are failed attempts. We tend to show off the positive and hide the negative. Use resist painting to call attention to things that you want to emphasize, and experiment with painter's tape to block out or mask off areas as a means for creating interesting spaces as you explore the ideas of shadow and light.

WATERCOLOR RESIST

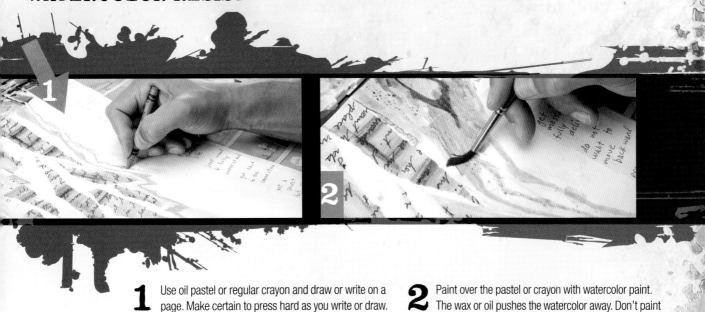

1 Use oil pastel or regular crayon and draw or write on a page. Make certain to press hard as you write or draw.

2 Paint over the pastel or crayon with watercolor paint. The wax or oil pushes the watercolor away. Don't paint over the same area too much or the color could work in under the crayon or pastel.

rlying turbulence

one part research and one part paranoi

HOUETTES = avoidance of the subj

CONVEYING FACTS

MASKING

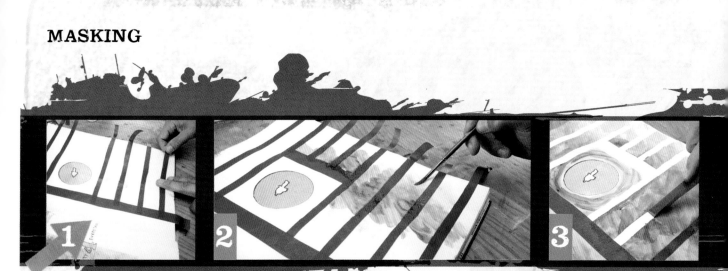

1 Using painter's tape, create a design on a page.

2 Paint in the spaces with watercolor.

3 Remove the tape. Be careful as you remove the tape so that you do not tear the paper. The paint might bleed under the tape, but that's okay!

ENVELOPES

Many times, there are events or issues that we wish to ignore, cover over or block out, hoping that they will simply go away. Despite the pain, embarrassment or discomfort, we must confront these problems. You may resist directly engaging these dark spaces in your journal, but the images or writing you create will help you work through your concerns. As a way to contain, hide or seal away these troubling matters, even from yourself, glue some envelopes into your journal to create safe places. The envelope provides a creative way to include these matters in your work without exposing more than you are ready for others to see. You can even use envelopes as special pockets for cherished images, writings and fodder.

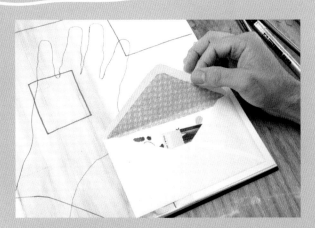

Glue an envelope in flat to create a pocket with a flap.

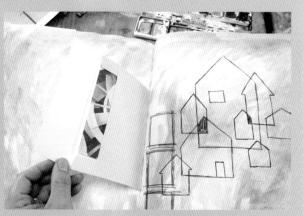

Glue an envelope by the edge into the center of the journal.

Use translucent envelopes. One is glued in with a tab of red construction paper, and the other is glued flat to the page.

COMPULSIONS AND OBSESSIONS: EAVESDROPPING

We don't always do it intentionally, but we can't go into the office, local coffee house or supermarket without overhearing the conversations of others. Eavesdropping is another form of research and note taking, and if you pay attention, you just might hear a great quote or story that inspires an interesting idea in the writing or drawing you might be working with in your journal. Pay attention to the conversations that are occurring around you. You never know what pearl of wisdom, bizarre phrase or funny anecdote you might hear.

OBSERVATIONS: LOOKING AT SHADOWS AND FINDING GOLD

Take a closer look at the physical shadows cast by the different objects you encounter in your day. Like the Impressionists, observe the different shapes and tones created by the same objects at different times of the day. How are shadows different when cast by natural light outside versus artificial light when indoors? How are the shadows in the moonlight different from the ones in the sunlight? How is the contour of your own shadow different from the shadow of another person?

Don't limit your observations to literal shadows, though. Think about psychological shadows as well, and explore what you see when you look deeper within these contours. Many times the solutions to the problems we face reside in the scary spaces we try to avoid. If it is true that every cloud has a silver lining, then maybe every dark shadow has the potential to be filled with gold. What positives and potentials are hidden in your shadow?

EXCURSION: TAKE YOUR JOURNAL OUT TO LUNCH

Just like you might with a good friend or coworker, take your journal out to lunch at some point, just you and your journal. Eating alone is an uncomfortable feeling for most people, and you can feel like a social pariah. But does that discomfort come from you or what others expect? Confront the discomfort, and see what lurks behind it. If you're at a fast food place, don't be afraid to open up your journal and use it as a place mat for your meal. You never know what inventive things could come from a drip of ketchup or a splash of coffee.

When you need to throw some trash away, the journal could even work as a tray for carting the trash to the waste can. If you are at a more "sit-down" restaurant, open your journal, and work in it while waiting for your food to arrive. You can occupy yourself instead of fretting about what others are thinking, and you may even invite conversation and interaction as others see what you are doing. How does it feel to eat alone? How does engaging the journal change the experience?

ANATOMY OF A JOURNAL SPREAD

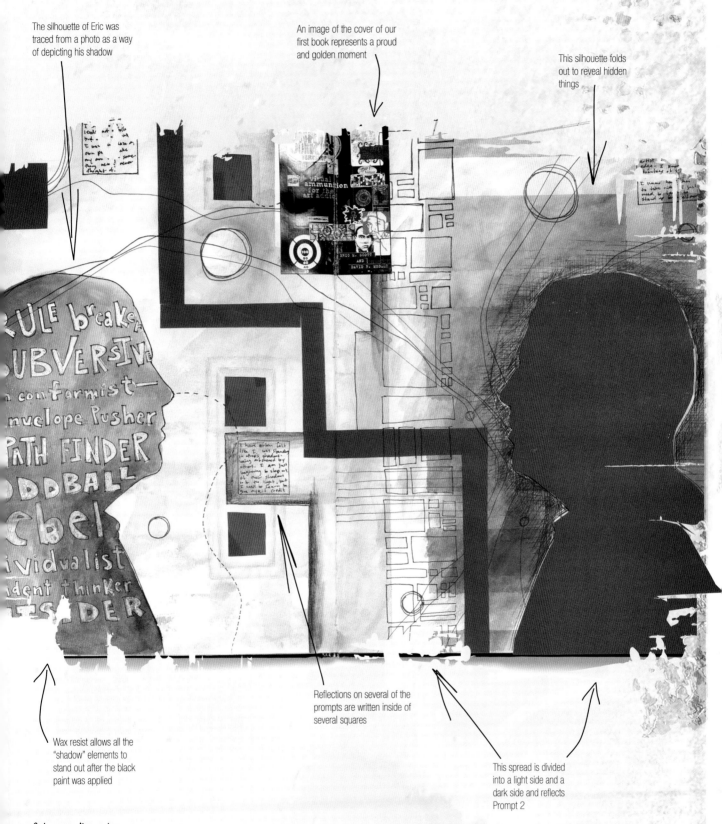

The silhouette of Eric was traced from a photo as a way of depicting his shadow

An image of the cover of our first book represents a proud and golden moment

This silhouette folds out to reveal hidden things

Wax resist allows all the "shadow" elements to stand out after the black paint was applied

Reflections on several of the prompts are written inside of several squares

This spread is divided into a light side and a dark side and reflects Prompt 2

Closing Thoughts

All parts of your life and experiences are worthy of documentation and exploration. Try to remain open to the ups and downs equally, and identify and utilize the highs and lows of your life as powerful conceptual connections for images and text in your work. Don't be afraid to look into the dark recesses, but proceed with caution. There's a lot buried there.

JOURNAL JUNKIES WORKS

VISUAL AMMUNITION FOR THE ART ADDICT

Two artist/educators discuss how their creative collaborations have motivated them to write and publish a book about visual journals and its connection to their scholarly research and studio practices.

semi charmed life

3
4

CONNECT

THE OHIO

GATHER YOUR FORCES: IMAGES OF SHARED HISTORIES— COLLABORATIONS AND FODDER BAG TRADES

Mountains of images and fodder accumulate as we work with the visual journal. Sometimes we find ourselves going back to the same things in our collections, and our growth can plateau as we build beyond continuity and border on being a one-trick pony. Break the monotony, and consider mobilizing your tribe to organize a fodder bag trade. Collect your most common and most utilized, possibly over-utilized, elements in your fodder stash, and fill several zip-top baggies with treasures from your inventory. Meanwhile, encourage others to do the sam, and schedule a time and place to get together to exchange your satchels of surprises. You might be amazed at how someone else's fodder sparks a new direction in your work.

The next time you hang out with someone, why not take it one step further and collaborate on some small drawings? This can be done with just one other person or several other people. A pocket sketchbook, napkin and small pieces of paper are ideal for these collaborations. You can even make it into your own little game and have a time limit for adding to a paper before you move to the next. The results will be diverse, offering some exciting fodder for the pages of your journal. This is a productive way to spend time as you wait for food at a restaurant or as you sit and talk at someone's house.

Seeking Company and Acquiring Accomplices

WHAT IS MY SUPPORT SYSTEM? WHO IS IN MY TRIBE?

This may be the final chapter, but it is not the end of the journey. We all need support and encouragement along the way, so create your network of friends and mentors who influence, guide, inspire and nudge you when the going gets tough. These people are vital to your line of inquiry, offering constructive criticism when you feel too close to the problem to see a solution, and they encourage growth when you feel stuck or stagnant. Identify the naysayers, because these party crashers make you feel like you are just spinning your wheels and going nowhere. They do everything they can to stall your process and do nothing to ignite it. Steer clear of anyone who bogs you down like a stick in the mud, filling your working space with negative energy.

Consider finding some good connections online. Be sure they will generate true discussion about your work, not just offer useless, patronizing praise or empty compliments. Seek accomplices that challenge you, your work and your process. Put yourself in situations and environments where you meet other journal keepers with like-minded interests, and maybe even get involved with a round robin or studio group to meet and share ideas. Start building those creative collaborations that help you maintain your journaling practice and recognize the ebbing and flowing patterns of your process. A journey is much more fun when shared, so look for ways to invite your accomplices along for the ride.

additional art-illery

You will need your basic journaling kit and the following:

a spray bottle
game score cards
extra drawing paper

STRATEGIC PLANNING

Start figuring out who has your back and who is stabbing you in the back, who is dragging you down and who is lifting you up. Allying yourself with motivational people can alter the course of your work, your art and your life. Discover who truly matters in your life.

WRITING PROMPT 1: *Accomplices*

Who are your artistic accomplices and creative collaborators? When we work alone, it is easy to become stagnant and lose motivation. We all need a nudge in the right direction or a pat on the back to keep us moving forward and working through the roadblocks. Think about the people in your life that get your creative juices flowing, and reflect on how your interactions with these people help you and your art-making. Examine the energy-giving forces in your world, and document their contribution to your practice. Just as others motivate and inspire you, find ways that you nudge and spark others' creative endeavors. Reflect on how you return the favor. Who do you turn to when you need some guidance or a bit of motivation? Who are the people who inspire and push your creativity? How do you in turn inspire and motivate others? How do you fulfill your end of the bargain?

WRITING PROMPT 2: *Feeding the Spirit*

How do you feed your spirit? Without proper nourishment, the body grows weak, and we must feed ourselves to maintain our physical health. Our spirit needs nourishment as well, but dealing with the world can run us down, exhaust us and put our spiritual health and mental well-being in jeopardy. We all have a different way of feeding our spirit. For some, it is a certain place that rejuvenates and refreshes us. Maybe it's hiking in the woods, paddling out into a set of double overhead waves or spending time at an art retreat. But it doesn't have to be a place at all. Perhaps it's the people who surround us, the daily phone call or email or the sharing of the ride to work that provides these spirit-feeding moments. It may be our routines and daily rituals that feed our spirit in small, meaningful ways. Possibly it's the morning cup of coffee, the daily crossword, or the comfy sweatshirt that gives us the lift we desire. Whatever the source, experience and recognize the connections you need in order to fill up your tank and keep yourself going. What people, places or things have the power to recharge your batteries? What daily rituals and routines energize you, fill you with purpose and allow you to tackle another day?

WRITING PROMPT 3: *Inheritances and Legacies*

What have you inherited from your past? What are you handing down to the future? Everything we do is built upon the accomplishments, and sometimes failures, of those who have come before us. Think about all that you have been given that has helped you get where you are and keeps you striving to achieve. Consider the artifacts you make and concepts you develop on a daily basis and how these ideas become the foundation for someone else. We all have much to gain from the past and much to give to the future, and if we make the most of every day, we honor that which we have inherited and provide the best of what we leave as a legacy. What objects, artifacts and stories have been handed down to you? What do have to leave behind for those who follow?

WRITING PROMPT 4: *Sharing the Journey*

What have you learned from this journey to share with others? Dan Eldon, our visual journaling inspiration, often said and wrote, "Safari is a way of life," and "The journey is the destination." These mantras speak to the process of our art-making and the adventures we encounter along the way. At times we get so caught up in the destination that we forget the journey. At other times we seem to be traveling all alone and forget to notice who is tagging along. Take the time to share your journey and your wisdom with loved ones, friends and complete strangers. Share your personal insights and outlooks while allowing yourself the opportunity to investigate the insights and wisdom of others. What are the artifacts that document your journey? Who have you invited onboard for your artistic ride?

WRITING TECHNIQUES

How do we engage the company we keep? How much do we really know about them? Collaborative writing builds a strong connection between you and others. If you have ever been engrossed in a conversation with a friend feeling that you finish each others sentences, or that the two or three or four of you never have awkward silent moments, collaborative writing may be a natural fit. Simply decide on a theme, and write something together. Or make it a game, and write one sentence at a time, adding to each other's thoughts as you go. Don't be afraid to collaborate with an acquaintance who you don't know very well because this can be a fun process for forging a new dialogue.

Another approach is to conduct research and gain insight into the lives and artistic practices of others by interviewing them. These discussions don't have to be formal undertakings, so jot down quick notes as you talk about each other's work. Conduct a biographical inquiry or examine their journaling and artistic practice. Think about what you already know and what you want to know. Be open to reciprocating and letting them interview you as well.

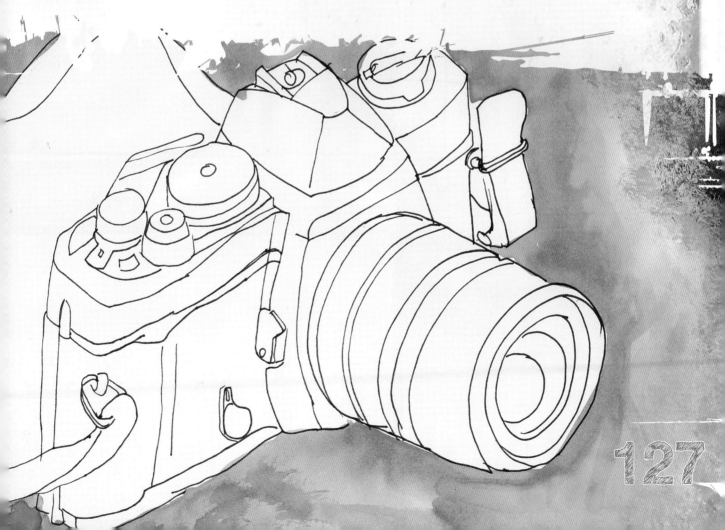

UTILIZING YOUR RESOURCES

Not all of your resources are material ones to be manipulated or glued into the journal. Sometimes they are human resources and come in the wide variety of people you come into contact with daily. They are integral to developing new concepts, exposing yourself to new content, and infusing your work with different stylistic concerns. Find some collaborators to bring into your process, and allow your journal to fully experience the outside world within its pages.

COLLABORATIVE DRAWING: SHARING THE PAGE

Open up the space in your journal to the people you encounter, and invite them not only to observe but also to actively participate in your pages. Encourage people to make collaborative drawings with you even if they don't have a journal of their own to share. It can be an enjoyable, freeing and creative experience to react to the marks of another. The process is always spontaneous in nature and the end results are always unpredictable. It is especially fun with children.

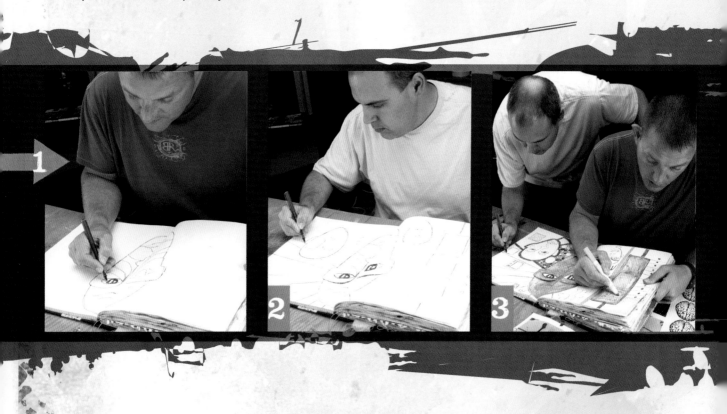

1 Draw something in your journal. Starting with a simple shape is an easy way to begin.

3 Embellish the drawing by thickening lines, adding color and using other media.

2 Pass it to a friend, and have them add something. Keep passing it back and forth to complete a basic drawing.

If you want to add an element of structure and surprise to this sort of activity, incorporate the game Exquisite Corpse. The Exquisite Corpse (also known as the exquisite cadaver, rotating corpse and exquisite character) is a method used to assemble an image through systematic collaboration with other people. The technique was invented by the Surrealists in the early twentieth century and was a popular parlor game among artists and writers of the period. Fold a piece of paper or napkin into multiple spaces and create a drawing of some sort in the first space. Fold the paper so the initial drawing is not visible, and pass it to the next contributor. After he or she adds to the drawing, pass it around, allowing others to add to it in the same fashion. It doesn't have to be a group collaboration, and you can just pass it back and forth with one other person. Usually folding a piece of paper into four sections is enough to have fun with this game. Of course, putting the results into your journal may be the most fun of all.

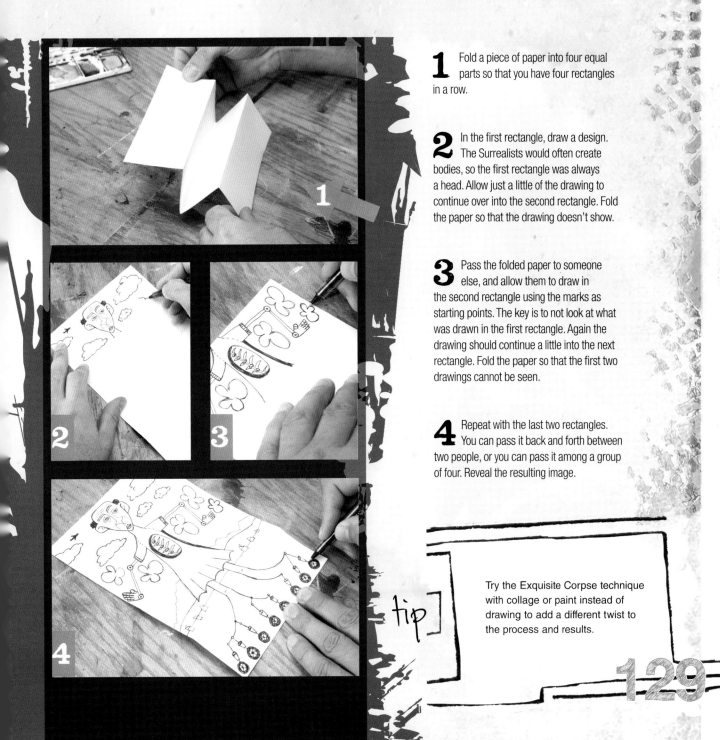

1 Fold a piece of paper into four equal parts so that you have four rectangles in a row.

2 In the first rectangle, draw a design. The Surrealists would often create bodies, so the first rectangle was always a head. Allow just a little of the drawing to continue over into the second rectangle. Fold the paper so that the drawing doesn't show.

3 Pass the folded paper to someone else, and allow them to draw in the second rectangle using the marks as starting points. The key is to not look at what was drawn in the first rectangle. Again the drawing should continue a little into the next rectangle. Fold the paper so that the first two drawings cannot be seen.

4 Repeat with the last two rectangles. You can pass it back and forth between two people, or you can pass it among a group of four. Reveal the resulting image.

tip

Try the Exquisite Corpse technique with collage or paint instead of drawing to add a different twist to the process and results.

Incorporating Hands

The first marks we made as children were most likely with our fingers and hands, no brush required. Just because we are older now and have more sophisticated ways of applying paint doesn't mean this approach is no longer valid. Pablo Picasso once said, "Every child is an artist. The problem is how to remain an artist once he grows up." Tap into your inner child as you experiment with paint in your journal, and utilize your human resources as the impetus for beginning pages or creating layers. Use yourself, other people and your physical bodies as tools in your art-making as you stamp hands and create silhouettes with a spray bottle of paint.

STAMPING TECHNIQUE

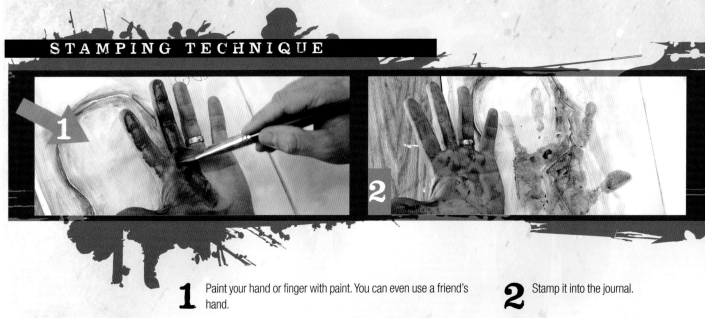

1 Paint your hand or finger with paint. You can even use a friend's hand.

2 Stamp it into the journal.

SPRAY SILHOUETTE TECHNIQUE

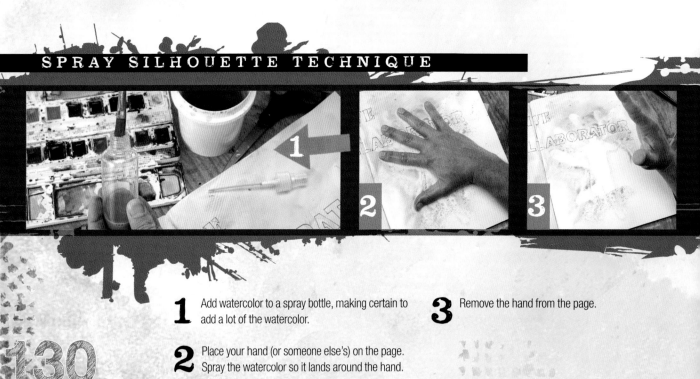

1 Add watercolor to a spray bottle, making certain to add a lot of the watercolor.

2 Place your hand (or someone else's) on the page. Spray the watercolor so it lands around the hand.

3 Remove the hand from the page.

COMPULSIONS AND OBSESSIONS: GAME SCORES

Many of the games we enjoy require keeping score in one manner or another, so the journal becomes an active space for us to record these friendly competitions. Our journals are inundated with scores of all sorts, but we especially love playing a dice game called Farkle. If you haven't heard of it, you should ask your friend Google and check it out! Try this game, or keep score for your favorite game. Don't stop with just keeping score. Explore how you integrate the lists of numbers into the pages with color and other embellishments. The rows of numbers take on an abstract pattern and an encoded quality when they are transformed into a more interesting visual element. They seem recognizable, but not completely understood, until people realize they are scores to a game.

The next time you play a game of Yahtzee, glue the scorecards in your journal, or re-create the scoring categories on a journal page and keep score directly in your book. At the bowling alley, have your journal along, and record the scores inside. It is a fun and interesting diversion from other types of documentation, and it brings an element of real activity, promoting dialogue about shared events and providing evidence of the merging of art and social experience.

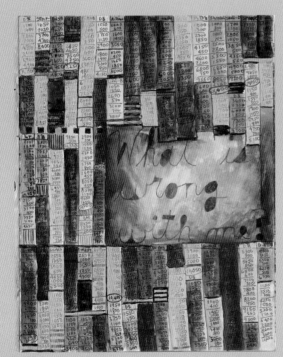

Farkle

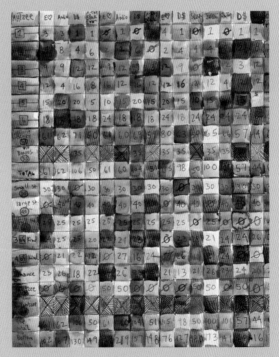

Yahtzee

131

OBSERVATIONS: JOURNALS FACE-TO-FACE

In our technology savvy and digitally laden world, it's easy to view artwork from all over the world without leaving your home or even getting out of your pajamas. The Internet has opened up a universe of access for both the maker and the viewer. But at what cost? The computer screen only gives you a vague notion of what it is like to fully encounter someone's journals because the real experience is not just visual. It is an all-encompassing sensory activity. Nothing compares to being face-to-face with someone's journal and getting a feel for the weight of the book, the tactile nature of the collage, the evidence of the book's constant maintenance and repair or the residual smell of the media used and the places the journal has traveled. Relying only on the digital documentation of artwork as the primary source of research relegates the process to looking at snapshots from a trip around the world as a substitute for the actual experience.

One of our favorite activities is being a voyeur of our own work as others look through our pages and we watch their interactions. Where do they stop to gaze a little longer? What pages do they skip by with a short glance? Are these the same reactions we have when we look through our journals? How is each person's engagement similar and different? Engage in your own spontaneous conversations about the style, concepts and content as you invite others to look at your journal. Look for spaces in your journal to embellish and add to as you revisit the pages over someone's shoulder and through someone else's eyes.

EXCURSION: TAKE YOUR JOURNAL TO VISIT A FRIEND

As you develop your network of accomplices, make it a point to always have your journal to share. But also be sure to take it when you visit other friends who may not be part of your journal tribe. The visual journal has the power to captivate, and when you are ready to make it public, you will build stronger bonds with all of the people who you invite into your private and intimate spaces. Not only will you get input, but you can also document the visits directly in the journal as they are experienced. How does it feel to open the journal to others? Do you feel apprehensive? How are these interactions different than your nonjournal interactions?

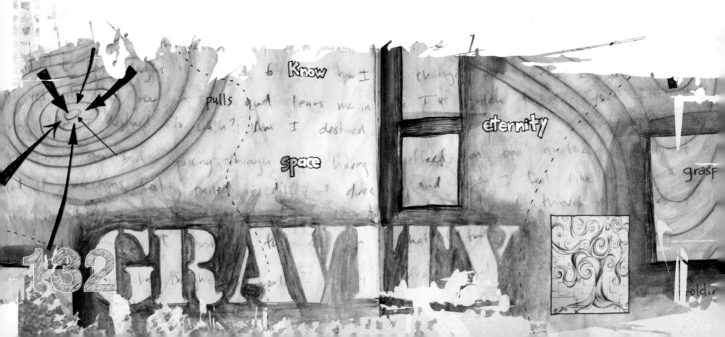

ANATOMY OF A JOURNAL SPREAD

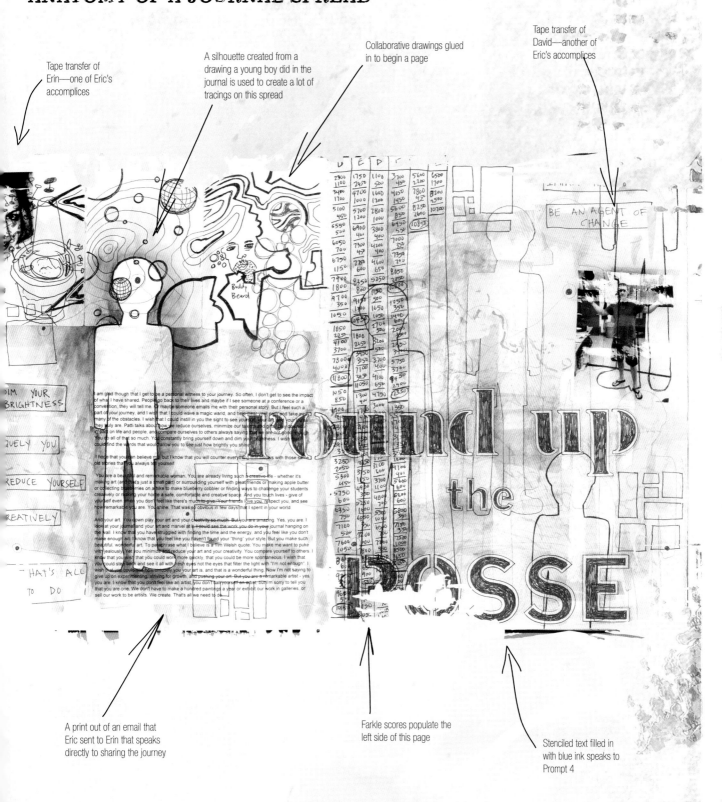

Tape transfer of Erin—one of Eric's accomplices

A silhouette created from a drawing a young boy did in the journal is used to create a lot of tracings on this spread

Collaborative drawings glued in to begin a page

Tape transfer of David—another of Eric's accomplices

A print out of an email that Eric sent to Erin that speaks directly to sharing the journey

Farkle scores populate the left side of this page

Stenciled text filled in with blue ink speaks to Prompt 4

Closing Thoughts

You can do it all alone, but an adventure is always more fun and meaningful when it is shared with a companion. Seek out your artistic accomplices and creative collaborators, invite others into your process, and become part of another's line of inquiry. No matter what collaborations you are able to initiate, always remember to move forward. And don't forget that you always have the Journal Fodder Junkies as well!

Afterword →

RITES OF PASSAGE

As you develop your own journaling method, it is important to develop some strategies so that you are not caught up in the complexities of working and overwhelmed by all the blank pages, media, and equipment. Simplify your process with ideas that enable you to work virtually anywhere at any time and help you continue and extend your artistic practice. Establish a habit so that you are never far from your journal, and experiment with the rites and rituals that can keep you engaged.

WORKING RITUALS

ACCESS: *Keeping the Book Open*

When your journal is out of sight, it is often out of mind and easily forgotten. It can be depressing to retrieve the journal from a bag or the studio only to realize that it has been quite a while since you last worked in it. Keep your journal close at hand, and if possible, keep it open. An open journal invites interaction and activity, so clear a space on your coffee table or kitchen counter where you can leave your open journal and a few essential materials so that you are always ready to work. If you take your journal to work, dedicate a space on your desk or on a counter, and open it to a page that needs work. When you have a few minutes, add something quick and simple. This meager act keeps the journal at the forefront of your thoughts and encourages your constant engagement.

LIMITED MATERIALS: *Only What's Necessary*

Many journaling approaches use a wide range of artistic materials including expensive and specialized media and techniques, but this often entails complex issues of setup and cleanup. Simplify your list of essential journaling materials so that you can get to work immediately and not spend a long time cleaning up in the end. Confine your journaling essentials to a pencil or brush bag to make your journaling ultra portable, and you can work everywhere from the kitchen table to the neighborhood coffee shop. Save the more complex ideas for the studio when you have more time and need more space. Limiting your materials to only what's necessary also pushes you to be more creative as you focus on new and different ways to use your basic tools and supplies. Keep your materials simple as a way to encourage quickly getting to work in the journal so that you are not bogged down with too many choices.

FREEING FIVE MINUTES: *Finding Focus*

Having the luxury of uninterrupted hours in the studio to journal is not a reality in many of our lives. With the hectic nature of contemporary life, we are lucky to have five minutes here or fifteen minutes there. Too frequently, we fill these moments with distractions and occupations such as texting friends, looking through magazines, checking Facebook and flipping through channels on the TV. However, these little periods of time are perfect opportunities for adding to the journal. In just five minutes, you can start a page with watercolor or watercolor pencil, glue in a few bits of fodder, complete a brain dump or add some of your compulsions and obsessions to pages. These brief minutes of focus here and there have a cumulative effect as random elements build up over time. Train yourself in the habit of taking advantage of these small periods of time, and keep your journal open and ready to go as a way to encourage these transient interactions. Become more mindful and purposeful of how you fill these fragmentary moments when you have "nothing to do."

MULTITASKING: *Purposeful Distractions*

It is not uncommon to multitask through our days, and it is too easy to distract ourselves to the point where we get very little done. But we can create the means to divert our attention in very purposeful ways. By having the journal easily accessible, you can be creating in the journal at any given time. So instead of mindlessly watching TV and flipping through channels during commercials, use those few minutes to add to your journal. If it's one of those shows or movies that you have seen multiple times, use it as background as you work in your journal. Also, use the journal as a purposeful distraction while texting a friend or having a casual conversation. In our multitasking society, why not take full advantage in a creative way?

When you need to take a break from other activities, allow the journal to occupy your attention. Take a fifteen minute break when you are busy with housework or yard work, and add something to your pages. Anytime you need to stretch your legs and your mind at work, use your journal as a brief and much needed distraction. As you read a book and need to process what you read, add quotes, notes and insights to a journal page. Find other ways to use your visual journal as a purposeful and meaningful distraction.

REFLECTION: *Looking for Stagnation*

There are times of great energy when we work fast and furious in the journal, and time slips by as we are immersed in our work. There are also times when the ideas don't flow, and working through our pages becomes more of a chore; we may feel as if we have lost the spark. This is the natural ebb and flow of your creative energy. It is a cycle, and as with all cycles, those times of energy and creation will come again. Become aware of periods of stagnation when your level of motivation drops, and turn your reflection on these slow periods into a process to work out in the journal. Describe the stagnation, vent your frustration, and confront these low times head-on. You become covertly productive even in times of your deepest rut as your reflections and writings pile up, moving you through these creative blocks.

Sometimes, stagnation can be kept at bay by simply showing up at the page and working. When you feel the hesitation of nothing new to say or do, come to the journal and set simple tasks for yourself. Paint a page, draw some lines and shapes or glue in some random collage. These little acts can help relieve the frustration as you push through it. Before long, you get into your artistic groove, breaking through the wall of uncertainty.

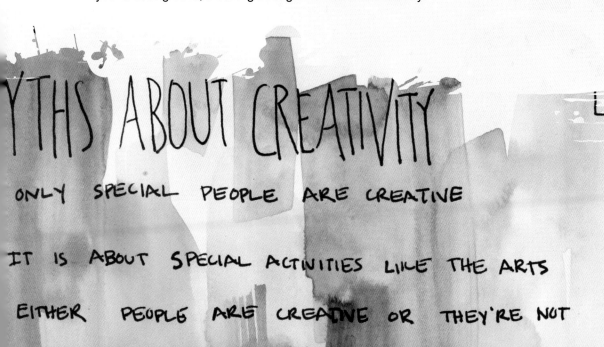

YTHS ABOUT CREATIVITY

ONLY SPECIAL PEOPLE ARE CREATIVE

IT IS ABOUT SPECIAL ACTIVITIES LIKE THE ARTS

EITHER PEOPLE ARE CREATIVE OR THEY'RE NOT

CALENDAR: *Plotting a Course*

Another useful tool in cultivating the journal habit is the calendar. We draw a calendar in the journal as one continuous grid from the very back of the book toward the front, so that we can add a month or two if necessary. It takes an average of eight months to a year for us to fill a journal, but sometimes we draw in too many months, and other times, we don't include enough. It's always good to have the flexibility to truncate or extend the calendar as necessary. Draw in a calendar by hand, or glue in pre-existing calendar pages.

 Physically writing on your calendar forces you to open your journal anytime you need to add a new engagement or check your schedule. Crossing off each day on your calendar gets you to consistently access your journal, and once it is open, you are more likely to flip through the pages and continue working. Consider creating intricate embellishments as you cross out the days so that the calendar becomes very patterned. The simple act of filling in the patterns gets your hand moving, and soon you find yourself filling spaces elsewhere in the journal.

TRANSITIONING RITUALS

As we get near the end of a journal, we must transition into a new one. The retirement and initiation of journals are simultaneous occurrences for us. There comes a time when we need more blank pages than remain in a current journal. That is when we begin the transition from the old to new. There is a thrill of getting a new journal, and it's hard to contain the excitement when picking it up. It is so new, crisp, blank and pristine. Imagining the possibilities of this object growing into a rich, personal artifact is such a thrill and a moment of promise.

RETIRING A JOURNAL

A current journal ultimately runs its course, and it must be retired to the shelf. There is no key in knowing when it is time to retire a journal. Our general sense is that when it has been several weeks since we last worked in the old journal and we are thoroughly entrenched in the new journal, it is time to stop carrying around the excess weight and to retire the journal. We use the word "retire" instead of "finish" because to finish something has such finality. It is finished, over and done. That's it. To retire has an air of promise. It has worked hard, and now has time to relax. However, it is continuing, and like some professional athletes, an old journal can always come out of retirement.

When you retire a journal, that at times means pages, especially near the end, never get fleshed out like the others. These pages often have an unfinished look and feel, and that's fine. The journaling process isn't about finishing pages. It is about the natural flow. Usually you just need to retire the journal so that you don't have to lug it around anymore.

INITIATING A NEW JOURNAL

There are several rituals and routines that we undergo even before we begin working in a new volume. We apply a few stickers to the cover, leaving enough room to add more as we collect them. We place our contact information in the front cover, and write in the visual journalist's oath, which we adapted from Robert Kaupelis's book, *Experimental Drawing*. We create one or more pockets for fodder, and we draw in a new calendar, picking an appropriate date to begin keeping our appointments and engagements. See our first book for more detailed information and instruction for the rituals that we use to ease into a journal.

The visual journalist's oath: "I solemnly promise that from this day forward I shall never again be caught without a journal and also that I shall use it faithfully everyday."

Create your own oath if you wish.

Once the journal is ready, we use it as an extension of the previous journal, and for some time we carry around both, working in them equally. When we need fresh blank pages, we pull out the new journal, and when we need to develop ideas and want to work on established pages, we work in the older journal. Eventually we work exclusively in the new journal, developing pages and ideas, and the old one gets placed up on the shelf with all its predecessors. By working in this manner, the books are merely a continuation of one another. We see the individual journals as part of the same process, our living process.

SHARING RITUALS

Oftentimes, it is an artistic exchange or a creative collaboration that gives us a little nudge and helps keep the artistic spark burning. As mentioned, we all need artistic accomplices to inspire us, push us and motivate us. There are a variety of ways to include these collaborations into your mode of working. This type of sharing, supplies the impetus to move forward, carry on and keep up the journaling habit, and it helps keep the connection among your artistic accomplices and creative collaborators.

RETURNING THE COMPLIMENT: *Mail Art Postcards and Artist Trading Cards*

The exchange of small works of art with our friends is a wonderful way to share our journey with other artists. This exchange feeds creativity, prods your studio practice and enables you to share ideas and techniques with your artistic accomplices. You stay connected to these people even when you are divided by great distances. Mail art postcards and artist trading cards have become very popular forms of sharing and exchanging artistic expressions between people. These pieces can even be glued into the journal as evidence and documentation of the relationship and connection.

The idea of the mail art postcard is to create postcards to actually mail to your creative collaborators. Just as you might send a postcard from a vacation spot, you send a small piece of art. Use any medium that is durable and can withstand being sent through the mail. Collage, acrylic paint, drawing, watercolor paint, digital art and mixed media are all appropriate. You might want to seal your postcard with an acrylic medium as a layer of protection before you mail it. Make certain that the work of art is the correct postcard size, include your friend's address and the correct postage and drop it into the nearest mailbox. It's a delight to get these little surprises in the mail. Of course, the idea is to exchange these cards, so that once your friend receives your card, he or she creates one and mails it to you.

Artist trading cards, also know as ATCs, are another way to exchange small works of art. This cultural phenomenon started in the late 1990s in Switzerland and has grown in popularity ever since. The premise is simple. You create a small work of art that is exactly 2½" × 3½" (6cm × 9cm), and you trade it with someone else. Artist trading cards are never sold. You can trade them through the mail, or you can trade face-to-face. There are books, websites and resources out there if you want to learn more about this art form.

TAG TEAMING STRATEGIES: *Collaborative Journals and Round Robins*

Another way to maintain the connection with your fellow artists and fuel the inspiration is to share journals. This idea may scare some because of concerns that the others may mess up our work or we may mess up theirs. But if you have the time and energy, collaborative journals and round robins are wonderful ways to fan the flames of collaboration and inspiration.

A collaborative journal is a single journal that is shared by two or more people. The idea is that it belongs to all equally. Quite often the collaborative journal is shared between just two people as documentation of their shared journey and friendship. The journal is mailed back and forth, or it is exchanged face-to-face. The participants may decide that each will keep the journal for a set amount of time so that the collaboration doesn't stagnate and stop if one person keeps putting it off. In a truly collaborative journal, it is not only the book that is shared, but every page is shared. Each person can add something to a page worked on by others. There is no idea of *my page* and *their page*. The artwork, style, and words begin to interact, and a genuine dialogue between the collaborators takes place.

There are issues in any collaborative endeavor. One issue is the possibility that one collaborator will do something to completely "mess up" a page. Often when we start a page, we develop an idea about how we want it to turn out, and if we are overly attached to that idea, we react negatively when others do something that we didn't expect or something that we don't like. There needs to be an openness on everyone's part, and everyone has to agree to this type of collaboration. The other issue is one of ownership. Who gets physical custody of the journal when it's finished? This is a contentious subject with each person having equal ownership. An easy solution is to create a second or third journal, depending on how many are participating. That way each person can keep a journal of the shared journey, but it may be difficult to sustain the creative energy to fill a journal for each collaborator. Other solutions may need to be explored.

A round robin is usually a bit more formal with each participant having his or her own journal. The group may decide on a collective theme that everyone explores, each individual may choose an independent theme or there may be no theme whatsoever. Usually an order for the rounds is decided so that each person is always passing the journals onto the same person. Just as with the collaborative journals, a specific time period may be set for holding on to someone's journal. But unlike the collaborative journal, participants usually create their own unique pages. Sometimes there are collaborative pages, but that has to be agreed upon by the group to avoid stepping on toes. Also, the group may set a certain number of pages to complete during each round. The journals are sent around the group in the predetermined order until each owner gets his or her journal back. If the journals are not complete, the group may decide to send them around again.

The biggest issue with the round robin is the possibility of a back log. It is easy for someone in the chain to get behind. There are emergencies, illnesses, general busyness and, of course, sheer creative block that can keep people from meeting the deadline of creating work and passing them on. Weeks and months pass, and journals pile up. Sometimes the round robin comes to a screeching halt because one person is so overwhelmed that they end up with nearly every journal. Another issue is just the formal nature of it. The details need to be worked out in advance with everyone agreeing to the terms.

Despite the risks and issues, when collaborative journals and round robins are successful, they can be a great source of inspiration, collaboration, connection and motivation.

Utilizing these strategies keeps you motivated to work in the journal and fully engaged in the habit of visually journaling. We hope that your experience with the journal has led to personal and artistic growth, and that it is a journey that you will continue for years to come.

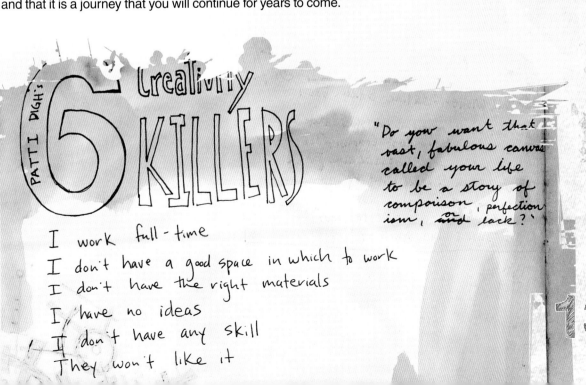

PATTI DIGH's

6 Creativity KILLERS

"Do you want that vast, fabulous canvas called your life to be a story of comparison, perfectionism, and lack?"

I work full-time
I don't have a good space in which to work
I don't have the right materials
I have no ideas
I don't have any skill
They won't like it

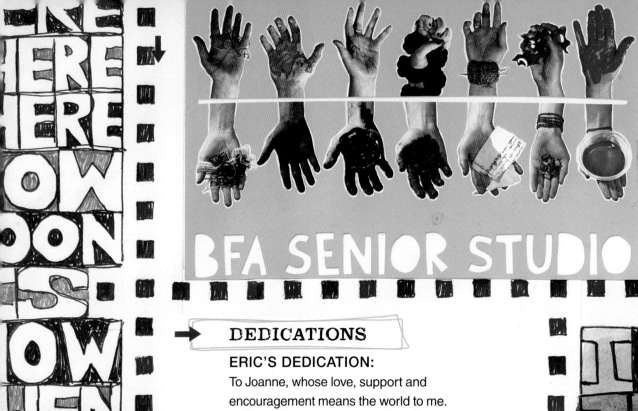

BFA SENIOR STUDIO

→ DEDICATIONS

ERIC'S DEDICATION:

To Joanne, whose love, support and encouragement means the world to me.

To Mom and Dad, who always encouraged me to follow my dreams and taught me that I could do anything.

To all of the critters and creatures who give love unconditionally and bring comfort and joy to me.

DAVID'S DEDICATION:

To my parents, John and Karen, and my friends, who are always there when I need them the most.

ACKNOWLEDGEMENTS

We would like to thank F+W Media and North Light Books for taking another chance on us in publishing this book. Specifically we would like to thank acquisitions editor Tonia Davenport for pushing us to think differently about a new book, editor Rachel Scheller for her sense of humor and for guiding us through the first part of the process, editor Kristy Conlin for leading us through the rest of the process, photographer Christine Polomsky for her enthusiasm and great photos, and designer Kelly O'Dell for her wonderful vision of our book. We want to thank everyone who has come to see us at our various workshops, seminars and presentations; have bought our first book; have visited us in cyberspace; and have supported and encouraged us in our journey. We also want to acknowledge the continued inspiration and support of the Eldon family as we try to carry on Dan's legacy.

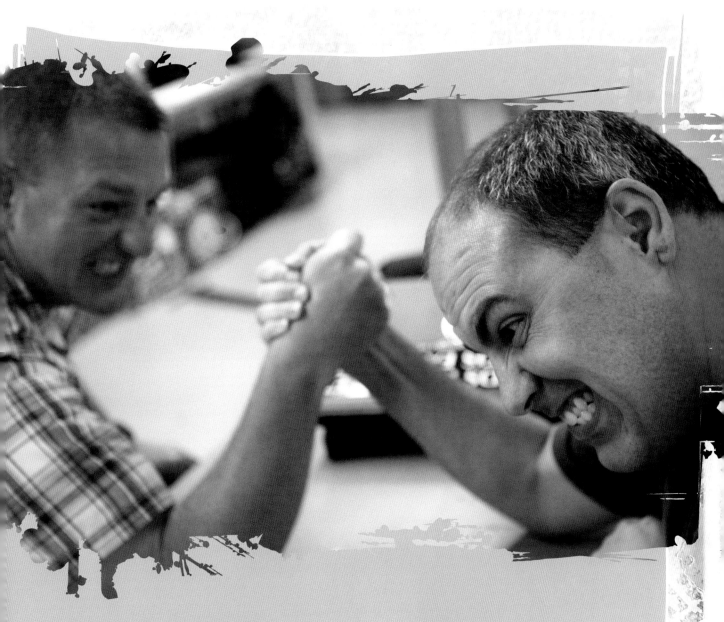

ABOUT THE AUTHORS

David R. Modler is an artist/educator born and raised in Baltimore. He earned his Bachelor of Science and Master of Education in art education from Towson State University, and taught elementary art for fifteen years. David earned a Master of Fine Arts in drawing and painting from James Madison University in Harrisonburg, Virginia, and now holds a teaching position at Appalachian State University in Boone, North Carolina.

Eric M. Scott is an artist/educator born and raised in Washington, Pennsylvania. Earning his Bachelor of Science in art education from Edinboro University of Pennsylvania, he currently lives in Purcellville, VA. Eric is a National Board Certified teacher and teaches art for Loudoun County Public Schools.

In 2005, David and Eric teamed up to officially become the **Journal Fodder Junkies** (JFJ), and they have been spreading the power and the joy of the visual journal to all who seek creative release. David and Eric have continued to provide workshops, presentations, and seminars to teachers, students, and artists throughout the country, and they have coauthored the best selling book, ***The Journal Junkies Workshop: Visual Ammunition for the Art Addict***.

INDEX

16 15 14 13 12 5 4 3 2 1

Distributed in Canada by Fraser Direct
100 Armstrong Avenue
Georgetown, ON, Canada L7G 5S4
Tel: (905) 877-4411

Distributed in the U.K. and Europe by F&W MEDIA INTERNATIONAL
Brunel House LTD, Newton Abbot, Devon, TQ12 4PU, ENGLAND
Tel: (+44) 1626 323200, Fax: (+44) 1626 323319
Email: enquiries @ fwmedia.com

Distributed in Australia by Capricorn Link
P.O. Box 704, S. Windsor NSW, 2756 Australia
Tel: (02) 4577-3555

ISBN-13: 978-1-4403-1840-5

Edited by Kristy Conlin and Rachel Scheller
Designed by Kelly O'Dell
Production coordinated by Greg Nock
Photography by Christine Polomsky and Al Parrish

www.fwmedia.com

metric conversion chart

to convert	to	multiply by
inches	centimeters	2.54
centimeters	inches	0.4
feet	centimeters	30.5
centimeters	feet	0.03
yards	meters	0.9
meters	yards	1.1

More Fodder for Your Journaling Adventures!

Looking for more? We have tons of free **Journal Fodder 365** bonus content to inspire you! Have a smartphone with a QR code reader? Just scan the code to the left for access to tutorials covering everything from painting to layering to drawing to collage. You can also access all the same goodies by visiting: createmixedmedia.com/journal-fodder-365-bonus-content.

These and other fine North Light mixed media products are available at your local art & craft retailer, bookstore or online supplier. Visit our website at CreateMixedMedia.com.